earth spirit fire

Korean masterpieces of the Chosŏn dynasty (1392-1910)

Edited by Claire Roberts and Michael Brand

POWERHOUSE MUSEUM
QUEENSLAND ART GALLERY

POWERHOUSE PUBLISHING

PART OF THE MUSEUM OF APPLIED ARTS AND SCIENCES

A co-publication by the Powerhouse Museum and the Queensland Art Gallery

First published 2000
Powerhouse Publishing, Sydney, Australia

Powerhouse Publishing
part of the Museum of Applied Arts and Sciences
PO Box K346 Haymarket NSW 1238 Australia
www.phm.gov.au

The Museum of Applied Arts and Sciences incorporates the Powerhouse Museum and Sydney Observatory.

Publication management: Julie Donaldson (Powerhouse Museum)
Content coordination: Claire Roberts (Powerhouse Museum) and Sarah Tiffin
(Queensland Art Gallery)
Editing: Rowena Lennox
Design: Colin Rowan (Powerhouse Museum) and Rhys Butler
Maps: Rhys Butler
Printing: Inprint Pty Ltd

National Library of Australia CIP
Earth, spirit, fire: Korean masterpieces of the Chosŏn dynasty
Bibliography
ISBN 1 86317 0804
Ceramics—Korea—Exhibitions. 2. Korea—History—Yi dynasty, 1392-1910. I.
Roberts, Claire, 1959—. II Brand, Michael, 1958—. III Powerhouse Museum.
IV. Queensland Art Gallery.
759.9519

Published in conjunction with the exhibition Earth, spirit, fire: Korean masterpieces of the Chosŏn dynasty organised
by the Queensland Art Gallery, Powerhouse Museum and the National Museum of Korea in association with the Ho-
Am Art Museum. The exhibition is an official event of the Sydney 2000 Olympic Arts Festival.

Queensland Art Gallery 16 June — 20 August 2000.

Powerhouse Museum 8 September 2000 – 28 January 2001.

Principal sponsor

Official Partner

Sponsored by

SINGAPORE
AIRLINES

Supported by

Ministry of Culture and Tourism of the Republic of Korea
and the Australia-Korea Foundation

Contents

Forewords

As part of the Sydney 2000 Olympic Arts Festival, Samsung Electronics Australia is proud and honoured to be associated with the first major exhibition focusing on Korean ceramics, and indeed only the second major Korean exhibition ever held in Australia —- *Earth, spirit, fire: Korean masterpieces of the Chosŏn dynasty*. This remarkable collection of ceramics, painting, furniture and calligraphy, from the National Museum of Korea, the Ho-Am Art Museum and a number of other institutions and private collections in Korea, provides an insight into the richness of Korean culture.

Geographically, Korea lies between China and Japan and, despite the trade, religious, political and artistic exchanges that undoubtedly existed, Korea was able to develop its own unique cultural independence which is particularly evident in the exhibition and this publication.

All the pieces in the exhibition were created to be functional and originate from a broad cross-section of Korean society. When viewed together, such items provide a perception of Korean life during the Chosŏn period and reflect a strong association with the cycle of life from birth to death. Yet remarkably, the pieces manage to have a contemporary aura.

As Samsung Electronics Australia enters an exciting new era, that of digital technology, we are delighted to be able to share with Australia and the world, Korea's resplendent cultural heritage through this extraordinary exhibition and the associated publication. We hope this collection of Korean masterpieces will bring enjoyment not only to the people of Australia but also to the many overseas visitors to the Sydney 2000 Olympic Games. In this way, Samsung Electronics hopes to stimulate the future through providing awareness and understanding of the past.

J S Shin, Managing Director, Samsung Electronics Australia Pty Ltd

I am delighted that *Earth, spirit, fire: Korean masterpieces of the Chosŏn dynasty*, an exhibition of ceramics, painting, calligraphy and furniture of the Chosŏn dynasty, is to be shown in Brisbane and Sydney during the 2000 Olympic Games.

Significant examples of Korean art have rarely been exhibited in Australia. This is the first grand exhibition of Korean art from the National Museum of Korea that has travelled to Australia. The exhibition features selected masterpieces from the Chosŏn dynasty, a period during which culture flourished and which forms an important part of 5000 years of Korean history. *Earth, spirit, fire: Korean masterpieces of the Chosŏn dynasty* is an official event of the Sydney 2000 Olympic Arts Festival and will provide a significant opportunity to introduce Korean art and culture not only to Australians but also to international visitors.

Australia and Korea have shared a relationship of friendly exchange in various fields and it is hoped that this exhibition will be an important contribution towards building greater cultural understanding between our two nations.

This exhibition would not have been possible without the cooperation and participation of the Queensland Art Gallery in Brisbane, the Powerhouse Museum in Sydney, the National Museum of Korea in Seoul, the Ho-Am Art Museum in Yongin and private lenders in Korea to whom I would like to take this opportunity to express my deepest gratitude.

Ji Gon-gil, Director, National Museum of Korea, Seoul

Earth, spirit, fire: Korean masterpieces of the Chosŏn dynasty continues a long tradition of cultural exchange between Australia and countries in the Asia-Pacific region. The Queensland Art Gallery and the Powerhouse Museum are especially pleased to present this major exhibition developed in collaboration with the National Museum of Korea, in association with the Ho-Am Art Museum, as part of the Sydney 2000 Olympic Arts Festival. The title of the exhibition reflects the key themes: the *earth* from which Korean artists have formed one of the world's great ceramic traditions; the *spirit* of Korean philosophy and ritual; and the *fire* of Korean creativity and innovation in the field of ceramic technology in particular.

Recent history has brought Australia and the Republic of Korea much closer through activities in the areas of trade, tourism, education and cultural exchange. Australia and Korea also share the experience of hosting the summer Olympics. While Australians have come to learn more about Korean history and culture in the twelve years since Seoul hosted the Olympic Games in 1988, very few masterpieces of Korean art have travelled to Australia and there are very few Korean objects in the collections of Australian museums and galleries. Owing to the great generosity of the Ministry of Culture and Tourism of the Republic of Korea, Korean cultural institutions and private collectors during the year 2000, audiences in Australia will be able to see and appreciate some of the finest examples of Korean ceramics, furniture, painting and calligraphy from the Chosŏn period.

We would like to especially thank Dr Ji Gon-gil, the Director, and staff of the National Museum of Korea in Seoul, our partner in the *Earth, spirit, fire* project and the main exhibition lender. The Ho-Am Art Museum in Yongin, just outside of Seoul, through its Director, Madam Ra Hee Hong Lee, has also been extremely generous with loans of some of its precious objects. We would also like to thank the four other Korean private and institutional lenders who have made works available for the exhibition: Kim Nak-joon, Chairman of the Kumsung Publishing Cultural Foundation; the Changsŏgak Collection, The Academy of Korean Studies; the Sŏngam Archives of Classical Literature; and the Chŏng So-hyŏn Collection.

We would like to acknowledge the contribution of the curatorial team that developed the exhibition and carried out all the major negotiations: Chung Yang-mo, Director-General of the National Museum in Seoul until his retirement in December 1999; Michael Brand, Assistant Director at the Queensland Art Gallery; and Claire Roberts, Curator of Asian Decorative Arts and Design at the Powerhouse Museum. Special thanks are also due to Terence Measham AM, Director of the Powerhouse Museum until December 1999; Kim Jae-Yeol, Deputy Director of the Ho-Am Art Museum; and Kenneth M Wells, Director of the Centre for Korean Studies, Australian National University, Canberra.

Samsung Electronics is the principal sponsor of this exhibition and we express our deep gratitude for its support of this significant international project. We have also received important assistance from the Samsung Foundation of Culture through its Executive Managing Director Lee Shil and his predecessor Han Yong-Oe. We would also like to acknowledge the sponsorship by Singapore Airlines and the support of the Australia-Korea Foundation. The objects in this exhibition have been indemnified by the Queensland Government Exhibitions Indemnification Scheme and the New South Wales Treasury Managed Fund.

We trust that *Earth, spirit, fire: Korean masterpieces of the Chosŏn dynasty* will make not only a significant contribution to the cultural experience of our audiences in Australia but also to the international spirit of the Olympic Games.

Doug Hall, Director, Queensland Art Gallery, Brisbane

Kevin Fewster, Director, Powerhouse Museum, Sydney

Acknowledgments

The directors of the organising institutions Doug Hall (Queensland Art Gallery), Kevin Fewster (Powerhouse Museum) and Ji Gon-gil (National Museum of Korea), and the curators of the exhibition, Chung Yang-mo, Michael Brand and Claire Roberts, sincerely thank the many individuals and institutions who have helped to make this exhibition and publication possible.

Special thanks are extended to the other institutions and individuals who have generously lent objects for the exhibition, notably Madam Ra Hee Hong Lee (Director of the Ho-Am Art Museum), Kim Nak-joon (Chairman, Kumsung Publishing Cultural Foundation), Han Sang-jin (Director Changsŏgak Collection, the Academy of Korean Studies), Cho Byoung-soon (Sŏngam Archives of Classical Literature) and Chŏng So-hyŏn.

We are extremely grateful to the exhibition sponsors, in particular Samsung Electronics, the principal sponsor of the exhibition, the Samsung Foundation of Culture, and to Madam Ra Hee Hong Lee for her assistance in securing the major sponsorship for this project. We also wish to thank: Yun Jong-Yong (Vice-Chairman and Chief Executive Officer, Samsung Electronics), Han Yong-Oe (Executive Vice-President and Chief Executive Officer, Samsung Electronics and former Executive Vice-President, Samsung Foundation of Culture), Lee Shil (Executive Managing Director, Samsung Foundation of Culture) and Hong RaYoung (Deputy Director, Samsung Museum of Modern Art). Many thanks are due to Singapore Airlines for their sponsorship and we would like to acknowledge the support of the Sydney Organising Committee for the Olympic Games and the Australia–Korea Foundation.

Many staff from the three organising institutions have contributed to the exhibition and this publication and we would like to thank them all. In particular we would like to acknowledge Kim Dong-Woo (Assistant Curator, Registrar's Office, National Museum of Korea), Sarah Tiffin (Senior Project Officer, International Exhibitions, Queensland Art Gallery) and Kim Min-Jung (Assistant Curator, Powerhouse Museum), who have played key coordinating roles and been instrumental in the many facets of cross-cultural communication required by this project.

We are grateful to staff involved from the National Museum of Korea: Yoon Chung-ha (Director-General, Administration and Education), Lee Keun-moo (Chief Curator), Shin Kwang-seop (Chief Registrar), Choi Moo-hong (Director of Cultural Exchange and Education Division), Sim Dong-seup (Deputy Director of Cultural Exchange and Education Division) and Kim Jin-Myung (Coordinator of Overseas Exhibitions and Cultural Affairs). And also to staff involved from the Ho-Am Art Museum: Kim Jae-Yeol (Deputy Director), Cho In-soo (Chief Curator) and Kim Ja Myung (Administration Department).

The exhibition could not have happened without support from the government, notably, the Premier of Queensland the Hon. Peter Beattie, the Premier of New South Wales the Hon. Bob Carr and the Hon. Alexander Downer MP, Australian Minister for Foreign Affairs; and also diplomatic staff in Korea and Australia. At the Australian Embassy in Seoul: H E Tony Hely (Ambassador to Korea), Zorica McCarthy (Minister), Cho Beck-hee (Director, Public Diplomacy Section), Choi Moon-sun (Cultural Relations Manager) and Stephen Huang (Korea Section, Department of Foreign Affairs and Trade, Canberra). At the Embassy and Consulate-General of the Republic of Korea: H E Shin Hyo-hun (Ambassador, Canberra), Seok Tong-Youn (Minister, Canberra), the Hon. Baek Ki-moon (Consul-General, Sydney) and Kang Suk-woo (Consul, Sydney).

Thanks are also extended to the Ministry of Culture and Tourism of the Republic of Korea for their generous support of the exhibition and of the visit to Sydney by the National Centre for Korean Traditional Performing Arts for the exhibition opening in Sydney and subsequent performances at the Powerhouse Museum, in particular Ryoo Jae-Ky (Director, Cultural Exchange Division, Arts Bureau).

We would also like to thank the Asia Society Galleries New York, and the following people for their contribution to the project: Suh Bo-Yon, Hong Sun pyo (Professor of Art History, Ewha Women's University, Seoul), Huh Dong Hwa (Director, Museum of Korean Embroidery, Seoul), Nicholas Jose, Kim Won Seok (ceramic artist, Sydney), Lee Kyong-hee (Managing Editor, *The Korea Herald*, Seoul), Park Duk-Soo (School of Asian Studies, University of Sydney), Park Young-sook (Sajeon House, Seoul), Raymond Tregaskis, Yi Sŏng-mi (Professor of Art History, the Academy of Korean Studies, Sŏngnam), Yoon Yeoick (Samsung Foundation of Culture), Young-Oak Wells.

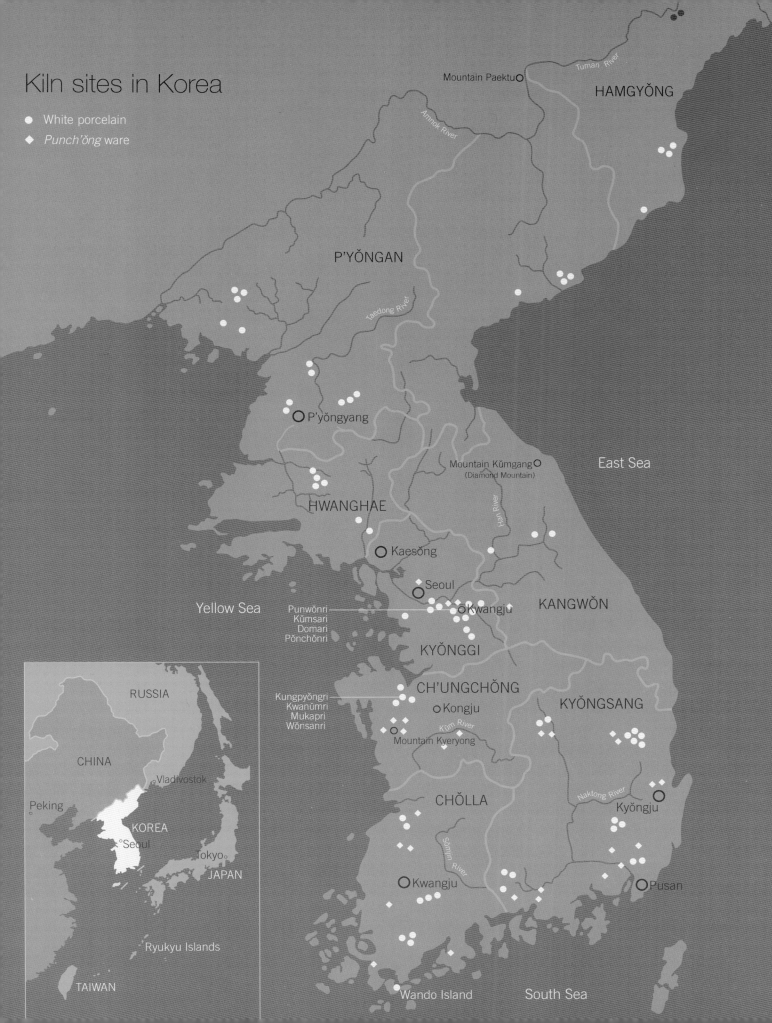

Kiln sites in Korea

- ● White porcelain
- ◆ *Punch'ŏng* ware

Mountain Paektu

HAMGYŎNG

Tuman River

Amnok River

P'YŎNGAN

Taedong River

P'yŏngyang

Mountain Kŭmgang
(Diamond Mountain)

East Sea

HWANGHAE

Han River

Kaesŏng

Seoul

KANGWŎN

Yellow Sea

Punwŏnri
Kŭmsari
Domari
Pŏnchŏnri

Kwangju

KYŎNGGI

CH'UNGCHŎNG

KYŎNGSANG

Kungpyŏngri
Kwanŭmri
Mukapri
Wŏnsanri

Kongju

Kŭm River

Mountain Kyeryong

Naktong River

CHŎLLA

Kyŏngju

Sŏmjin River

Pusan

Kwangju

RUSSIA

CHINA

Vladivostok

Peking

KOREA

Seoul

Tokyo

JAPAN

Ryukyu Islands

TAIWAN

Wando Island

South Sea

Arts of earth, spirit and fire
Claire Roberts and Michael Brand

Earth, spirit, fire: Korean masterpieces of the Chosŏn dynasty highlights the extraordinary creativity of artists from a country about whose culture the West still knows relatively little, but which has exerted a significant influence on international artistic practice, particularly in the area of ceramics. This exhibition, bringing together fine examples of Korean ceramics, painting, calligraphy and furniture drawn from the National Museum of Korea, the Ho-Am Art Museum and a small number of other institutions and private collectors in Korea, provides a perfect opportunity to seek inspiration for the future through a better understanding of the past.

The works of art in this exhibition are mainly functional wares expressing a distinctive Korean culture. They are informed by an aesthetic that emanates from the natural world and strives to achieve a balance between human beings, nature and the cosmos. At the heart of the this aesthetic is the philosophical concept of *ŭmyang ohaeng* (Yin, Yang and the five elements), which is ultimately derived from Chinese cosmology. Yin and Yang are the two complementary yet opposing forces of nature from which it was believed the universe was formed, and the union of which created the five elements. According to East Asian cosmology the five elements are earth, fire, wood, metal and water.

A Korean folding screen painted with a highly stylised landscape featuring the sun, moon and five mountain peaks (cat. no. 2), which was placed behind the king's throne, is a striking visualisation of Chosŏn political cosmology.[1] The sun and moon represent Yang and Yin respectively, and the five peaks allude to the five elements and, by association, the five directions of the universe (north, south, east, west and centre). Symmetrically composed, the painting represents an ideal of perfect harmony and balance. When the Chosŏn king was seated on the throne he became the central point of the composition, the centre of the universe and the mediator between heaven and earth. Invested with sacred power, the screen represented the virtue of the king and bestowed upon

him the favour of heaven and the ancestors.[2] Earth, fire, wood, metal and water combined with human ingenuity, creativity and spirit are seen as the building blocks of society. These five elements are also the natural materials first used by all human beings to fashion objects of utility and aesthetic presence.

The blue hills follow nature's way,

So do the green waters that flow.

Hills and waters go nature's way

And I follow it between them

As I have grown up with both of them

So I will grow old following their way.

Kim In-hu (1510–1560)[3]

The ceramics, paintings, calligraphy and furniture in this exhibition all have a human scale. They were made to be used in living environments determined by the climate and landscape of Korea. The ceramics were made for drinking, eating and storing food, for the production of calligraphy and painting, for birth and burial rites and for ceremonies associated with ancestor worship. Their involvement with rites of passage gives them a strong affinity with the cycle of life, from birth to death. Some objects were used in the royal court; others were used at home by scholars, the elite and the less well-to-do. Seen together, these objects offer a clear window onto aspects of Korean life during the Chosŏn period. They also have an ability to communicate on a universal level, representing an inspired aesthetic response to the increasingly important issue of the relationship between human beings,

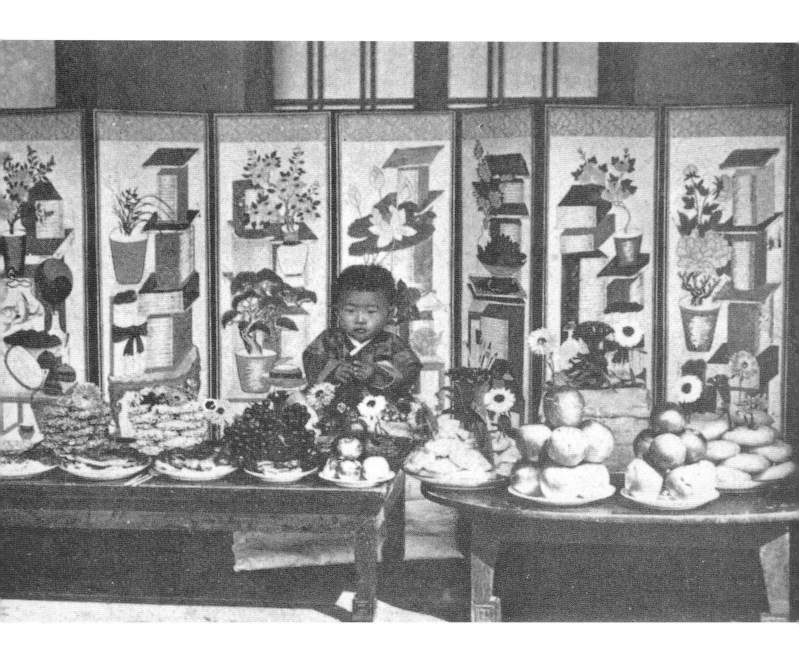

Offerings for a baby boy's first birthday, late 1800s.

Photo courtesy Seomundang Publishing Co, Seoul

the natural environment and the cosmos. In part they reflect the values emphasised by Neo-Confucianism, the guiding ideology of the Chosŏn dynasty, with its stress on self-cultivation through filial piety, moral and intellectual education, and maintaining the proper harmony between things.

When I wake up from a midday nap

To the persistent cries of a cuckoo,

I find my little son reading,

My daughter-in-law weaving cloth

And my grandson toying with flowers in the yard.

My wife happens to be straining the wine;

She tells me to come and taste it.

O Kyŏng-hwa (late Chosŏn)[4]

Lying to the north-east of China and south of Russia, the Korean peninsular at its south-eastern tip is about 200 kilometres from the main Japanese island of Honshu. Its geographical situation, between China and Japan, facilitated great trade, artistic and religious exchange, and also conflict between the three countries. Owing to its proximity, size and political authority, China has long exerted a powerful influence over Korea. Since the 3rd to 2nd century BCE the Chinese written language was introduced to Korea and became the language of government, official culture and the literati. It was not until 1446 that an independent Korean script, known as *Hunmin chŏngŭm* (Correct sounds to instruct the people) was created under the instruction of the King Sejong (reigned 1418–1450) of the Chosŏn dynasty. Han'gŭl, as the script is now known, is a unique phonetic system of writing that is much easier to learn than the complex system of Chinese characters (cat. no. 73).[5] Its introduction during the Chosŏn dynasty highlighted Korea's growing cultural independence and promoted literacy among men and women who did not have access to classical Chinese language.

The Chosŏn-period stoneware and porcelain vessels that form the core of this exhibition belong to an almost universal human tradition. Originally, this ceramic technology had a strongly functional purpose, but the mastery of technique quickly lead to the pursuit of aesthetic ideals. Made from clay by hand with the aid of a wheel and fired in a kiln at a high temperature with glazes to make them impervious to liquids, these ceramics represent a union of science, technology and art. The shape of the vessel coaxed from a lump of clay seems to emerge spontaneously—almost as if it is an extension of the human body, so natural and symbiotic is the action of its making. But the process of firing provides far less opportunity for human control. It is governed by factors such as the composition of the clay and glaze, the temperature of the kiln, how the heat is controlled and even the luck of the day. What happens inside the kiln is akin to a magical process of transformation: a vessel that enters the kiln as a matt and lifeless object may emerge at the end of the firing covered with a lustrous skin that glows with life. Part of what gives ceramics their majesty and allure is the very fact that risk is involved and the outcome is never certain. In the final object, earth, fire and the spirit of the maker expressed through form are combined in a masterpiece of art.

The earliest pottery unearthed in Korea dates from the Neolithic period, around the 8th century BCE, and shares similarities with pottery found in China and Japan.[6] For centuries Chinese ceramics have been unearthed in Korean royal tombs, highlighting the high regard in Korea for Chinese wares. Korean ceramics were also appreciated by connoisseurs in China, particularly the kingfisher or jade-green celadon wares made during the Koryŏ dynasty (935–1392), immediately preceding the Chosŏn dynasty. During the Song dynasty in China (960–1279) a Chinese writer known as Taiping Laoren wrote: 'As for the "secret colour" of celadons, the "secret colour" of Koryŏ is first under Heaven. Although [potters of] other areas imitate them, none of them can achieve [the same qualities].'[7] Chosŏn white porcelain was also coveted in China. An official census dating from 1424–1425 documents that white porcelain vessels were made at the official kilns in Kwangju near Seoul for presentation to the Ming emperor of China. Korea had abundant deposits of good china clay and, at that time, there were 324 kilns including 139 for porcelain and 185 for stoneware.[8]

Unlike their Chinese counterparts of the Ming (1368–1644) and Qing (1644–1911) dynasties, Korean potters of the Chosŏn dynasty prized spontaneous markings that occurred in the kiln and were not the result of human contrivance. Similarly, there was a great appreciation in Korean culture of asymmetrical forms rather than perfect shapes, crooked lines over straight lines, blushes of colour rather than perfectly clear glazes. For the Korean artist, firing was a natural process and chance, nature and the elements played important and acknowledged roles.

Among the mountains and streams I build

A thatched hut under the rock.

The ignorant will mock my grass roof;

Can they fathom my true intent?

Indeed, this life best befits

A simple but rustic mind.

From 'Random Thoughts' (1642) by Yun Sŏn-do (1587–1671)[9]

The important 20th-century Japanese ceramic artist Hamada Shōji (1894-1978) was a great admirer of the rustic beauty of Korean ceramics. Regarding the difference between Japanese, Chinese and Korean ceramics, he believed 'that in the whole world there are no pots which are so imbued with the spirit of a people as these, particularly the Yi [Chosŏn] works. Between Japanese life and the pot 'taste' emerges; with the Chinese, 'beauty' creates a distance, but in the Korean works the object contains the life of the people.'[10]

During the Chosŏn period, ceramics not only achieved a unique technical and aesthetic distinction, they also reflected a changed political, social and cultural milieu. The preceding Buddhist-dominated Koryŏ dynasty was, by the 1300s, characterised by excess and corruption. During this time ornate and precise inlaid celadons were produced. The rustic *punch'ŏng* wares and austere white porcelains of the Chosŏn made a strong contrast. The emergence of these

wares during the Chosŏn period can be seen as part of a larger collective imperative to affirm a uniquely Korean identity with a strong relationship to Neo-Confucianism.

Punch'ŏng ware is a stoneware with a celadon-type glaze that was only produced in Korea during the 1400s and 1500s. The word *punch'ŏng* is an abbreviation of the Korean term *punjang hoech'ŏng sagi*, literally 'ceramic wares of a greyish-green clay body covered with white slip and a clear greenish glaze' (cat. no. 9). *Punch'ong* wares were everyday functional objects made quickly and in large numbers. Production ceased, however, in the late 1500s, and was affected by the invasions in 1592 and 1597 by the Japanese military ruler Toyotomi Hideyoshi (1536–1598). The country was devastated. Many of the main kiln sites were damaged and large numbers of Korean potters were taken by force to Japan. These potters went on to play a key role in the development of Japan's ceramic industry.

The decoration of *punch'ŏng* wares is spontaneous and devoid of pretension to high art. Casually brushed, incised or stamped marks reveal the artist's hand and imbue the works with an intimate vitality (cat. no. 14). The warm earth colours of the body and slip convey a naturalness and a truth to materials. The robust, unsophisticated beauty of *punch'ŏng* wares was highly prized in Muromachi Japan (1392–1568), particularly by tea masters who were inspired by their bold and rustic forms.[11] This appreciation was revived in the early twentieth century by the Japanese folkcraft theorist Yanagi Sōetsu (1889–1961). Together with his colleagues —the Japanese potter Tomimoto Kenkichi (1886–1963) and British potter Bernard Leach (1887–1979)—Yanagi Sōetsu was inspired by Chosŏn ceramics and was responsible for the formulation of the Mingei theory of folk crafts.[12] Mingei, a Japanese word meaning literally 'the art of the people', valued objects produced for local use by craftspeople who had no interest in a high artistic status and were not motivated by the desire for individual self-expression. In the second half of the 20th century the Mingei movement spread from Japan to Britain, Europe, the United States and Australia and continues to exert a profound influence on ceramic practice in Japan and the West.

How many times has the universe been made and marred?

How many heroes can you name?

The ups and downs of a nation

Are but a fleeting dream in a short sleep.

What idiotic spirits over there try

To sway us against seizing the day?

Cho Ch'an-han (1572–1631)[13]

After a period of external aggression by Japan and China in the late 1500s and early 1600s ceased, the Korean ceramic industry was revived under Chosŏn court patronage. Undecorated white porcelains, characteristic of the early period of Chosŏn production, were influenced by Chinese white porcelain of the Yuan (1279–1368) and Ming (1368–1644) dynasties and reflect the ideals of the new, Neo-Confucian state (cat. no. 24). Filial piety was the cornerstone of Confucian philosophy and dictated respect for and obedience to one's elders and to king, father, son and deceased ancestors. Rites of passage such as the coming of age, marriage and death and the practice of ancestor worship were important parts of daily life in Chosŏn Korea. Monochrome white wares, sometimes inscribed with the character *che* or 'offering' written in cobalt-blue, were used in ritual ceremonies (cat. nos 32, 33). These austere white objects express the concepts of honesty, purity, simplicity and frugality, which were cultivated and promoted during the Neo-Confucian Chosŏn dynasty. The significance of Korean white porcelains lies both in the power of their restrained, inner beauty and in the role they played within a clearly articulated social order. In the Korean language there are many different words to describe the spectrum that is possible within the colour white, for example milk-white, snow-white, grey-white and blue-white, highlighting the important symbolism of white in a Confucian context.

During the latter part of the Chosŏn dynasty a greater number of white porcelains were produced, decorated with designs painted in iron-brown, cobalt-blue and copper-red, inspired by contemporaneous Chinese wares (cat. no. 61). A relatively large number of these ceramics survive including brush holders, brush rests, water droppers and incense holders. These objects were created to delight and amuse the literati or scholar-officials, and display variety and inventiveness. Water droppers, for example, could take on the form of a peach, a symbol of longevity, or be ornamented with a painted design of bamboo (cat. nos 41,56). Bamboo, symbolic of moral strength and an upright character, is one of the 'Four noble plants' of East Asian culture and was a favourite subject for Korean scholar-artists during the Chosŏn dynasty. The others, also symbolic of noble human virtues, are plum blossom, orchid and chrysanthemum and represent the ability to suffer hardship, loyalty and endurance respectively.

Eightfold screens painted with images of items from a scholar's studio, known as *ch'aekkŏri*, were also very popular during this period (cat. no. 68). *Ch'aekkŏri* screens feature the 'Four treasures of the scholar's studio' (brush, paper, inkstone and inkstick) as well as books, scrolls, seals, antiques, auspicious things (for example, peaches symbolising longevity) and objects of artistic contemplation (fine porcelain vases and bowls). The screens were an important functional and decorative piece of furniture within a scholar's studio and symbolised scholarly aspirations with respect to culture and learning.

However, the ceramics conjured from earth, spirit and fire best encapsulate the unique artistic achievements of Korea during the Chosŏn dynasty. No object in this exhibition illustrates this better than the white porcelain bottle painted in underglaze iron-brown with a rope design (cat. no. 47). This simple flask, with a narrow neck and a full body, was originally made for wine. It is ornamented with a seemingly abstract painted line that encircles the neck of the bottle and curls down around the body. In fact, the design echoes the rope with which the wine bottle would have been carried, creating a humorous visual pun. In this Korean government–designated 'Treasure' a strict economy of form is strikingly coupled with honest and restrained ornamentation. The beauty of the bottle lies in the everyday familiarity on which its artistic brilliance is based. Like many of the objects in the exhibition, the bottle was crafted by an unknown artist who, in balancing the laws of heaven and earth, may truly be described as a master of harmony.

Genre scene by Kim Hong-do (1745-1806), ink and colour on paper.

Treasure no. 527. Photo courtesy National Museum of Korea, Seoul

Notes

1 Kim Hongnam, 'Exploring eighteenth-century court arts', in *Korean arts of the eighteenth century: splendour and simplicity*, ed., Kim Hongnam, Asia Society Galleries, New York, 1993, pp 40–1.

2 For a detailed discussion of sun, moon and five peaks screens see Yi Sŏng-mi, 'The screen of the five peaks of the Chosŏn dynasty', *Oriental art*, 42(4), 1996–1997, pp 13–24.

3 Translated by Jaihiun J Kim, in Jaihiun J Kim, *Classical Korean poetry: more than 600 verses since the 12th century*, Asian Humanities Press, Fremont CA, 1994, p 38. Kim Inhu was a scholar of the Academy of Scholars, established by King Sejong in the early 1400s.

4 Translated by Jaihiun J Kim, in Jaihiun J Kim, p 172. The poem is undated.

5 Of the 28 original letters forming the Korean alphabet, 24 are in use today. Chung Yang-mo, 'The art of the Korean potter: from the Neolithic period to the Chosŏn dynasty', in *The arts of Korea*, coordinating ed. Judith Smith, Metropolitan Museum of Art, New York, 1998, p 242.

6 See Chung Yang-mo, 'The art of the Korean potter', p 222.

7 Taiping Laoren, 'Xiuzhongjin', in *Xuehai leibian*, ed., Cao Rong (1613–1685) quoted in Chung Yang-mo, 'The art of the Korean potter', p 234.

8 Chung Yang-mo, 'The merit lay in "absolute purity"', in *Korea: ceramics*, ed., Jan Van Alphen, Snoeck-Ducaju & Zoon, Ghent, 1993, p 56.

9 Translated by Peter H Lee in Peter H Lee, *Pine river and lone peak: an anthology of three Chosŏn dynasty poets*, University of Hawaii Press, Honolulu, 1991, p 145, see also pp 4-6. Yun Sŏn-do is considered one of the finest poets of *sijo*, a vernacular lyric poetic form. He was a scholar-official and held various important court positions. He was also a man of courage and integrity and spent numerous periods in retreat and 14 years in exile for political reasons. He was accorded the posthumous rank of minister of personnel.

10 Hamada Shōji, quoted in Bie Van Gucht, 'Contemporary ceramic art', in *Korea: ceramics*, p 66. The Chosŏn dynasty is sometimes also referred to as the Yi dynasty, named after General Yi Sŏng-gye who established the Chosŏn dynasty in 1392 and became its first ruler King T'aejo (reigned 1392–1398).

11 Chung Yang-mo, 'The art of the Korean potter', p 244.

12 See Yuko Kikuchi, 'The myth of Yanagi's originality: the formation of Mingei theory in its social and historical context', *Journal of design history*, 7(4), 1994, pp 247–66. See also Yanagi, Sōetsu, *The unknown craftsman: a Japanese insight into beauty*, Kodansha International, Tokyo, 1989.

13 Translated by Jaihiun J Kim, in Jaihiun J Kim, p. 80. Cho Ch'an-han was a scholar-official and served two Chosŏn kings. He held various positions including local magistrate.

14 Translated by Peter H. Lee in Peter H. Lee, *Pine river and lone peak*, p 65, see also pp 5–6 and 11–20. Chŏng Ch'ŏl was a scholar-official and held various important political and court positions including governor of Kwang'wŏn province, minister of rites, inspector general and second state counsellor. In 1593 he was sent as an envoy to Ming China. He spent significant periods in retreat and political exile, and is regarded as one of the greatest poets of the Chosŏn dynasty. He is renowned for his prose poems and *sijo* and *kasa*, which are two enduring forms of Korean vernacular poetry.

A time to drink

Let's drink a cup,

And then another.

Let's pluck flowers and count

As we drink more and more.

When your body dies,

It will be on a rack

Wrapped around with a straw mat,

 or in a hearse with coloured curtains,

With myriad people following in tears.

And when you're laid down

Among the rushes,

Under overcup oaks and white poplars,

Under yellow sun and white moon,

Under fine rain or thick snow,

Or when chilly winds sough,

Who will offer you a cup of wine?

Furthermore, when only a monkey whistles

On your grave,

What good will it do to regret?

Chŏng Ch'ŏl (1537–1594)[14]

Korean cultural values in the Chosŏn dynasty:
Neo-Confucian principles and their alternatives[1]
Kenneth M Wells

During the Chosŏn dynasty in Korea (1392–1910), Neo-Confucianism was canonised as the state ideology and as the basis for national morality. The close identification of Neo-Confucianism with the state apparatus directly supported, it is assumed, the domination of Korean society at almost all levels by the literati, the educated aristocracy. And the dependancy of Neo-Confucianism on state patronage is believed to account for its seeming sudden death at the end of the dynasty in the late 19th and early 20th centuries. But rather than dominating at all levels, Neo-Confucianism was more a preoccupation among the educated elites of Korea. This essay focuses on what Neo-Confucianism was in terms of its values, what impact it had on Korean society progressively through the dynasty, and what other cultural lineages need to be considered in order to grasp the aesthetic sources and characteristics of ceramic culture during the Chosŏn dynasty.

Intellectually Neo-Confucianism involved a negative and a positive direction. It involved a negative critique of Buddhism, which had been the dominant cultural tradition up to that time, and also of Daoism, and it revived a positive interest in searching for what could be known by reflecting or reaffirming the reality of nature and asserting the meaningfulness of practical social life. Neo-Confucian scholars proposed two major polarities: firstly, the solitary, drawn from Buddhism and Daoism, and the communal, drawn from the Confucian idea of social cohesion; secondly, world denial, which was supposed to be Buddhist and Daoist, and world affirmation, which was the celebration of life as it was experienced every day.

In fact Korean Neo-Confucianism was differentiated from Confucianism by its somewhat mystical vision of the cosmos and human nature. In order to convey a sense of the metaphysical reality that was supposed to lie behind social harmony and cohesion, Neo-Confucians based many of their ideas on elements drawn from Buddhism and Daoism, reworking Daoist and Buddhist propositions in terms of Confucian morality. Through their studies of texts such as *Chuyŏk, The book of changes,*[2] which was also a favourite book of the Daoists, Neo-Confucian scholars created a philosophical system that explained how material phenomena arose from the five elements (fire, water, metal, earth and wood), how these five elements arose from the complementary opposites Yin and Yang, and how the Yin and Yang in turn arose out of the Supreme Ultimate. The Supreme Ultimate was thought to be clearly present in the exercise of proper human relationships, in particular in filial piety: the relation between a father and a son. This relation became the foundation for all other relationships in society, state and family.

Korean Neo-Confucianists became far more religious in their adherence to their creed than their Chinese and Japanese counterparts. In Korea there was a high degree of emotional intensity in the commitment to the ultimate value of knowledge. Scholars advocated a concept of knowing in which knowledge had a spiritual object with moral consequences. In the initial period this idea inspired a great deal of cultural activity, but later it is thought to have become the cause of some inflexibility and rigidity, and possibly ties in with the failure in the 1600s to restore the *punch'ŏng* pottery tradition, which had roots in the Koryŏ dynasty, and the strong emphasis placed on the 'purity' of white porcelain.

The introduction of Neo-Confucianism based on filial piety and the idea that harmony would issue from its permeation of the social fabric had an impact in a number of areas. There was a a growing restriction of women of all classes, but chiefly in the higher classes, to certain roles and functions. Houses were divided into women's and men's quarters. No female (of higher than farmer's class) was to be seen without a chaperone in public. Serving one's husband and producing a son and heir became a woman's most important role. There was of course more leeway among commoners. But the division between male and female roles was institutionalised in the Chosŏn dynasty progressively

from the beginning of the 1400s through to the 1600s. This can be related to the particular interpretation of Yin and Yang, the female and male, as complementary opposites. In turn, certain cultural systems and values, which were creating more and more ire among the Confucian scholars and becoming more and more associated with women, were suppressed. For example, early in the 1400s family shrines were given a Confucian interpretation and were made compulsory in officials' houses of all ranks for Confucian ceremonies. Traditionally ancestors were regarded as beings whose spirits continued to influence one's life for good or ill and required feeding and other services. A more Confucian scheme of rites supplanted traditional ideas, one that enacted respect for the authority of the father and his tradition and subsumed this under loyalty to the monarch and the authority of the scholar-official world that surrounded him.

This attempt to cast central understandings of life in Neo-Confucian terms actually led to, or deepened, the division between what we might call folk and elite cultures. Folk culture became associated with women's culture, and Confucian culture and learning became more associated with men's culture. The division between male and female in society eventually started to percolate down to the villages, but it cannot be said that the traditional popular values and ideas of gender relations were done away with completely. A reading of some of the documents from the Chosŏn dynasty suggests that the officially intended and often claimed uniformity of values and principles was never achieved.

Of special relevance is shamanism, a tradition in Korea that involved Korean women in its leadership. With regard to shamanism, it seems that most of the Chosŏn rulers followed a policy of disguise and utilise. For example, in the late 1400s there was a drought, and in the court records of the time there is a discussion about what ceremonies might be appropriate for attracting rain. Practically all households were told to place a willow branch in a jar of water in front of

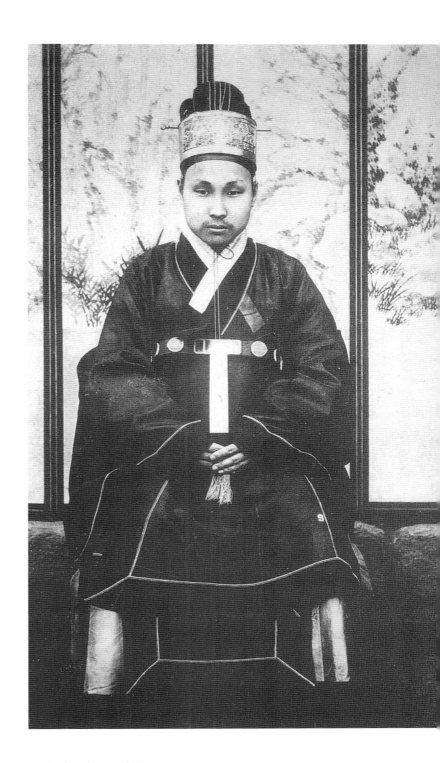

Civil official, late 1800s.

Photo courtesy Seomundang Publishing Co, Seoul

their houses. This practice was carried out with a mixture of Buddhist incantations, and Buddhist priests and shamans were ordered together to pray for rain. Ancestral worship was performed at the shrine of the royal ancestors and before the four city gates of Seoul. For three days ceremonies to dragon spirits were held in five strategic locations; each spirit was represented by paper models in their respective colours. It is clear from this that shamanist traditions, Buddhist incantations and their associated array of colour and representation were alive and well, and could be called upon whenever the monarch required.

The shamanist epic of Princess Pari, which is often performed in modern Korean ballad singing and in funeral rites, shows that the common people continued to view even the monarchical system through traditional cultural lenses. In this epic, the king wants a son as a royal heir, but has daughter after daughter. When the seventh daughter is born he orders that she be cast into the Eastern Sea, and his wife is filled with remorse and shame at her failure to produce the required son. But the lord Buddha sweeps the baby up and delivers her into the care of a humble rustic couple who raise her until one day in her adolescence she is mysteriously summoned to the royal palace to save the king and queen from a rare and incurable disease. Pari learns the truth about her birth, tells her royal parents that their illness was due to her lack of filial piety and departs on a magical journey to heaven to secure the divine waters that are able to cure her parents. When she finally reaches the spirit god who guards the water of life, she has to marry him and bear five sons before she can return to the world of the living with the water. This she does just in time for the funeral procession of her parents. No matter, the divine water is strong, she applies it and they are restored to life.

There are a number of elements from several traditions in this epic, which has certainly been developed over time. The Confucian elements of filial piety—preference for a son and duty to one's parents even to the point of crossing the boundary between life and death—are obvious. So are the Buddhist elements—the lord Buddha himself is involved. There are also shamanist elements—the idea of spirit beings, of crossing the boundaries between the ordinary world and a more noumenal world in which spirit forces may be called upon for various purposes. Further, there is a narrowing of the gap that had been opened up between women and men in Korean society. Fatherly authority, the king's authority, becomes fatherly affection when he is restored to life. The patriarchal spirit is countered by a matriarchal one. The disciplinarian order of Confucianism is mellowed through the activity not of educated men but a girl who had been brought up in a lowly setting. The idea of harmony in this story is based not simply on strict social hierarchies as in Confucianism, but on bringing together all the various components of life. Crossing boundaries or mixing elements was regarded as 'impurity' to the Neo-Confucian leadership, but to dominant folk traditions it was a means of reconciliation and healing.

What are the implications of these developments for aesthetics during the Chosŏn dynasty? The introduction of Neo-Confucianism at the beginning of the dynasty ushered in a period of tremendous cultural activity. The first 80 years or so of the Chosŏn dynasty is considered one of the greatest periods of cultural activity and development in Korea's entire history. It is the period in which the Korean alphabet was formulated and refined and in which there was rapid progress in scientific discovery, mathematics and medicine. There were great developments also in cartography, astronomy, literature, music and the visual arts, and it is to ceramics that we must now turn.

The principal difference between the ceramics of the Koryŏ and Chosŏn dynasties is between Koyrŏ celadon with its inlaid patterns and white Chosŏn porcelain with its sophisticated but simple form and design. It is sometimes claimed that *punch'ŏng* ware, which was produced for around 200 years, marked the transition between the two. This view is a little oversimplified, and I will return to *punch'ŏng* ceramics presently.

In contrast to Koryŏ celadon, which was made from grey clay, Chosŏn white porcelain was manufactured from fine white china clay and finished with a pure glaze (often with a bluish tint). As Chung Yang-mo and others

have pointed out, the aesthetic principle was 'absolute purity' based on a Korean Neo-Confucian ethos of frugality and a notion that embellishment undermines beauty (cat. no. 27). Although the Koreans' love of nature was reflected in simple designs of bamboo, plum blossoms and chrysanthemums, white porcelain was characteristically austere in design (cat. no. 42). It developed alongside an artistic emphasis on depictions of scholarly settings and Confucian classical scenes (cat. nos 69, 65, 71), and an ideological commitment to the belief that learning and morality were wedded and together led to great harmony in state and society. Not surprisingly, white porcelain ware was dedicated for use in state and elite family rites: in 1466 its use by people below high official rank was prohibited and indeed it was reserved mostly for use in the royal households into the 1500s. Although in the 1600s some of the white porcelain featured reasonably dense but predominantly symbolic patterns, overall patterns were few and simple, and a uniformity of design was imperative. Centered as it was on the elite cultural groups, the style and design of white porcelains were generally valued for their transcendence of locality and their reflection of the core values of a civilisation that was deemed to rest on universal virtues and principles (cat. no. 48).

Punch'ŏng ware, however, was made with the same greyish clay as Koryŏ celadon, but was coarser in texture. The designs tended to be stamped or carved rather than inlaid and the vessels were covered with white slip (cat. no. 15). Although towards the end of the 1400s a variety of punch'ŏng wares painted with designs in iron-brown (ch'ŏlhwa) with a fine top layer of glaze was developed, production of this type was small (cat. no. 20); the brushed slip (kwiyal) and stamped (inhwa) punch'ŏng wares with coarser surfaces were more common (cat. no. 5).

Punch'ŏng wares were in fact produced in large quantities, and their design and patterns reflect the area of their manufacture, particularly in the central and southern provinces where most of the kilns were located. In line with this localisation, punch'ŏng ware was characterised by a measure of spontaneity or 'naturalness'. The calligraphic quality of the brushstrokes that developed with the iron-brown painting under the glaze of the late 1400s gives a strong sense of freedom and spontaneity (cat. no. 18).

This quality of 'naturalness' is a feature of Daoism. Although the idea of Yin and Yang is borrowed from Daoism, in Neo-Confucianism it stands as the central aesthetic principle of harmony stemming from a strictly ordered system of social functions. In Daoism, however, water is very important as the prime example of the unorganised but effective flow of nature, as opposed to the Confucian emphasis on conscious direction of oneself and society. Something of this disagreement may be detected in the difference between the style and usage of punch'ŏng and white porcelain products. The former are generally coarse in finish and used for everyday purposes. Their patterns are not disciplined. As in the natural world, one does not straighten things just because they are not symmetrical (cat. no. 11). In the latter, conscious discipline and purity of design is given great value, and the finest ware is set aside for Confucian rites (cat. no. 34).

Significantly, from the mid 1600s, after the prohibition against ordinary people using white porcelain was lifted, it became increasingly used for ancestral rites in the homes of commoners. At this point, to its simplicity were added qualities of warmth and vitality. From the mid 1800s, however, when state support of the kilns lapsed, white porcelain products started to reflect a mixture of aesthetic influences and a decline in 'purity' as popular styles and designs once more gained their opportunity (cat. no. 61).

Although Neo-Confucianism was the dominant cultural system during the Chosŏn dynasty, and was imposed by the people who had all the advantages, it did not hold complete sway and did not manage to displace everything else. Even in the highest ranks and certainly in the arts one can see the fusion of many traditions.

Notes

1 This essay was adapted from a lecture delivered by Kenneth M Wells at a seminar on Korean culture organised by the Powerhouse Museum and the Asian Arts Society of Australia at the Powerhouse Museum in September 1998.

2 The book of changes (Yijing in Chinese) is regarded as one of The five classics (Ogyŏng in Korean, Wujing in Chinese) of ancient China, which may date from as early as the Zhou dynasty (about 1027–475 BCE). The book of changes is primarily a divination manual comprising a series of brief texts for a sequence of 64 hexagrams. The other Five classics are The book of songs (Sigyŏng or Shijing), The book of history (Sŏgyŏng or Shujing), The book of rites (Yegi or Liji) and The spring and autumn annals (Ch'unch'u or Chunqiu). The five classics and The four books (Sasŏ or Sishu) form the canon of Confucian classics and outline the primary ideas of the Confucian school of cosmology, ethics and government.

Korean ceramics of the Chosŏn dynasty[1]

Chung Yang-mo

Humans first produced simple earthenware vessels from clay some 10 000 years ago. For thousands of years thereafter, low-fired, soft-bodied earthenwares were produced without a kiln. Instead they were fired in the open air, employing the oxidisation process. As human culture developed the demand for vessels of greater durability grew and kilns were devised, allowing for the production of high-fired, oxidised wares, which eventually developed into high-fired stoneware made through the reduction method. Natural ash-glaze was applied to these stonewares, initiating the experimentation with celadon and porcelain glazes that soon culminated in the manufacture of porcellaneous ware.

China was the indisputable leader in the development of ceramics and it was during the 8th to the early 10th centuries, under the Tang dynasty (618–907) and the Five Dynasties (907–960), that celadon and white porcelain were first developed at such kiln sites as Yuezhou in Zhejiang province in southern China. Yuezhou technique and artistry were introduced to Korea during the 9th century, at which time potters of the United Silla kingdom (667–918) developed the technology to produce celadon and white porcelain. Thus, Korea and China emerged as the two earliest porcellaneous cultures. Japan attained the technology to produce porcelain in the early 1600s, followed by Germany in 1709, and France and England in the mid to late 1700s.

Emergence of porcellaneous ware

Though glazed stoneware was produced from as early as the Three Kingdoms period (57 BCE – 668 CE) in Korea, the ultimate genesis of porcelain during the second half of the 9th century was a revolutionary event. Porcellaneous ware emerged only in the south-western coastal areas of the Korean peninsula while other regions in Korea still produced stoneware. The development of porcelain in the south-west was the result of a number of factors among which the region's topography, consisting of rich farmland, extensive coastline and numerous islets, was a primary force. Such conditions provided the ideal background not only for the development of an affluent agricultural economy, but also for the establishment of an active maritime trade with China. Also important to the economic development of the region was the rise to power of such individuals as Chang Po-go, who controlled much of the trade between Korea, China and Japan from his base on Wando Island, off the coast of South Chŏlla province. The ascendancy of such privately run trade operations is indicative of a political situation in which the central government was gradually losing control of the provincial governments, with the local gentry gaining ever greater authority. Thus the south-west, more than any other region of Korea, enjoyed the economic prosperity and resultant cultural sophistication essential to the development of a porcellaneous society.

Ceramicist incising a pattern in a jar for Koryŏ-style inlaid celadon, late 1800s.

Photo courtesy Seomundang Publishing Co, Seoul

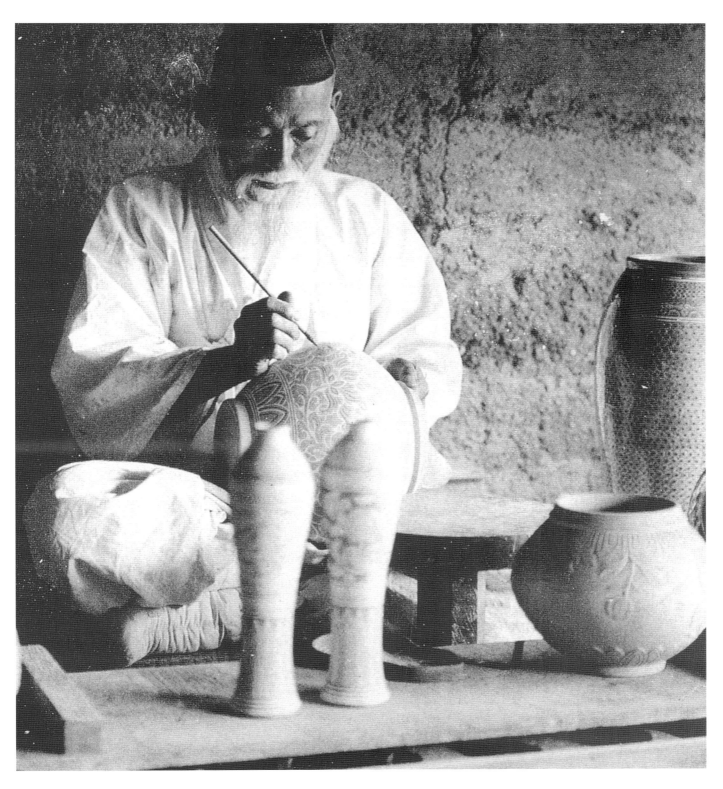

Koryŏ celadon

Superior-quality celadons with broad foot rims were produced from the second half of the 9th century until the first half of the 11th century. In contrast to the early Koryŏ period, when celadons were produced under the patronage of the provincial gentry, celadon production in subsequent years fell under the supervision of the official government kilns. A great deal of influence from the kiln sites in northern and southern China is apparent.

The first half of the 1100s witnessed pure celadon production at its height, the perfected celadon colour attaining an ever more exquisite clarity, thereby reflecting the increasing mastery of the reduction firing method. Jade-green celadon glaze was applied to a body of light-grey clay with the superior firing technique resulting in a smooth glaze surface without any trace of crazing (tiny cracks that appear on the glaze surface when the glaze and the clay body have not adhered sufficiently). Furthermore, the forms and decorative styles of this period reflect the emergence of a uniquely Koryŏ celadon style, distinguishable from the previous domineering Chinese prototype.

Though decoration on early celadons and the succeeding pure celadons was limited, Koryŏ potters of the early 1100s developed incising (in which the design is incised into the clay body) and carving (in which the background is carved out of the clay body to reveal a raised design or a mould is used to impress the design into the clay body) techniques, skilfully applying diverse flower, plant, and animal motifs to the surfaces of the vessels. During the second half of the 1100s, the *sanggam* or inlay technique, which had been minimally employed from as early as the 10th century, appeared more frequently and rapidly became the truly remarkable decorative technique unique to Koryŏ ceramics. Such inlaid decoration is created by first incising the desired design onto the unglazed clay surface, and then filling in the spaces with black or white slip. Any surplus slip is then wiped off and the entire surface is covered with glaze. The result is a lively yet harmonious balance between the exquisitely rendered patterns of lotus, peony scroll, chrysanthemum, willow, cloud and crane motifs against the subtle jade-green of the celadon background.

Koryŏ celadons reached their height during the reigns of King Injong (reigned 1123–1146) and King Ŭijong (reigned 1146–1170) and exemplify one of the most outstanding achievements of Korean art. Inlaid celadons reflected the refinement of the aristocracy, who were devoted patrons of Buddhism, academic learning and the arts. However, during the 1200s, Mongol invasions and the subsequent infiltration of Korea by Central Asian and Western cultures resulted in a decline in the production of ceramics and changes to forms and firing techniques. Consequently, though pure and inlaid celadon production continued into the 1200s, the diverse ceramic styles of the previous century gradually disappeared, with the ultimate demise of celadon production occurring during the 1300s.

Punch'ŏng ware

Ceramic production during the transitional period between the Koryŏ (935–1392) and Chosŏn (1392–1910) dynasties continued to decline with the centralised kilns of the preceding centuries replaced by smaller scale kilns dispersed throughout the peninsula. Though celadon and soft-bodied white porcelain wares akin to those of the Koryŏ period continued to be produced, *punch'ŏng* ware, which is defined as 'pottery decorated with white slip and covered in a pale bluish-green glaze', dominated ceramic production during the early Chosŏn period (cat. no. 3). *Punch'ŏng* ware is fundamentally a stoneware made of the same, albeit slightly coarser, greyish clay and, somewhat thinner, glaze as that of Koryŏ celadon. Much of the early *punch'ŏng* ware is similar in both form and decoration to inlaid celadon so that its classification and dating is controversial.

The decoration on *punch'ŏng* ware consists of a layer of white slip, the manipulation of which results in a variety of diverse effects. Such effects and the techniques that created them serve as the basis for the categorisation of *punch'ŏng* ware into the following seven groups: *sanggam* or inlaid (continued from Koryŏ inlay, but with a freer and more simplified design) (cat. no. 2), *inhwa* or stamped (impressed design, in which the desired pattern is stamped into the semi-dry clay upon which white slip is brushed allowing the slip to sink into the impressions) (cat. no. 6), *pakchi* or sgraffito (reversed inlay,

in which the background is scraped off revealing a raised pattern) (cat. no. 15), *chohwa* or incised (in which linear designs are incised into the base of white slip) (cat. no. 13), *ch'ŏlhwa* or underglaze iron-brown (in which the designs in underglaze iron-brown are painted onto the surface of the white slip) (cat. no. 18), *kwiyal* or brushed white slip (in which white slip is applied with a coarse brush) (cat. no. 9) and *tombong* or dipped method (in which the vessel is dipped into the white slip) (cat. no. 23). Any number of these techniques were employed simultaneously on one vessel. Highly imaginative effects were created during the mid 1400s, which is considered the height of *punch'ŏng* production. During the late 1500s, *punch'ŏng* ware witnessed a demise as the entire surface was simply covered in white slip.

Of these various decorative effects, bold and energetic *sanggam* designs prevailed throughout the peninsula, with *myŏn sanggam* (a technique similar to *sanggam* in which planar rather than linear designs dominate) appearing during the mid 1400s (cat. no. 17). Vessels with densely stamped decoration are found primarily on pieces from the south-western regions of Korea, while the sgraffito and incised techniques are prevalent on pieces produced in Chŏlla province. Underglaze iron-painted vessels with lively designs flourished in the Mount Kyeryong area of Ch'ungch'ŏng province (cat. no. 21) while during the later period, the brushed slip method was widely employed in Chŏlla province. The dipped method, which marked the transition from *punch'ŏng* ware to white porcelain, is found on pieces from throughout Kyŏnggi, Ch'ungch'ŏng and Kyŏngsang provinces (cat. no. 22).

Though the fluid forms of the preceding Koryŏ celadons continued to linger on in *punch'ŏng* shapes, the simplified yet expressionistic designs were indicative of a transformed aesthetic sensibility. The spontaneous and naturalistic tendency was due in part to the fact that, unlike the earlier celadons produced primarily for Buddhist rituals or for use by the aristocracy, *punch'ŏng* ware was made for more practical and domestic purposes. Towards the end of the 1500s, however, it was this very emphasis on practicality by the prevailing Neo-Confucian ideology that resulted in the demand for ever simpler art forms, namely plain white porcelain. In addition to transformations resulting from circumstances arising within Chosŏn society, exterior forces such as the invasions of Korea by Japan's Hideyoshi in 1592 and 1597 also contributed to the ultimate demise of *punch'ŏng* ware.

White porcelain

During the early Chosŏn period (1392–1649), relations with Ming China were strengthened and Confucianism replaced Buddhism as the dominant ideology of the ruling classes.

While ceramic production degenerated during the founding years of the dynasty, the reign of King Sejong (1418–1450) saw a reflourishing of ceramics, with the latter part of the 1400s ushering in the era of the renowned Chosôn white porcelain. The town of Kwangju was surrounded by rich forests, clear waters and accessible waterways, and was close to the capital of Seoul as well as the Han River tributary, the South Han River. It was the ideal location for the establishment of the official kiln centre. This new ceramic complex, which was supervised by the Saongwon, the government department responsible for court dining and entertainment, was in charge of the production of all wares used by the royal court and central offices, while local kilns were established to fulfil the demands of the provinces.

The Hideyoshi invasions contributed to the end of the production of *punch'ong* wares but the production of white porcelain wares, with forms that were relatively unaltered from those produced before the invasions, continued until the first half of the 1600s. Thus, the years prior to the mid 1600s constitute the early period in the development of Chosôn white porcelain.

The succeeding middle period, roughly 100 years between the mid 1600s and the mid 1700s, witnessed significant advancement in the quality, form, foot-shapes and firing methods of white porcelain. White porcelain painted with underglaze cobalt-blue also grew distinctly more sophisticated at this time, with designs becoming more simplified. Another important change that occurred during this period was the restructuring of the official kiln complex as a result of a new decree calling for the relocation of kiln sites every ten years. Consequently, the official kiln sites gradually shifted towards the main stream of the Han River where access to firewood and water was ensured.

Two upper-class men playing Korean chess in the male quarters
or sarangbang of a residence, 1890.

Photo courtesy Seomundang Publishing Co, Seoul

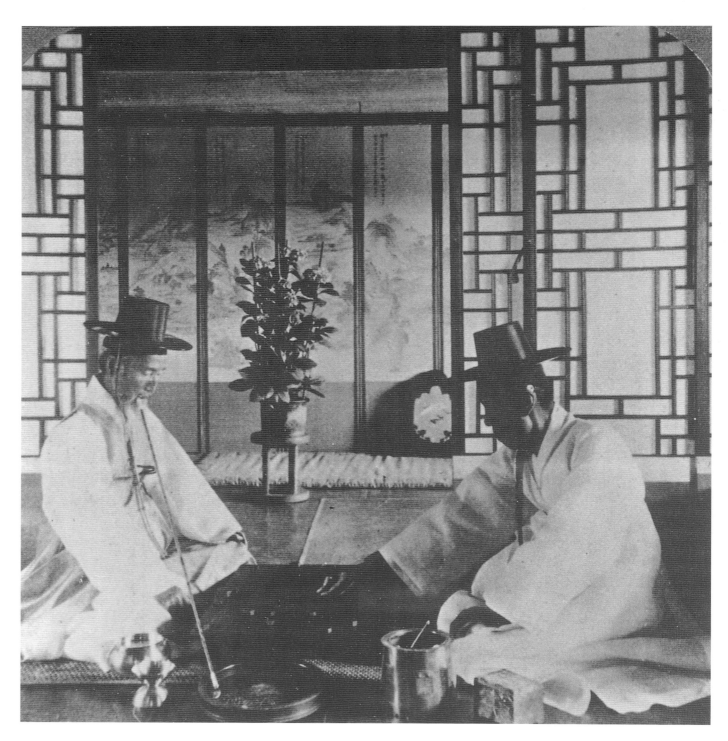

By 1752, the 28th year of the reign of King Yŏngjo (1724–1776), the official kiln complex was formally established in Punwon village, Namjong township in Kwangju county near Seoul, with large-scale production lasting until 1883, the 20th year of the reign of King Kojong (1864–1906). Thereafter, the official kilns were privatised. The period from 1752 to 1910 is classified as the later period in the development of white porcelain.

White porcelain wares produced during the early period, with their fluid forms and generous volume, possess a dignity embodying the ideals of the Neo-Confucian doctrine favoured by the new dynasty. The pure, light-bluish tones of the white porcelain wares of superior quality evoke the familiarity of dawn sunlight reflecting against freshly fallen snow. These early white porcelains were pure, elegant and undecorated (cat. nos 24, 25, 27).

Also produced during the early period was white porcelain with underglaze cobalt-blue decoration. Production levels were low during the reign of King Sejong because the deep, vibrant imported cobalt was scarce. During the reigns of King Sejo (1455–1468) and King Yejong (1468–1469), a domestic cobalt of a light, silvery-blue tone with a quiet, ethereal character was created, allowing for an increase in production. The decorative schemes of the 1400s and 1500s gradually shifted from those with subordinate patterns to those without subordinate patterns, and whose enlarged blank areas were filled with simplified and painterly designs. After a period of stagnancy as a result of the Hideyoshi invasions, production was resumed during the first half of the 1600s and consisted primarily of funerary vessels with decorative schemes composed of realistic, but slightly abstracted flower, plant, and *ch'ilbomun* (seven treasures) motifs.

White porcelains with underglaze iron-painted decoration were produced on a small scale from the second half of the 1400s to the 1500s. Truly remarkable examples emerged during the mid 1600s (cat. no. 48). The simplified designs and unusual compositions indicate the skill of the Chosŏn potter.

White porcelain wares of the middle period are characterised by their voluminous, refined and diverse shapes, with forms such as large jars with rolled rims and bottles with flattened sides (cat. nos 50, 42). The clear and translucent glaze, which was applied over the pure-white clay body, is slightly bluer in tone than the glazes seen on vessels of the preceding period. The tendency to localise the decorative schemes to portions of the surface represents a distinctively Korean style. Kilns of this period are found in the villages of Kungp'yŏng, Kwanūm, and Kŭmsa in Kwangju county.

Ceramics of extraordinarily diverse genre, form and decoration flourished at the outset of the later Chosŏn period, which came to an end as a result of Japanese colonisation during the early 20th century. White porcelain of this period is characterised by a glaze of pale-bluish tone applied to a pure-white clay body, the glaze becoming increasingly darker and resulting in a nearly blue surface. The predominant form of this period has relatively thick, solid walls with a wide, low foot supporting a voluminous body (cat. no. 59). During the latter part of the period, scholars' implements and ceremonial vessels of a distinctively Korean nature were produced on a large scale (cat. nos 40, 62). The blue-and-white porcelain wares of this period are also diverse, the densely rendered decoration suggesting the influences of metalware. Other decorative techniques employed include underglaze iron-painting, underglaze copper-painting, marbling, underglaze iron-coating, underglaze cobalt-coating, carving and, infrequently, incising.

Korean ceramics can best be described as charming, with their forms reflecting a sound and wholesome character. Always bestowing primary importance on function and practicality, Korean potters avoided the artifice of complex designs and ornamental colours. Instead they discovered the underlying beauty of unpretentious forms, understated decoration and subtle colours, creating ceramics that were profoundly in harmony with nature.

Notes

1 This essay is an edited version of Chung Yang-mo, 'A brief history of Korean ceramics', in *Masterpieces of the Ho-Am Art Musuem 1: historical art 1, ceramics*, Ho-Am Art Museum, ed., Samsung Foundation of Culture, Seoul, 1996, pp 177–85, reproduced by kind permission of the Ho-Am Art Museum.

The techniques of Chosŏn dynasty ceramics

Kim Jae-Yeol

Translated by Suzanna Oh

Ceramics of the Chosŏn dynasty are divided into two broad categories, *punch'ŏng* ware and white porcelain, a classification that is based primarily on their technical differences. In addition, this classification is deeply related to both Korea's long history of ceramics and China's influence on this tradition. To note briefly the history of Korean ceramic technique before the Chosŏn dynasty, archaeological finds have proven that inhabitants of the Korean peninsula began making primitive earthenware during the Neolithic period, some 7000 to 8000 years ago, and that technique was used up until around the birth of Christ. Yet about the 3rd century BCE, under the influence of Chinese Han dynasty (206 BCE – 220 CE) stoneware, Korean potters started to produce high-fired stoneware in kilns with a reducing atmosphere that allowed for the development of new glaze qualities. This revolutionary innovation soon brought Korean ceramics in step with those of China. The acquisition of the technology to produce high-fired ash-glazed stoneware was a turning point in the development of Korean ceramics and clearly distinguishes it from the low-fired lead-based glazing techniques that developed in Egypt and Central Asia and later spread to Europe.

In the Three Kingdoms period (57 BCE – 668 CE) stoneware with a hard body and reduction-fired temperature of up to 1200°C was produced. Already by the 7th and 8th centuries glazed stoneware was being produced and the basic technique necessary to create porcelain was in place at least by the 8th or 9th centuries. Soon afterwards in the 9th and 10th centuries Chinese techniques were influential in the creation of celadon and white porcelain, marking Korea's full entrance into the era of porcelain ceramics. It is important to note that, from an early date, Korean artisans produced almost-perfect white porcelain and celadon wares.

During the Koryŏ period (935–1392) the development of beautiful glazes and a unique inlay technique known as *sanggam* sparked the creation of celadon works whose quality was unmatched in the world. From the end of the 1200s, Koryŏ became a politically subordinate state to the Chinese Yuan dynasty (1279–1368). In the 1300s at the Jingdezhen kilns Chinese artisans created both *shufu* porcelain and blue-and-white porcelain, and this trend naturally influenced Korea. Eventually, in the Chosŏn dynasty, the celadon tradition was succeeded by the manufacture of *punch'ŏng* ware and the influence of new white porcelain from late Yuan to early Ming dynasty (1368–1644) China, in combination with the techniques of Koryŏ white porcelain, resulted in the development of Chosŏn white porcelain. This essay will first outline the diverse techniques found in *punch'ŏng* ware and will then briefly discuss the technical aspects of Chosŏn white porcelain.

Punch'ŏng ware

In terms of technique, Korean ceramics can be divided into three major categories: stoneware, celadon and *paekcha* (white porcelain). Of these, *punch'ŏng* ware is considered a type of celadon and it was made only in Korea. The original meaning of the term *punch'ŏng* comes from the fact that *pun* (white slip) was applied to the *ch'ŏng* (celadon). The clay and glaze of *punch'ŏng* ware are similar to those of celadon. *Punch'ŏng* ware differs from celadon because it is decorated with Chosŏn-style motifs, as well as employing decorative techniques different from those found on Koryŏ celadon. *Punch'ŏng* ware was produced throughout Korea in regional kilns and its most outstanding feature was the variety of decorative techniques used in its creation. In contrast to the unified appearance of Koryŏ celadon or Chosŏn white porcelain, *punch'ŏng* ware demonstrates unique characteristics based on the region where it was produced, making for a ceramic artform that was both exceedingly diverse and plentiful. There are seven different decorative techniques used in the making of *punch'ŏng* ware.

Sanggam (inlaid) punch'ŏng ware

Sanggam punch'ŏng ware directly carried on the unique decorative technique tradition of Koryŏ *sanggam* celadon.

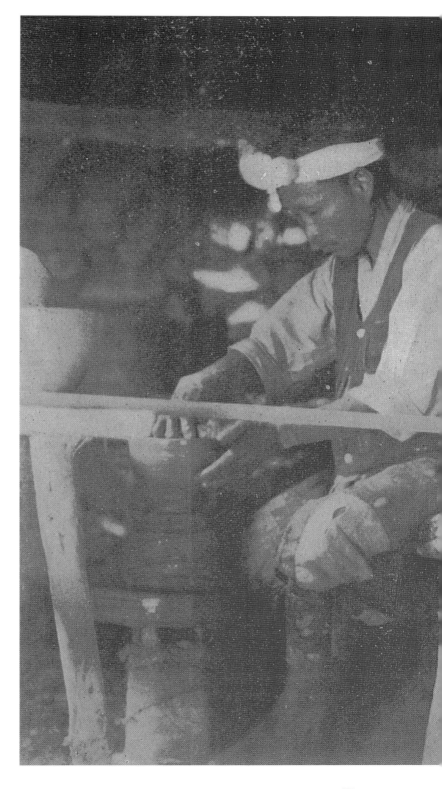

A potter making a bowl on a wheel, late 1800s.

Photo courtesy Seomundang Publishing Co, Seoul

Vessels were made of clay and dried, and then designs were incised on the surface and carefully filled with two types of clay that would turn white or black when fired (cat. no. 2). The first round of firings consisted of a low-heat firing of around 700–800°C. This bisque would then be glazed and fired again at the high temperature of 1200°C making for a hard, vitrified ware. Initially *sanggam punch'ŏng* ware was made using a method that followed Koryŏ celadon exactly, using white or black inlaid lines to define the motif, but as time passed the *sanggam* portion gradually increased so the motif went from line to surface.

Inhwa (stamped) punch'ŏng ware

The *inhwa* technique also began with Koryŏ celadon and involved imprinting the vessel with a stamp that had a design carved onto it, thus saving the time and trouble of having to incise each and every motif, which the *sanggam* technique required, as well as creating a more uniform design. Next the piece was covered with white slip and fired (cat. no. 8). *Inhwa* can be regarded as a type of *sanggam* technique and stamped motifs can be found among those used in late Koryŏ period. But it was with *punch'ŏng* ware that *inhwa* was actively used, creating a very distinctive type of beauty.

Chohwa (incised) punch'ŏng ware

The *chohwa* technique involved applying white slip to the surface of the vessel with a brush and using a decorating tool to carve out the desired design in lines. The greyish colour of the clay underneath was then revealed (cat. no. 14).

Pakchi (sgraffito) punch'ŏng ware

Pakchi literally means to cut away the surface. *Pakchi* ware was produced using the same technique as *chohwa* except that unlike *chohwa*, in which only lines were incised, in this technique the entire surface of the design was carved out. Often these two methods were used in conjunction (cat. no. 15). This technique was also popular at China's Cizhou kiln in Hebei province but there appears to be no direct relationship to the technique used in Korea, which is believed to have developed from the technique of *myŏn sanggam*, a similar technique in which planar rather than linear designs dominate.

Ch'ŏlhwa (underglaze iron-painted) punch'ŏng ware

In this technique, after white slip was applied to the surface of the vessel, designs were painted with pigments of high iron content. This porcelain was produced only at kilns located at the entrance to Mount Kyeryong in South Ch'ungch'ŏng province (cat. no. 19). However, recently, in the southern coastal region of Chŏlla province, dipped *punch'ŏng* wares with simple designs of plants and flowers painted in underglaze iron were discovered, although the quantity was very small.

Kwiyal (brushed slip) punch'ŏng ware

The term *kwiyal* refers to a brush made of very coarse hairs. This decorative technique refers to the application of white slip to the surface of the vessel with a coarse brush. The brushstrokes were rapid, producing brush tracks with a very dynamic feel. This technique was used in conjunction with *chohwa*, *pakchi* and *ch'ŏlhwa* techniques and produced the most distinctive *punch'ŏng* ware (cat. no. 14). Eventually *kwiyal* was used by itself to create a simple but striking form of decoration.

Tŏmbŏng (dipped) punch'ŏng ware

This type of *punch'ŏng* ware was created, not by brushing the white slip on, but by dipping the vessel in the slip itself. The term *tŏmbŏng* describes the sound made when a vessel is dipped into the slip and since there are no traces of any brushstrokes, a surface that is smooth and clean like white porcelain is produced (cat. no. 23).

Chosŏn paekcha (white porcelain)

The term *white porcelain* refers to high-quality porcelain made of kaolin, glazed with a nearly translucent glaze and

fired at high temperatures of approximately 1300°C. This type of white porcelain began to be made around the middle of the 6th century in China and was used for a long time along with celadon, but the white porcelain era began in earnest around the 1300s, during the Yuan dynasty. This influenced the manufacture of white porcelain in Chosŏn Korea from the 1400s on. Japan, utilising the skills of Korean ceramic artisans kidnapped during the Hideyoshi invasions (1592 and 1597), began its manufacture in the early 1600s. European production was spurred on by the export of Chinese white porcelain so that by the 1700s Europe too could manufacture its own. Thus the universal manufacture and use of porcelain is not more than 200 to 300 years old and we are, in fact, still living in the porcelain era.

During the first 100 years of Chosŏn dynasty ceramics, white porcelain and punch'ŏng ware were produced simultaneously, but afterwards white porcelain became the most popular type of ceramic. The high-quality white porcelain produced for the royal court was manufactured at special kilns, while that used by ordinary people was made at local kilns found throughout the country. While the appearance of the vessels and the manufacturing techniques were basically the same, a difference was found in the quality of the kaolin used. The kilns where the royal white porcelain was produced functioned as ceramic-technique centres and the techniques developed there were transmitted throughout the country.

During the Chosŏn dynasty people favoured pure white porcelain with no decoration, which was produced and used in large quantities. This white porcelain, fired in a traditional Korean 'dragon' kilns (long tunnel-shaped kilns built on a slope) with a reducing atmosphere, was pure white, although firing in an oxygen-reduced environment created a bluish glaze on the surface. The colour of white porcelain varied according to the era and depended on the quality of the clay, the transparency of the glaze and the amount of iron present in the glaze. For official purposes, the finest kaolin from throughout the country was used, while for local kilns, local clays were used.

In discussing the techniques used in Chosŏn white porcelain, the most noticeable fact is that Chinese-style wucai (literally 'five-colours', underglaze cobalt-blue and overglaze coloured enamels) porcelain was not made, probably because Korea was strongly influenced by Confucian values of frugality, which rejected extravagance. Wucai porcelains were loud in colour and not only did they not suit the Korean aesthetics of the period, the coloured pigment used was made of harmful lead, and it peeled off easily and made the porcelain impractical for everyday use.

Chosŏn white porcelain can be divided into different types depending on the pigments used in creating the motifs.

Sunbaekcha (pure-white porcelain)

The vast majority of white porcelain produced during the Chosŏn dynasty consisted of pure-white porcelain (cat. nos 24, 25). While pieces without any decoration at all are common, small quantities with ŭmgak (intaglio), yanggak (relievo) and t'ugak (open-work) decoration were made. Ŭmkak white porcelain represents a traditional technique used in Korean ceramics, but in the production of white porcelain this technique would have produced little artistic effect and was rarely used. Yanggak, which is the technique of raising up a motif and cutting out the background, was also rare (cat. no. 39). T'ugak was a technique that opened up the empty space in the motif or a specific portion of it, but detailed portions were done in either intaglio or relievo.

Ch'ŏnghwa paekcha
(white porcelain with underglaze cobalt-blue decoration)

Cobalt pigment was used to paint designs on the white porcelain, then the piece was glazed using a translucent glaze and fired at a high temperature creating white porcelain with a blue painted design (cat. no. 44). Because cobalt was imported from China at very great cost, few of these pieces were manufactured. Blue-and-white porcelain, the production of which began in the 1400s, was regarded as the highest quality white porcelain produced in Korea during the Chosŏn period. It was influenced by Chinese blue-and-white porcelain of the late Yuan – early Ming period. For many years only small quantities were made, but by the late 1700s relatively larger quantities were produced (cat. nos 45, 46).

Ch'ŏlhwa paekcha
(white porcelain with underglaze iron-brown decoration)

In these wares paint with high iron content was used to create a design, after which glaze was applied and the piece was fired at a high temperature producing motifs of a reddish-brown colour (cat. no. 49). This technique, known as *ch'ŏlhwa*, was also commonly used in Koryŏ celadon. *Ch'ŏlhwa* white porcelain was manufactured throughout the Chosŏn dynasty, but was especially popular in the 1600s. After the Japanese invasions in 1592 and 1597, conditions in Korea were very difficult and instead of the expensive cobalt-blue, easily obtainable iron-based pigments were used and white porcelain painted with underglaze iron-brown designs became popular.

Chinsa paekcha
(white porcelain with underglaze copper-red decoration)

For white porcelain wares decorated with copper-red, designs were painted with pigments of high copper content, glaze was applied and the work fired at a high temperature, resulting in designs with a red colour, also known by the Japanese term *chinsa* (cat. nos 59, 58). This technique was developed first in Korea in the 1100s by artisans in the process of making Koryŏ celadon and was virtually unused in the making of white porcelain until after the 1700s. Because of the unpredictability of copper, occasionally the colours green or brown resulted after high-temperature firing. In the 1800s there was also a type of white porcelain whose entire surface was painted with *chinsa* (copper-red) (cat. no. 62).

White porcelain with multi-coloured painted decoration

This term refers to white porcelain that was decorated using the *ch'ŏnghwa*, *ch'ŏlhwa* and *chinsa* techniques. In general, these pieces were produced after the 1700s, but it is extremely rare to find examples where all three pigments were used at the same time (cat. nos 61, 62). The combinations of *ch'ŏnghwa* plus *ch'ŏlhwa* and *ch'ŏnghwa* plus *chinsa* were more common. Firing two paints of different composition to achieve the desired colour was extremely difficult. The wares reveal how advanced the techniques used in the creation of Chosŏn white porcelain were.

Illustrations

Unless otherwise stated the catalogue entries were written with information supplied by the National Museum of Korea, Seoul. Particular thanks are extended to Kim Dong-Woo, Assistant Curator, Registrar's Office, National Museum of Korea, and Kim Min-Jung, Assistant Curator, Powerhouse Museum. Translation was undertaken by Kim Min-Jung, Park Duk-Soo and Suh Bo-Yon with the assistance of Claire Roberts and Kenneth M Wells

Maebyŏng bottle

Cat no. 1

15th century

Punch'ŏng ware with inlaid design of lotus and willow

28 (h) cm

National Museum of Korea, Seoul

This distinctively shaped bottle is known as a *maebyŏng* or plum blossom bottle in Korean. The *maebyŏng* shape originated in China and was used in Korea from the Koryŏ dynasty (935–1392). The *maebyŏng* has a beautiful, rather voluptuous silhouette formed by undulating contour lines. A small flaring lip, broad, swelling shoulder and a waisted base are characteristics of its shape. This bottle is decorated with a design of lotus flowers and willow trees that have been inlaid with contrasting white slip and red slip (which turns black after firing). The rhythmical lines of the lotus stems and willow branches create a bold and animated design. The willow is thought to repel evil and the lotus is symbolic of purity and has strong Buddhist associations. This bottle is a fine example of inlaid ware during the period of transition from the Koryŏ to the Chosŏn dynasty. The technique of inlaying (*sanggam*) was perfected during the Koryŏ dynasty, when where it was most often used with a celadon glaze. This bottle has been coated with a pale blue-grey *punch'ŏng* glaze.

Reference: Chung Yang-mo, Kim Wŏn-yong et al., eds, *Han'guk ŭi mi 3: punch'ŏngsagi* [Korean beauty 3: *punch'ŏng* ware], Chungang Ilbo, Seoul, 1981, cat. no. 15, p 203.

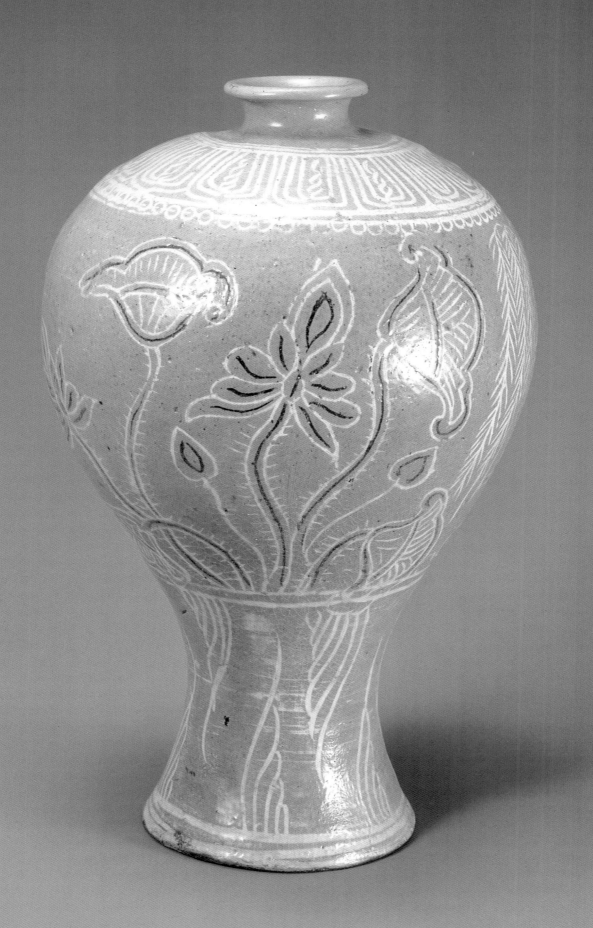

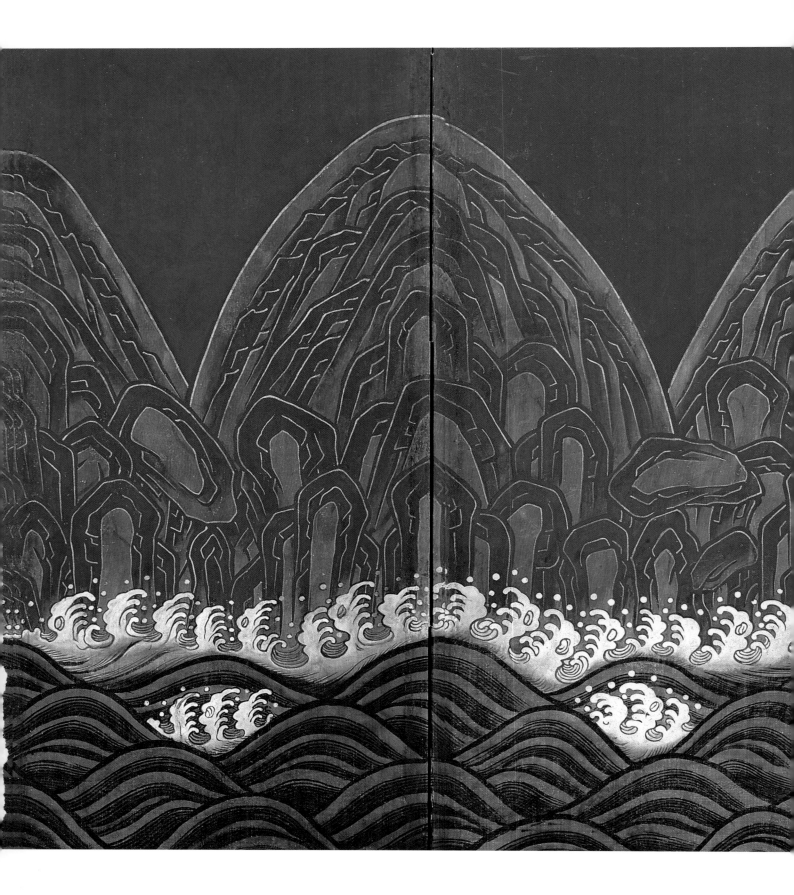

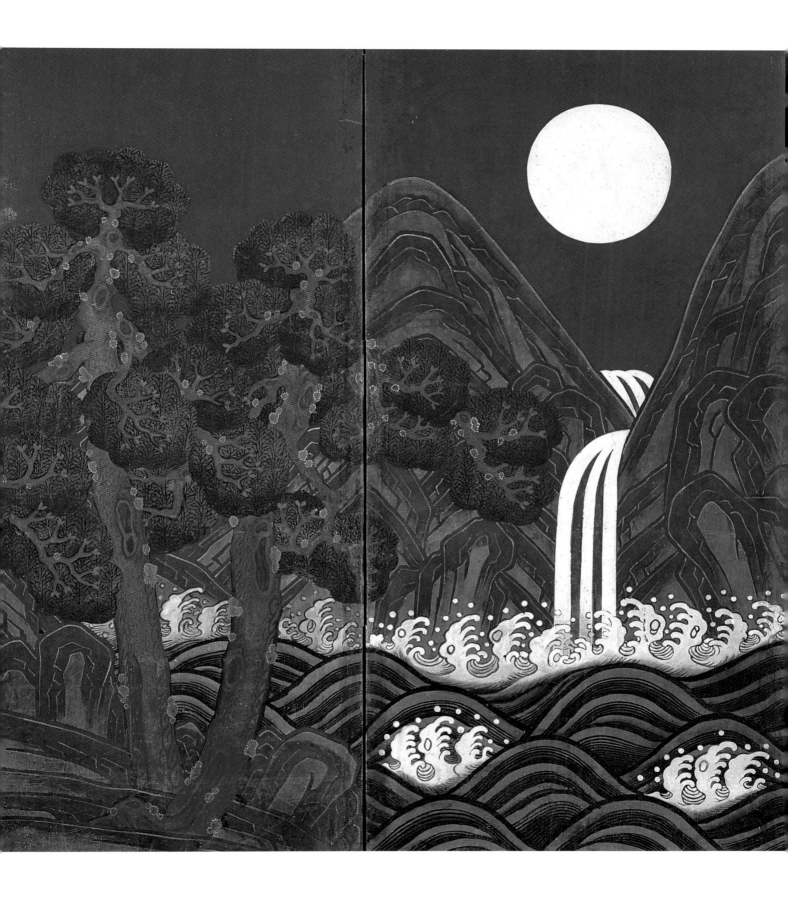

Sixfold screen painted with sun, moon and five peaks

Cat no. 2

19th century

Ink and colour on paper

160.3 (h) x 270.2 (w) cm

Ho-Am Art Museum

The sun, moon and five peaks (*irwŏl-obongdo*) screen from the late 1800s is unique to Korea. Traditionally screens decorated with this design were placed behind the king's throne or behind the king's portrait. The screen was symbolic of the royal throne and it is thought that its function was to protect royal power, even after the death of a king.

This screen is painted with a stylised sublime landscape or *sansu* (meaning mountains and water in Korean). The sky is dark blue and there is a red sun, a white moon and five mountain peaks. Two waterfalls on either side of the valley and two pine trees complete the symmetry. Water is depicted as waves and stylised, semicircular ripples. The precise meaning of the depiction of the sun, moon and five mountain peaks is not certain, but it is thought that it relates to the 'nine items of nature' in the *Ch'onbo (Tianbao)* poem of the classical Chinese text *Shijing* (*Sigyŏng* in Korean, meaning *The book of poetry*). The 'nine items of nature' allude to the virtue of the king, and his quest for blessings from heaven and his ancestors. Five of the 'nine items in nature' are protective gifts from heaven: high hills, mountain masses, topmost ridges, greatest mounds, and streams and rivers; and four are manners in which the ruler practises his virtue: the moon waxing to become full, the sun ascending to the heavens, the longevity of the Southern Mountain and the luxuriance of the fir and cypress.

It is also thought that the sun and the moon represent the king and the queen respectively, and that the five mountain peaks are symbolic of the royal throne and represent the Kollyun (Kunlun) Mountain, the highest and most sacred mountain in China. The screen is an expression of the highest authority of the royal family and the eternal life force of heaven and earth and living things, represented by the sun, moon, pine trees and water. Hence the picture may be seen to reflect a national philosophy that the many spirits portrayed by these eternal life forces are the guardians of the prosperity of the country.

In the late Chosŏn period the sun, moon and five peaks screen, which had been exclusively used in the palace, was also used by the people. For example, these screens could be purchased at the Pyŏngp'ungjŏn (screen shop) under Kwangt'onggyo Bridge in Seoul. One of the screens was also found in the shamanist Mokmyŏk shrine in the Kuksa Hall at Namsan Mountain in Seoul.

Reference: Yi Sŏng-mi, 'The screen of the five peaks of the Chosŏn dynasty', *Oriental art*, 42(4) 1996–1997, pp 13–24.

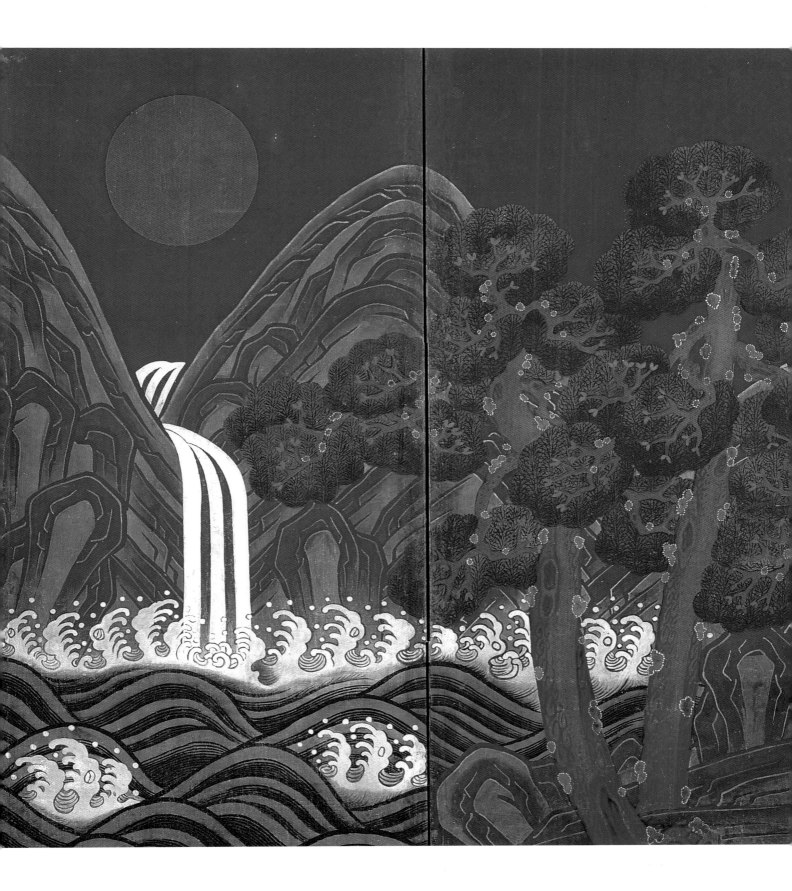

Bowl

Cat no. 3

15th century

Punch'ŏng ware with inlaid design of crane and clouds

6.7 (h) cm

National Museum of Korea, Seoul

This style of bowl with a lip for pouring is thought to have originated during the Bronze Age. Similar examples were popular in Yuan dynasty China (1279–1368). This particular bowl is similar to those produced in Korea in the 1300s during the late Koryŏ dynasty (935–1392). The curve of the spout and the fullness and depth of the bowl, however, indicate that it dates from the 1400s. The exterior of the bowl is decorated with an inlaid design of cranes and stylised clouds in white slip and red slip (which turns black after firing), and the interior wall with lotus flowers, willow trees and birds. The centre of the interior of the bowl is ornamented with a design of a pair of cranes surrounded by clouds and a phoenix. The crane is symbolic of longevity, the phoenix of the queen and good fortune, the lotus of purity and fertility, and the willow is thought to repel evil.

Reference: Chung Yang-mo, Kim Wŏn-yong et al., eds, *Han'guk ŭi mi 3: punch'ŏngsagi* [Korean beauty 3: *punch'ŏng* ware], Chungang Ilbo, Seoul, 1981, cat. no. 188, p 225.

Bowl

Cat no. 4
15th century
Punch'ŏng ware with stamped and incised design and
brushed white slip
9.7 (h) cm
National Museum of Korea, Seoul

This *punch'ŏng* ware bowl is made from stony grey clay,
which is rich in iron. The high foot, decorated with an incised
line, indicates that it was probably for ritual use. The upper
section of the interior of the bowl has been stamped with an
all-over design. White slip has been brushed over the stamped
areas and then wiped away leaving residual slip in the
patterned area. The interior of the bowl has been incised
with two concentric lines that expose the body of the bowl. The
exterior of the bowl has been brushed with white slip and left
to dry. The brush strokes give this bowl its particular charm.

Punch'ŏng wares employing white slip, stamped and incised
designs are thought to have been produced at the Mount
Kyeryong kilns at Hakbong, village, Panpŏ township, Kongju
county, South Ch'ungch'ŏng province. Many *punch'ŏng*
ware vessels were fired at these kilns from the mid 1400s to
the early 1500s.

Bowl

Cat no. 5
15th century
Punch'ŏng ware with stamped design and brushed
white slip
8 (h) cm
National Museum of Korea, Seoul

This *punch'ŏng* ware soup bowl is made from stony grey clay
which has a high iron content. The interior of the bowl has
been stamped with an all-over chrysanthemum design
above a band of stamped lotus petals near the interior of the
base. White slip has been brushed over the stamped areas
and then wiped away leaving residual slip in the patterned
area. A band of concentric lines has been incised into the
white slip at the rim. The exterior of the bowl has been brushed
with white slip and left to dry, leaving the impression of the
brush strokes. This bowl is thought to have been produced
at the Mount Kyeryong kilns in South Ch'ungch'ŏng province.

Bowl

Cat no. 6

15th century

Punch'ŏng ware with stamped design, incised inscription and brushed white slip

6.8 (h) cm

National Museum of Korea, Seoul

This small *punch'ŏng* ware food bowl is decorated with a stamped design of chrysanthemum flowers and an inscription. After stamping (*inhwa*), the bowl has been brushed with a yellow-white slip. The inscription in Chinese characters '*chang hŭng go*' is the name of the government bureau that supervised the supply of goods to the royal court and government of Korea. The bowl would have been used by officials working in the bureau. Inscriptions were intended to prevent theft of government objects.

Stamped decoration first developed in the late Koryŏ dynasty (935–1392) in order to deal with the impurity of the clay used for inlaid (*sanggam*) celadon wares. The stamped design, filled with white slip, disguised the rough surface of the bowl. The design was also regular and could be standardised, and was therefore suited to ceramics used by government departments and at court. Stamped decoration, which was popular in Korea in the mid 1400s, was time consuming in comparison to other *punch'ŏng* techniques of decoration, such as brushed white slip and incised designs. This bowl was made in the government kilns at Kwangju in Kyŏnggi province.

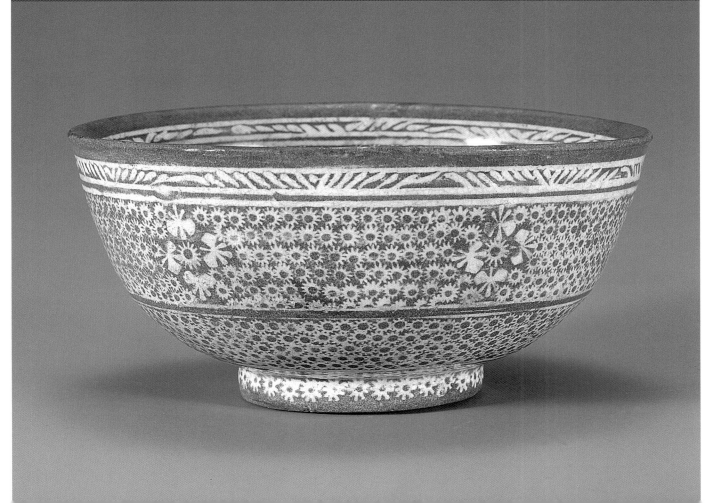

Bottle

Cat no. 7

15th century

Punch'ŏng ware with stamped design and brushed white slip

27 (h) cm

National Museum of Korea, Seoul

The shape of this bottle is characteristic of early Chosŏn *punch'ŏng* wares. The beautifully proportioned, voluminous lower body narrows to form an elongated neck and a flaring rim. The fullness of the body is accentuated by a small foot. Made to hold, carry and pour liquid, probably rice wine, the bottle has a strong functional as well as an aesthetic dimension. It is decorated with a stamped design of chrysanthemum flowers, which creates an all-over stippled effect. The stamped chrysanthemum motif, which is overlapped on the body, is clearly visible above the neck and at the base of the bottle. The chrysanthemum, symbolic of the character of a noble man or a scholar-recluse, was a popular decorative motif for ceramics.

Reference: Chung Yang-mo, Kim Wŏn-yong et al., eds, *Han'guk ŭi mi 3: punch'ŏngsagi* [Korean beauty 3: *punch'ŏng* ware], Chungang Ilbo, Seoul, 1981, cat. no. 33, p 206.

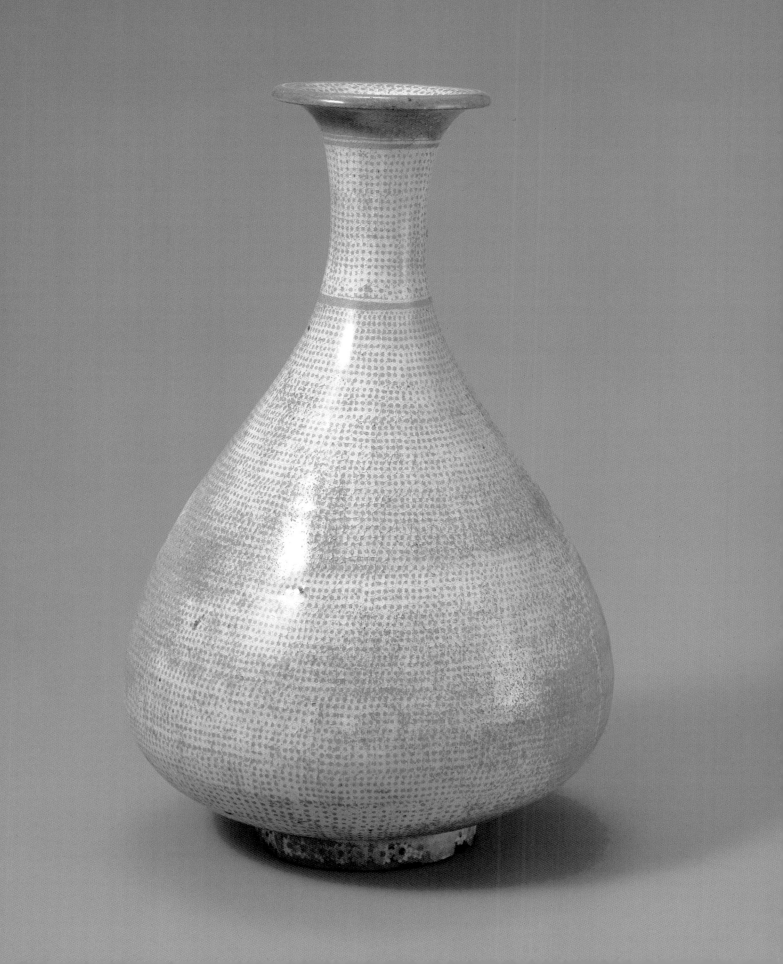

Rice-bale shaped bottle

Cat no. 8

15th century

Punch'ŏng ware with stamped design and brushed white slip

17.2 (h) cm

Ho-Am Art Museum, Yongin

This rice-bale shaped bottle, known as *changgun* in Korean, was used for storing liquids such as water or rice wine. It could be stood on its side, which was convenient for storage. The shape was formed by beating the vessel all over with a wooden mallet. The process of beating has created a handcrafted yet uncontrived surface that is full of life and movement. The exterior of the vessel has been further enhanced by the addition of an all-over stamped design, which has been filled with white slip and fired with a pale blue *punch'ŏng* glaze. A stamped chrysanthemum design enclosed by three concentric lines ornaments the end of the bottle. The bottle was fired by attaching sand spurs to one side.

References: Ho-Am Art Gallery [Museum], *Punch'ŏngsagi myŏngp'umch'ŏn: Ho-am misulgwan sojang* [Masterpieces of *punch'ŏng* ware from the Ho-Am Art Gallery [Museum]: looking for the root of Korean beauty], Samsung Foundation of Culture, Seoul, 1993, cat. no. 54, pp 55, 164.

Ho-Am Art Museum, ed., *Masterpieces of the Ho-Am Art Museum: antique art, vol. 1, ceramics*, Samsung Foundation of Culture, Seoul, 1996, cat. no. 79, pp 91, 204.

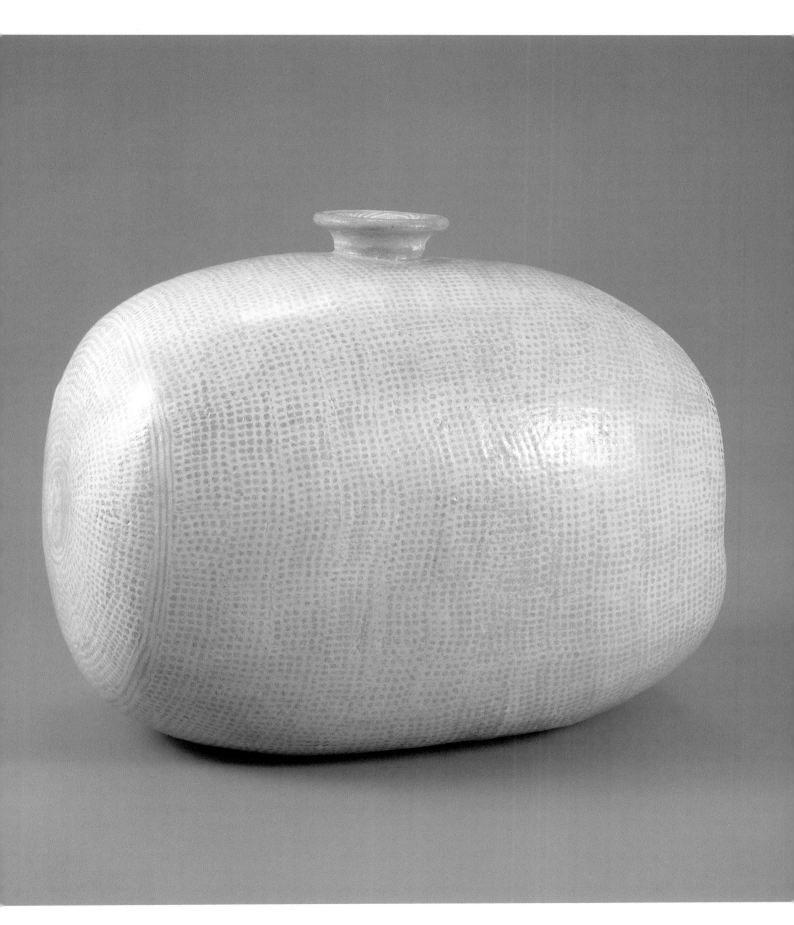

Flask

Cat no. 9

15th century

Punch'ŏng ware with brushed white slip

23 (h) cm

National Museum of Korea, Seoul

This flask has a voluminous form, which indicates that it was made on a wheel. Each side was flattened by being beaten with a wooden mallet covered in cloth to prevent the transfer of the wood grain. A layer of white slip has been painted rapidly onto the body of the flask with a wide, coarse brush. The fluent brush strokes are expressive of the artist's temperament and follow the form of the flask. The flask has been coated with a thick grey-green celadon glaze, which dribbles down one side in a very natural and unaffected manner. Unlike stamped *punch'ŏng* wares, which require precise and painstaking work, *punch'ŏng* wares with brushed designs could be created quickly and in relatively large numbers. This technique became popular in the mid 1400s when production of *punch'ŏng* wares with stamped designs began to decline.

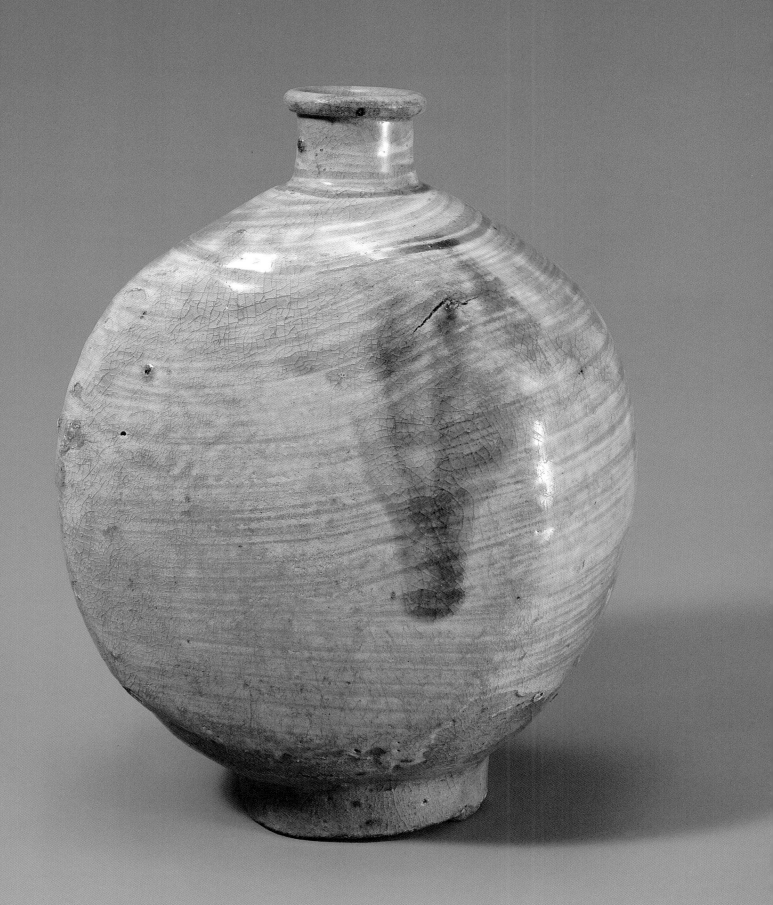

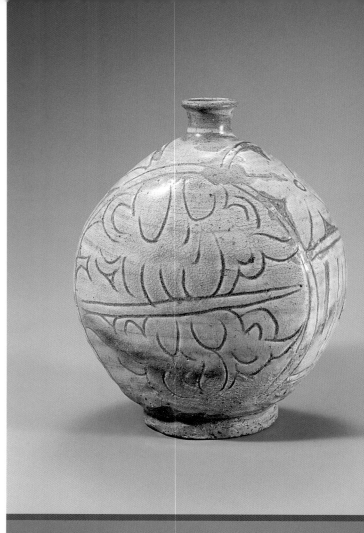

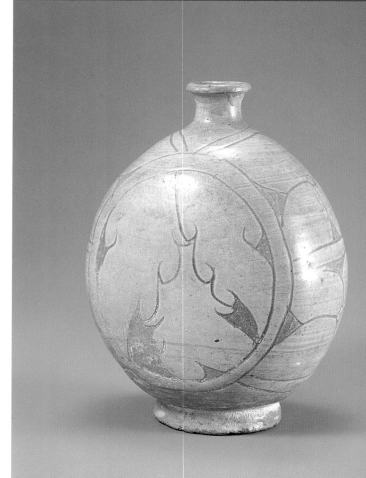

Flask

Cat no. 10 *(above)*

15th century

Punch'ŏng ware with white slip, with incised and cut-away design of peony flowers

23.2 (h) cm

Kim Nak-joon collection, Seoul

This *punch'ŏng* ware flask, used for rice wine or water, was made by flattening two sides of a round bottle with a wooden mallet. Although it is rare to find a perfectly symmetrical flask made using this method, the full body and flat surfaces are well balanced and create a visual harmony. The flask has been brushed with white slip and the front and back faces decorated with a design of peony flowers. The design was created by incising lines and cutting away some areas of white slip. The patterns on the sides are divided into an upper and lower register: the upper features an incised abstracted four-petal peony flower, the surrounding areas of which have been cut away, and the lower an incised line pattern. The flask has been coated with a clear, shiny glaze.

Flask

Cat no. 11 *(below)*

15th–16th century

Punch'ŏng ware with white slip and incised and cut-away design of peony flowers

22.9 (h) cm

National Museum of Korea, Seoul

In order to make this distinctively shaped *punch'ŏng* ware flask, a round bottle was produced on the wheel and then the front and back were flattened. The flask has been brushed with white slip before being decorated with an incised pattern. The front and back of the flask are ornamented with a design of peony leaves contained within two freely drawn, concentric circles. The areas of void have been cut away, creating a three-dimensional effect and a contrast between the colour of the slip and the body. The leaf design has been quickly and simply drawn with calligraphic strokes using a sharp implement. The sides of the vessel are decorated with an incised and cut-away design of abstracted peony flowers. The peony is symbolic of riches and honour, and was a popular decorative motif. The flask is coated with a clear, shiny glaze that shows some crazing. The interior of the base has been cut away and the vessel was fired on fireproof clay pellets mixed with sand.

Reference: Chung Yang-mo, Kim Wŏn-yong et al., eds, *Han'guk ŭi mi 3: punch'ŏngsagi* [Korean beauty 3: *punch'ŏng* ware], Chungang Ilbo, Seoul, 1981, cat. no. 89, p 212.

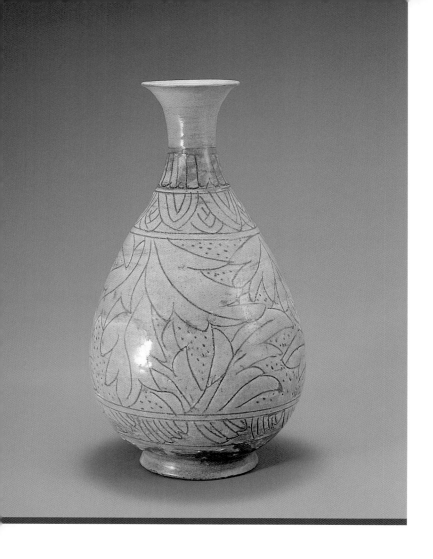

Bottle

Cat no. 12 *(left)*

15th century

Punch'ŏng ware with white slip and incised foliate design

32.6 (h)cm

Kim Nak-joon collection, Seoul

This *punch'ŏng* ware bottle, used for rice wine or water, has been painted with white slip and incised with a design of peony leaves. The area around the leaves has been decorated with incised dots, which gives the design a heightened sense of animation. A lotus leaf design may be seen around the neck, shoulder and base of the bottle. The decoration on many *punch'ŏng* ware bottles is divided into separate registers, as on this bottle.

Bottle

Cat no. 13 *(right)*

15th century

Punch'ŏng ware with white slip and incised design of fish and lotus flower

25.1 (h) cm

National Museum of Korea, Seoul

White slip has been applied to this bottle with a *kwiyal* or coarse brush and then incised (*chohwa*) with a sharp tool to create the design. Areas of the neck have also been cut away in a technique known as *pakji* (sgraffito). The incised lines reveal the clay body and create a subtle colour contrast. One face of the bottle has an incised design of a fish playing with a lotus bud and on the other a large fish holds a small fish firmly in its mouth. Both vignettes evoke the life of fish during summer. Fish are symbolic of abundance, fertility and prosperity. Freely drawn scenes from nature imbued with a sense of humour such as these are characteristic of the type of decoration often found on *punch'ŏng* wares.

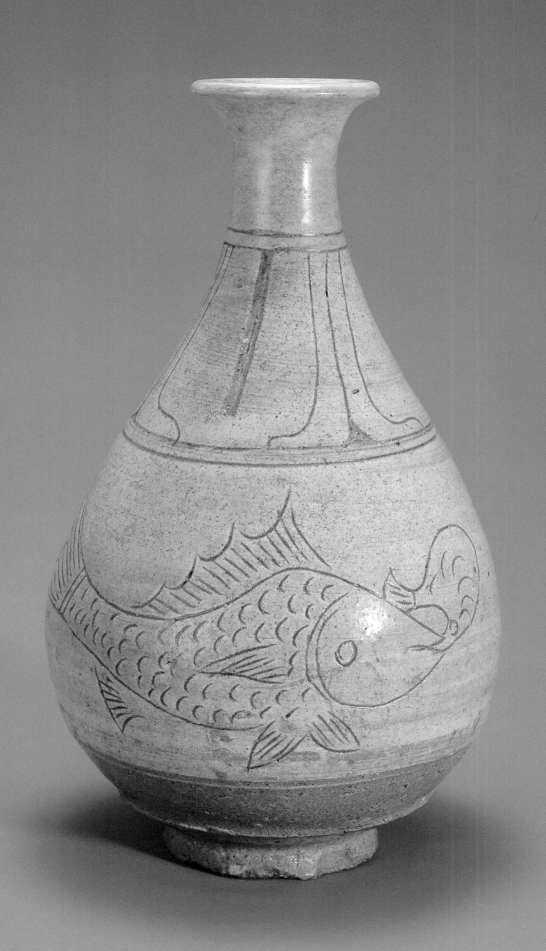

Flask

Cat no. 14

15th century

Punch'ŏng ware with white slip and incised floral and
tree-and-bird design

22.6 (h) cm

Ho-Am Art Museum, Yongin, Treasure no. 1069

This flask has a distinctive shape and was originally made for
rice wine. The body is round and full but the front and back
have been beaten with wooden mallets, which were covered
in cloth to prevent the transfer of the wood grain, and
flattened when the clay was still malleable. The narrow neck
and gently flaring rim contrast with the wide foot, which
gives stability to the form. Thin white slip has been applied
with a coarse brush to the body of the vessel and reveals the
natural colour of the clay, which is brown and slightly
textured. The area below the neck is incised with a band of
roughly rendered petals. The front and back of the flask
feature a freely drawn design of radiating flower petals and
birds, and on the two sides are a floral pattern and a
schematic tree-and-bird design respectively. A transparent
green glaze has been applied to the body of the flask before
it was fired on sand.

References: Ho-Am Art Gallery [Museum], *Punch'ŏngsagi myŏngp'um ch'ŏn: Ho-am misulgwan sojang* [Masterpieces of *punch'ŏng* ware from the Ho-Am Art Gallery [Museum]: looking for the root of Korean beauty], Samsung Foundation of Culture, Seoul, 1993, cat. no. 2, pp 11, 148.

Ho-Am Art Museum, *Masterpieces of the Ho-Am Art Museum: antique art, vol. 1, ceramics*, Samsung Foundation of Culture, Seoul, 1996, cat. no. 85, pp 97, 205–6.

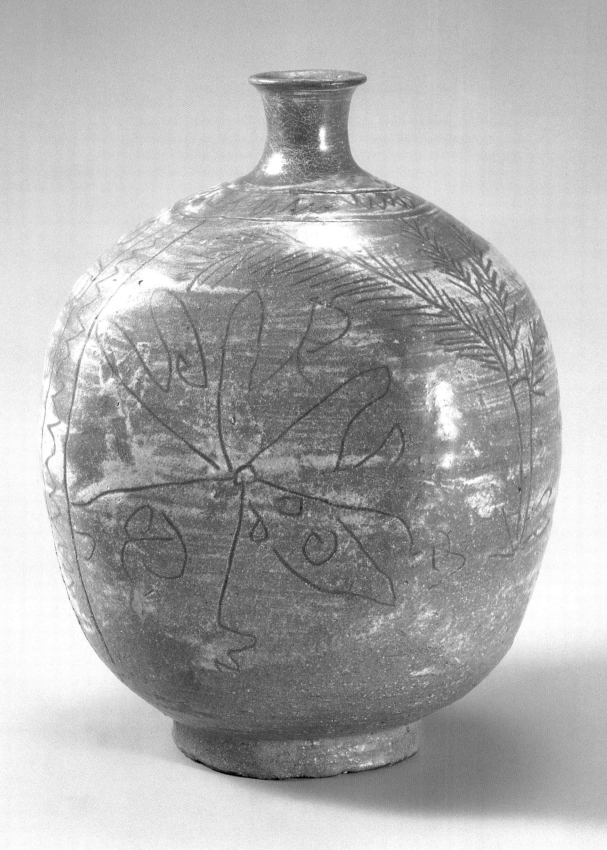

Jar

Cat no. 15

15th century

Punch'ŏng ware with white slip and incised and cut-away design of peony flowers

45 (h) cm

National Museum of Korea, Seoul

This tall jar is characteristic of early Chosŏn *punch'ŏng* wares. It would have been used for display by an upper-class person. White slip has been quickly and casually brushed onto the body of the vessel leaving areas at the rim and base exposed. The seemingly unfinished application of white slip is typical of many *punch'ŏng* wares and is a quintessential expression of the *punch'ŏng* aesthetic. Freely drawn peony leaves have been incised into the brushed slip in the upper register of the pattern and in the middle register areas of slip have been incised and cut away to form a peony and wheel-shaped chrysanthemum pattern. The peony is symbolic of riches and honour and the chrysanthemum of longevity. A transparent *punch'ŏng* glaze, thinly applied to the vessel, reveals the natural colour of the clay. The body of the jar is dark owing to the high iron content of the clay and the presence of mineral impurities, and creates a striking contrast with the white slip design. The rim of the jar has been repaired.

Reference: Chung Yang-mo, Kim Wŏn-yong et al., eds, *Han'guk ŭi mi 3: punch'ŏngsagi* [Korean beauty 3: *punch'ŏng* ware], Chungang Ilbo, Seoul, 1981, cat. no. 95, p 213.

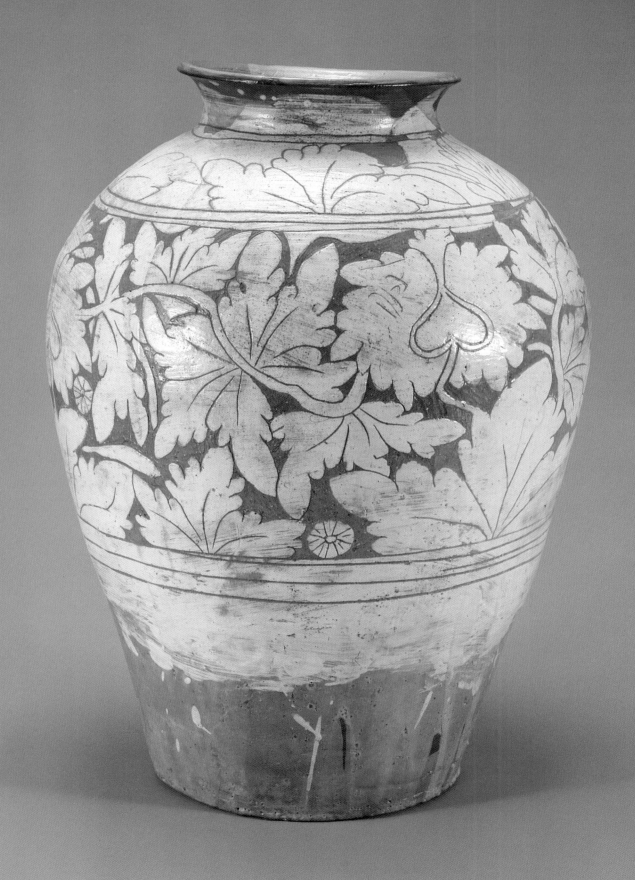

Bottle

Cat no. 16

16th century

Punch'ŏng ware with white slip and cut-away design of
fish and lotus

35 (h) cm

National Museum of Korea, Seoul

This bottle has been formed from rough grey clay to which a
thick and relatively even layer of white slip has been applied.
The design of fish and lotus has been lightly incised into the
slip and then cut away (*pakchi*) to expose the natural clay
body, leaving the white slip as the background. The
technique of lightly scraping away the design is distinctive
and makes this bottle quite rare. The head of the fish has
been inlaid with white slip. Fish are symbolic of abundance
and the lotus of purity. The bottle is well proportioned and
the body is quite full at the mid point, which is characteristic
of *punch'ŏng* wares dating from the 1500s. This bottle was
probably made at a kiln at Mount Kyeryong in South
Ch'ungch'ŏng province. The neck and lip have been repaired.

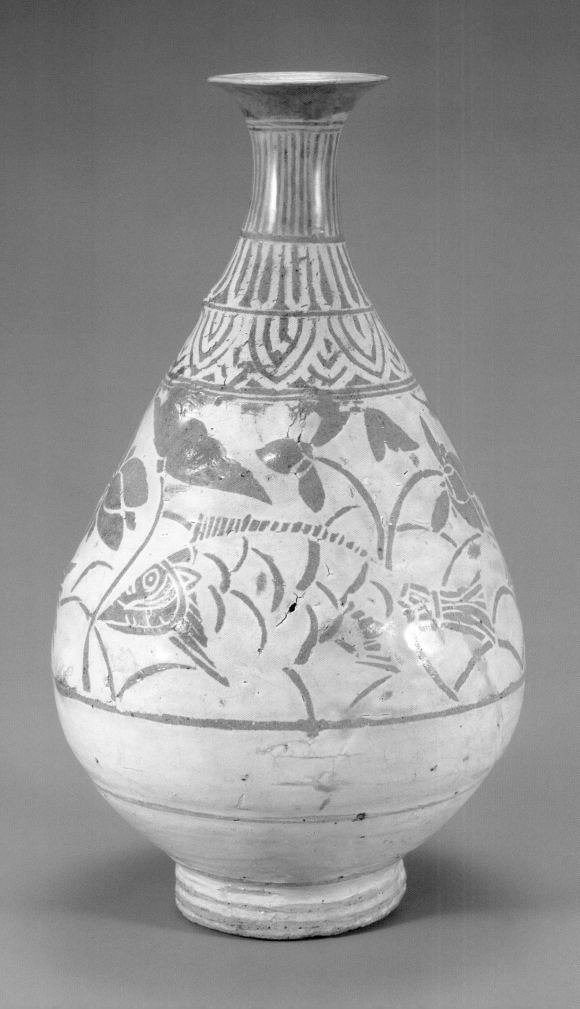

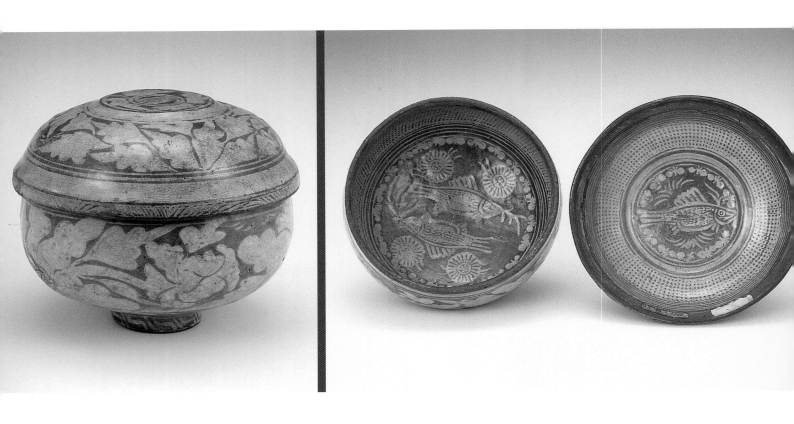

Covered bowl

Cat no. 17

15th century

Punch'ŏng ware with inlaid design of peony flowers and
leaves

12.8 (h) cm

National Museum of Korea, Seoul

This covered rice bowl is typical of early Chosŏn dynasty
punch'ŏng ware. It has a full body and a narrow but tall foot.
Food bowls were covered as a sign of respect and to keep
the food hot and clean during the transfer from the kitchen
to the men's or women's quarters where meals were eaten. The
exterior of the bowl is decorated with an inlaid (*myŏn sanggam*)
design of peony flowers and leaves. The peony is symbolic
of prosperity and honour. Large pattern areas have been
carved out and white slip has been inlaid into the iron-rich
brown clay to create a bold, contrasting design. The interior of
the bowl is also decorated, but with a stamped design of fish
and chrysanthemums, which has been filled with white slip to
create a striking contrast. A transparent pale blue-grey glaze
has been applied to the vessel.

Covered bowl

Cat no. 18
15th–16th century
Punch'ŏng ware with white slip and underglaze iron-brown lotus and scroll design
15 (h) cm
National Museum of Korea, Seoul

Covered rice bowls like this one are typical of those used by upper-class people and government officials during the early Chosŏn period. They were also made in metal or white porcelain. This bowl has a beautifully potted, full body, brushed with white slip, which tapers rapidly to form a narrow but tall foot. The slip has been painted in underglaze iron-brown with a design of lotus flowers and scrolling forms. The motifs have been quickly executed in fine rhythmic brush strokes. A series of lines incised in the slip reveal the colour of the clay body, which beneath the lotus flower creates the impression of a waterline. Symbolic of purity, the lotus rises from the muddied waters unsullied.

The lid is painted with a reverse scroll design between wave-pattern borders. There is a groove on the inside of the lid that allows a close fit to retain heat. When upturned the lid could also be used as a dish. A light yellowish glaze laid over the white slip gives the covered bowl a pale golden glow. Crazing is evident in the glaze. There are sand vestiges on top of the lid, which indicate that it was fired upside down. Glaze from the base of the lid was wiped away before it was placed on a support of fireproof clay pellets mixed with sand and then fired. It was probably made at the Mount Kyeryong kiln, in the South Ch'ungch'ŏng province.

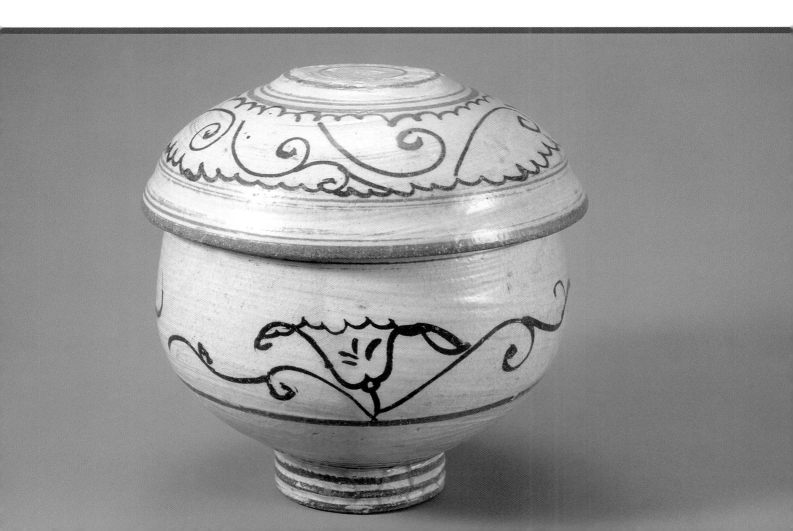

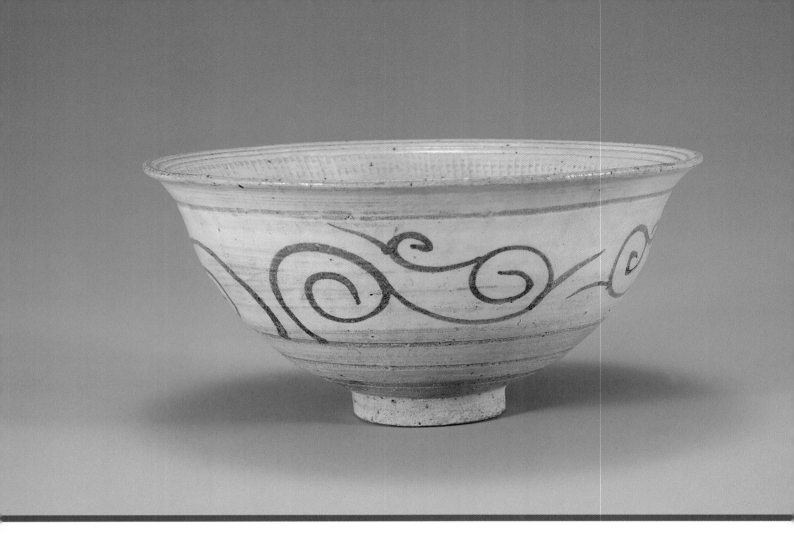

Bowl

Cat no. 19 *(above)*
Late 15th – 16th century
Punch'ŏng ware with stamped design, brushed white slip and underglaze iron-brown scroll design
8.4 (h) cm
National Museum of Korea, Seoul

The interior of this food bowl has been decorated with a stamped design and then the whole bowl has been brushed with white slip. The exterior of the bowl has then been painted in underglaze iron-brown with a scrolling design of vine tendrils. Freely painted, abstracted designs such as these are characteristic of underglaze iron–painted *punch'ŏng* wares. Many of these wares were made in the Mount Kyeryong area in South Ch'ungch'ŏng province and are known as Mount Kyeryong *punch'ŏng* wares.

Bottle

Cat no. 20 *(right)*
Late 15th – 16th century
Punch'ŏng ware with white slip and underglaze iron-brown design of fish
28.4 (h) cm
Kim Nak-joon collection, Seoul

This bottle was produced in the Mount Kyeryong kiln. It has a flaring rim, narrow neck, full body and small foot. The bottle has been brushed with white slip and then painted in underglaze iron-brown with a design of two large fish swimming freely among lotus-like water plants. The fish have been drawn quickly in an impromptu manner. They are abstract and simplified, yet they have a dignified air.

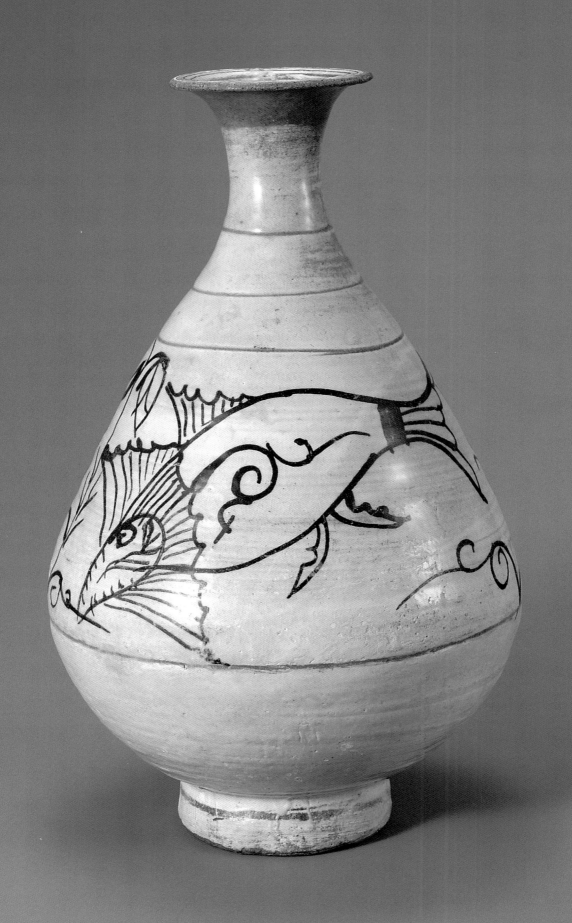

Jar

Cat no. 21 (below)

16th century

Punch'ŏng ware with white slip and underglaze iron-brown scroll design

11.1 (h) cm

National Museum of Korea, Seoul

This jar was made at a *punch'ŏng* kiln at Mount Kyeryong in South Ch'ungch'ŏng province. It would have been used for condiments such as bean sauce, soy sauce or pickles. It is a fine example of the strong design sense and the bold ornamentation employed by *punch'ŏng* ceramicists. The top section of the jar has been freely brushed with white slip and then painted with a spirited underglaze iron-brown scroll design to create a strong colour contrast with the dark brown clay body. The high iron content of the clay and the presence of many mineral impurities give the clay its dark appearance. The wrap-around brush strokes indicate that the slip was probably applied while the jar was still spinning on the potter's wheel. A transparent *punch'ŏng* glaze was applied before firing.

Reference: Chung Yang-mo, Kim Wŏn-yong et al., eds, *Han'guk ŭi mi 3: punch'ŏngsagi* [Korean beauty 3: *punch'ŏng* ware], Chungang Ilbo, Seoul, 1981, cat. no. 146, p 220.

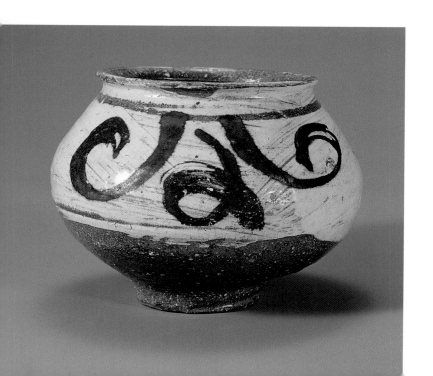

Bowl

Cat no. 22

16th century

Punch'ŏng ware with dipped white slip

5.5 (h) cm

National Museum of Korea, Seoul

This soup bowl is made from stony grey clay, which is rich in iron. Dipping a vessel in white slip so that the dipped area was coated with a smooth layer of slip was one of the decorative techniques used by *punch'ŏng* ware potters. Dipped *punch'ŏng* wares have a serene or tranquil quality owing to their simple decoration, which is free from brush marks or other patterns. Vessels are dipped into the white slip by holding the foot. When returned to the upright position the white slip runs down the interior and sides of the bowl. Most dipped *punch'ŏng* wares were produced during the 1500s, the period that preceded the large-scale production of white porcelain.

Bowl

Cat no. 23

16th century

Punch'ŏng ware with dipped white slip

9 (h) cm

National Museum of Korea, Seoul

This food bowl would have been used for rice, cereals, water, soy sauce or other liquids. Dipping a vessel in white slip so that the dipped area is coated with a smooth layer of slip was one of the decorative techniques used by *punch'ŏng* ware potters. Dipped *punch'ŏng* wares have a serene or tranquil quality owing to their simple decoration, which is free from brush marks or other patterns. The rim of the bowl has been repaired.

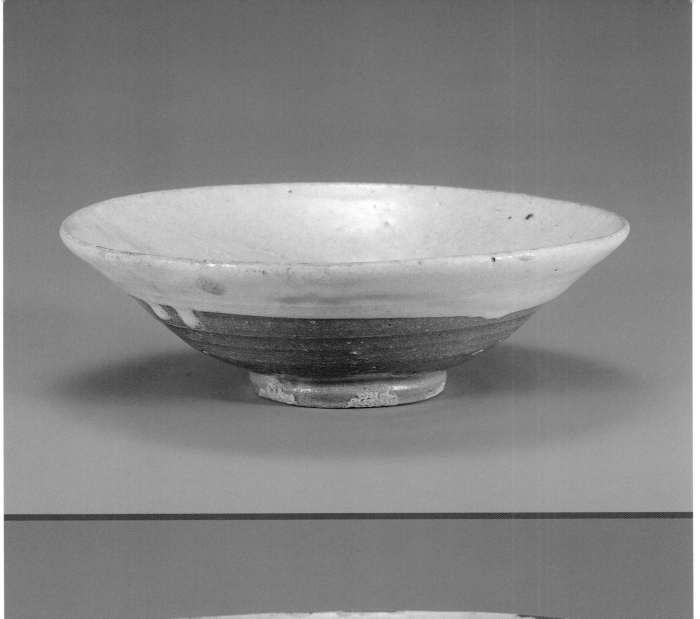
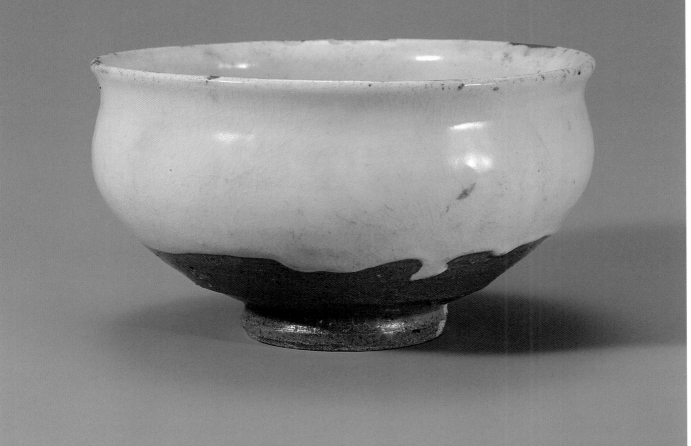

Bowl

Cat no. 24
15th century
White porcelain
11.8 (h) cm
National Museum of Korea, Seoul

The colour of Chosŏn dynasty white porcelain varies according to when it was produced. Generally milk-white porcelain dates from the 1400s to 1500s, grey-white and snow-white porcelain from the 1600s to the 1700s, and white with a slight blue tinge from the 1800s. Most of the white porcelain rice bowls produced during the Chosŏn dynasty are large with outwardly flaring sides. This bowl is covered with a thin, milk-white glaze that has a subtle sheen and was fired on fine floury sand.

During the reign of King Sejong (reigned 1418–1450) high-quality white porcelain wares such as this bowl are thought to have been produced in limited numbers for royal dining and only at the government kilns at Kwangju in Kyŏnggi province.

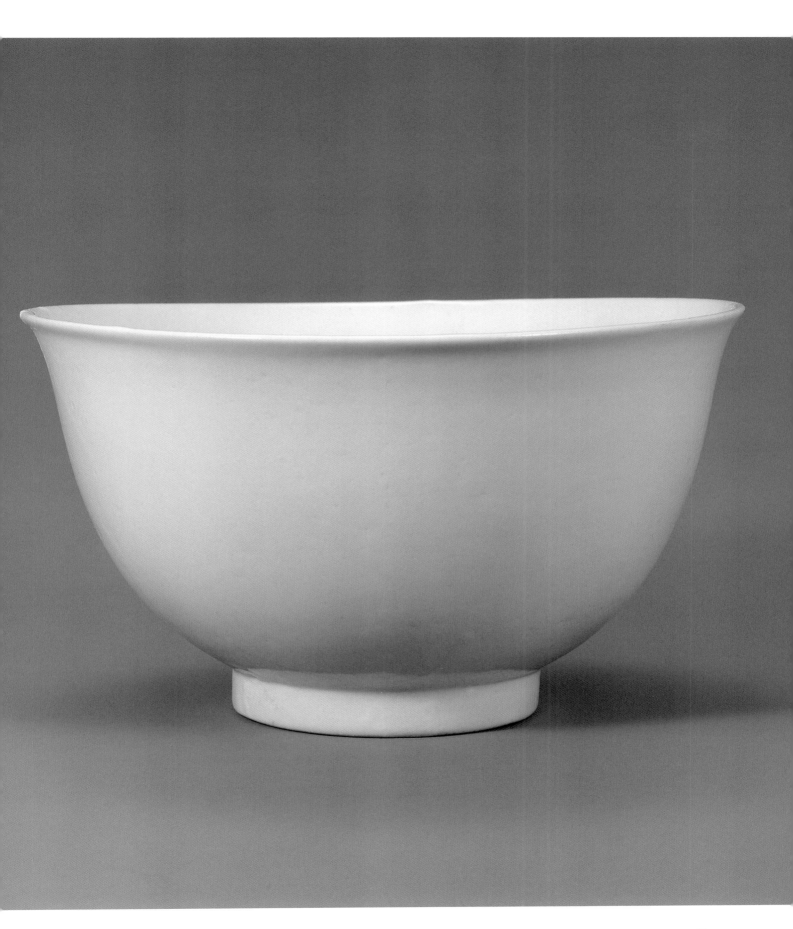

Bottle

Cat no. 25

15th–16th century

White porcelain

34 (h) cm

National Museum of Korea, Seoul

Bottles of this shape were produced in inlaid celadon in small quantities at the end of Koryŏ dynasty (935–1392). The shape became more popular during the Chosŏn dynasty and was used by royalty and the upper classes for rice wine. An even coat of white glaze was applied to the bottle and covers the base. It was made at the government kilns at Kwangju in Kyŏnggi province

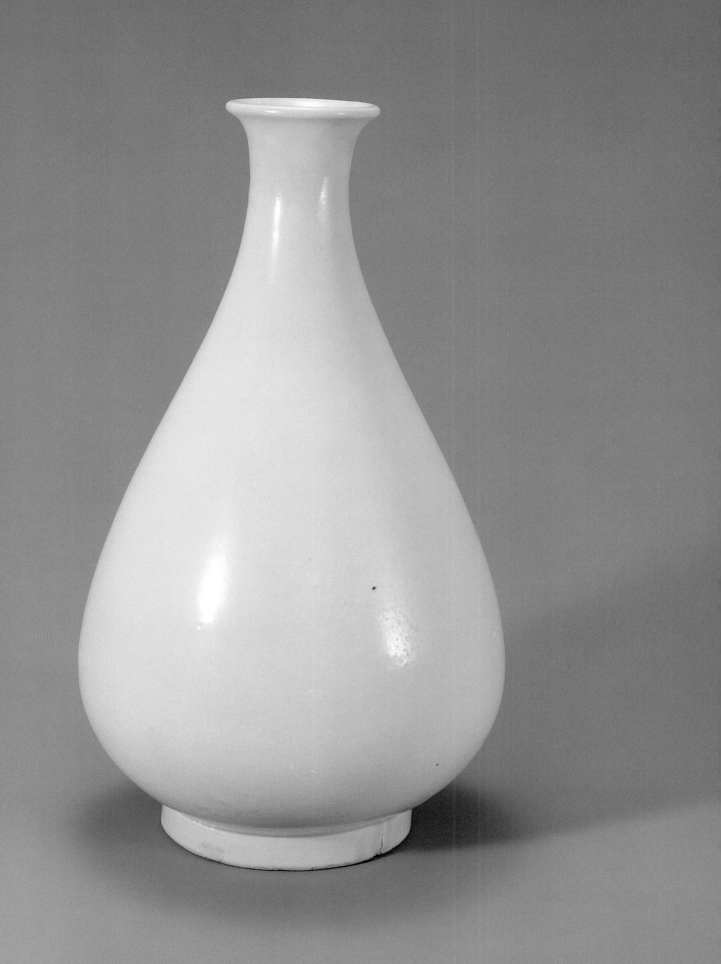

Ewer

Cat no. 26
Late 18th century
White porcelain
27.8 (h) cm
National Museum of Korea, Seoul

This ewer, possibly used for rice wine, is a fine example of white porcelain. The fine clay body has been coated with a thick blue-white glaze that is uneven in places creating subtle colour variations. The gentle curve of the body, spout and lid imbue the vessel with a feminine beauty and elegance. There are iron fittings on either side of the neck and a padlock on the handle side of the vessel to secure the lid. It is thought that this was to prevent the liquid inside from being contaminated by poison. Poisoning did occur and those at greatest risk were members of the royal court and people occupying important political positions. The ewer was made at the government's Punwŏn kiln at Kwangju in Kyŏnggi province.

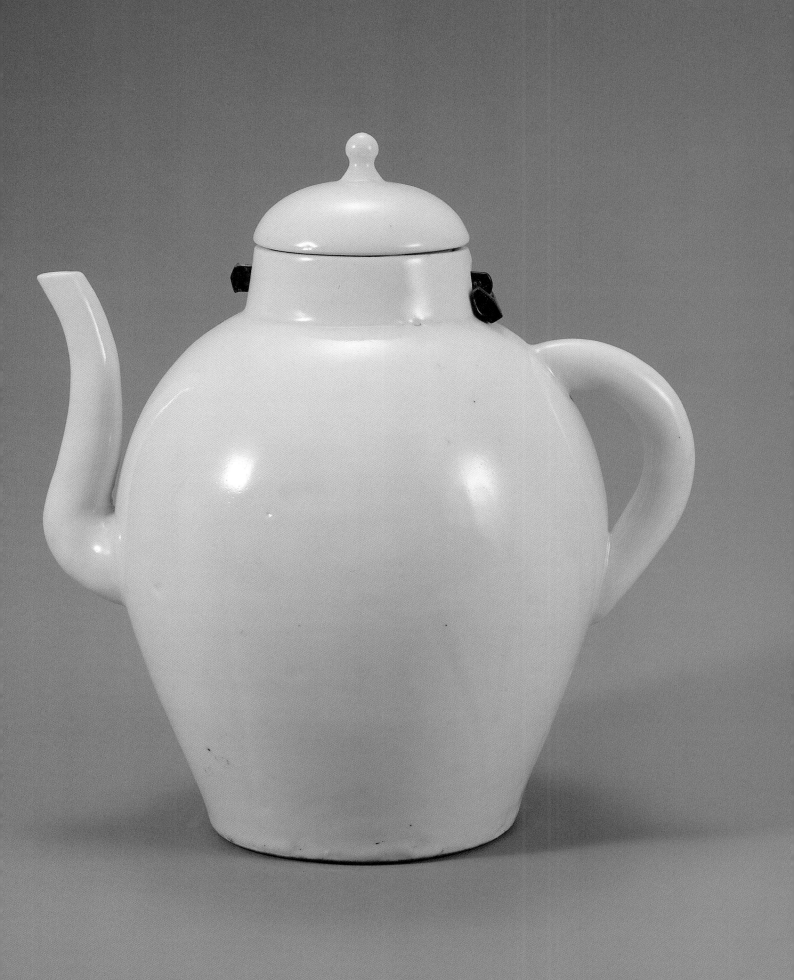

Flask

Cat no. 27

16th century

White porcelain

26.7 (h) cm

Ho-Am Art Museum, Yongin

This pure, milk-white porcelain flask with its clean, majestic form and pure lustrous glaze is typical of early Chosŏn ceramics. It has a sharply angled rim, short neck and slightly elevated oval-shaped foot. The flask was probably used for rice wine and was carried in a bag made of straw so that it could be easily transported. The undecorated form is evocative of a strong and upright Confucian character. The flask was made in two halves that have been joined together at the sides. There is a contrast between the circular, moon-like shape of the flask and the flattened sides. A high-quality transparent glaze was applied to the body and it was fired on sand. There is evidence of crazing in the glaze. The flask was made at the government kilns at Kwangju in Kyŏnggi province.

References: Ho-Am Art Museum, *Masterpieces of the Ho-Am Art Museum: antique art, vol. 1, ceramics*, Samsung Foundation of Culture, Seoul, 1996, cat. no. 112, pp 124, 211–12.

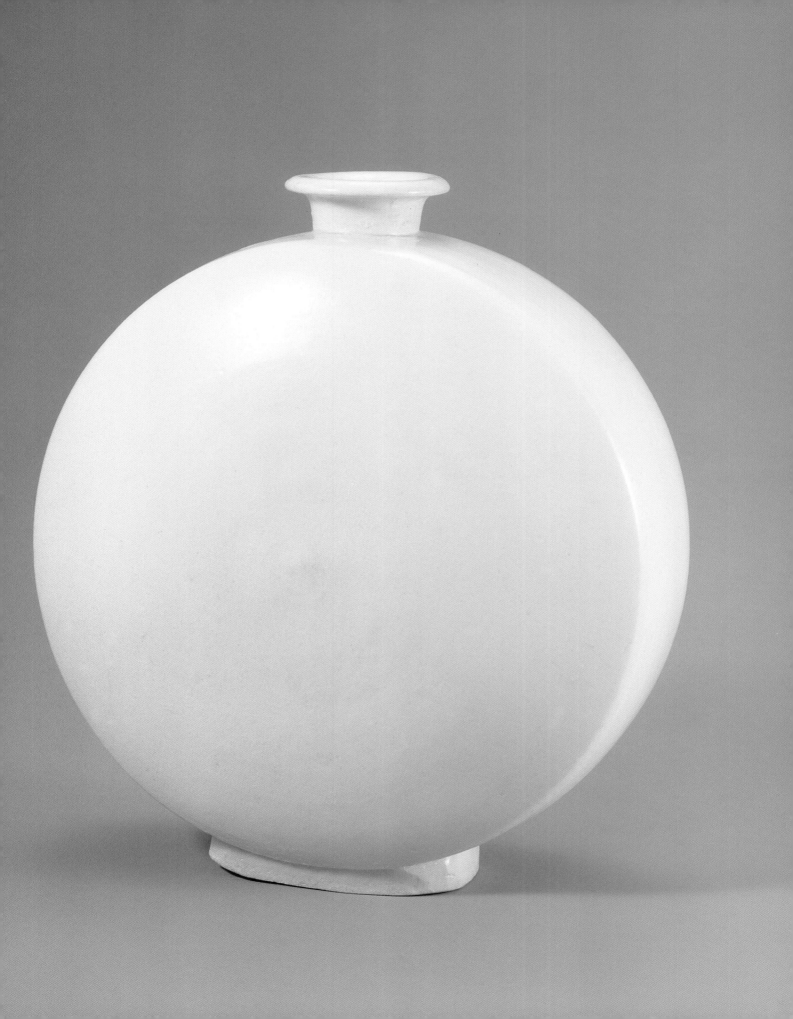

Jar

Cat no. 28
18th–19th century
White porcelain
33.2 (h) cm
National Museum of Korea, Seoul

This white porcelain *talhangari* or moon-jar was made from fine clay and has a pale, uneven blue-white glaze. Moon-jars were popular in the mid to late Chosŏn dynasty and were generally used for display. This jar was made in two halves, top and bottom, and joined at the centre. The natural, irregular shape of the jar, resulting from a slight sagging during the firing process, was appreciated as the outcome of a natural process. This jar typifies the Chosŏn potters' ideal of creating pure, modest forms that are determined by technique and function. Firing was risky and the temperature inside the kiln fluctuated according to the season and the quality of the wood. The iron content of the clay could also cause colour change. Prior to firing it was customary to hold a ceremony for a successful firing. The jar was made at the Kŭmsari kiln at Kwangju in Kyŏnggi province.

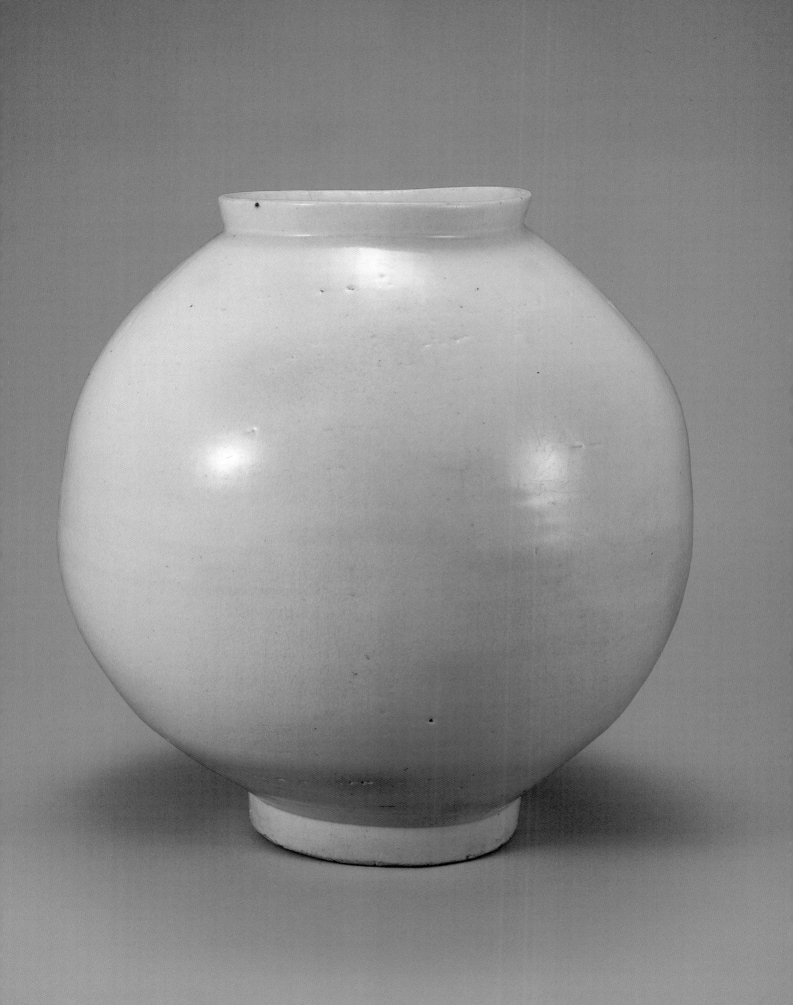

Covered bowl

Cat no. 29
19th century
White porcelain with moulded design of plum blossom
18.2 (h) cm
National Museum of Korea, Seoul

This carved bowl forms part of a high-quality dinner set dating from the 1800s. A typical traditional Korean dining table was set with rice and a number of different side dishes, sometimes as many as 12. The vessels used for dining are called *pansanggi* and usually include a rice bowl, a soup bowl, sauce bowls and bowls for side dishes. The shape of the rice bowl differs depending on the gender of the eater. For example, a rice bowl for a man is large and has outwardly flaring sides whereas a rice bowl for a woman is smaller with a narrower mouth and a fuller, wider base. All rice bowls are covered with a fitted lid. As rice was the staple food, the rice bowl was correspondingly large. This man's porcelain rice bowl and lid has a carved-relief design of plum blossom

Flask

Cat no. 30
19th century
White porcelain with moulded design of crane and deer
19.5 (h) cm
National Museum of Korea, Seoul

Most *punch'ŏng* ware flasks were thrown on a wheel as round bottles and then the two sides were flattened. Visually these flasks preserve the volume and roundness of their original wheel-thrown form. This porcelain flask, however is much flatter. Each side was made separately and then joined together at the sides. The form is of ancient origin and was first made from earthenware.

This flask was made for rice wine and was used for outdoor events such as picnics. The lugs on the shoulder, which have been hand modelled in the shape of an immature dragon, and the holes in the base allow a cord to be passed through to facilitate carrying. The cord was threaded from the base and through the lugs. The flask is decorated with a carved low-relief design of symbols of longevity—a crane, a pine and *pulloch'o*, a herb that is thought to bring eternal youth. On the other side of the flask the designs of a deer, bamboo and *pulloch'o* are also symbolic of longevity. The flask is covered with a blue-white glaze, which is typical of white porcelains of the 1800s.

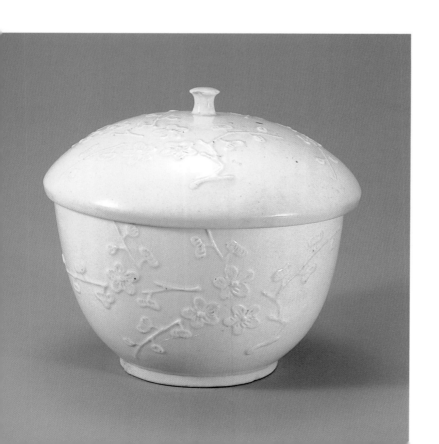

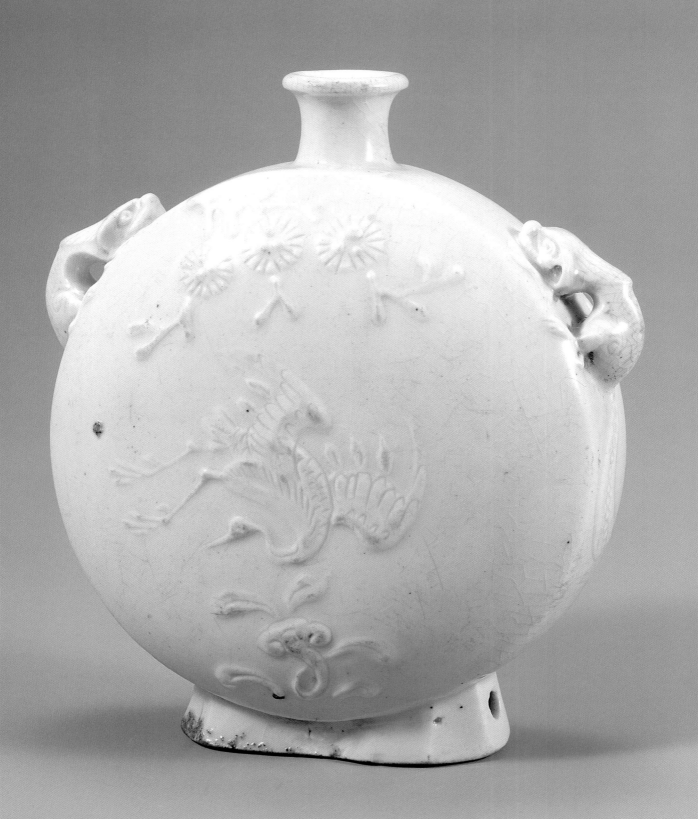

Placenta jars

Cat no. 31
1665
White porcelain
Outer jar: 23.4 (h) cm
Inner jar: 13.6 (h) cm
National Museum of Korea, Seoul

In Korea the custom of keeping jars that contained the placenta and burying them in the family burial mound at a mountain location was maintained by members of the royal family and wealthy individuals throughout the Chosŏn dynasty. It appears that jars made from *punch'ŏng* ware were used until the mid 1400s and white porcelain from the late 1400s. Placenta jars made from white porcelain usually have an inner and an outer jar. After a baby was born the placenta was stored in a room for a period of five to six months or longer. An auspicious day was chosen for the burial and the placenta was washed and then placed in the inner placenta jar on top of a coin, which symbolised payment to the god of the earth. The inner jar was sealed with oiled paper or indigo-dyed silk and the lid placed on top. It was wrapped with paper, sealed with wax, tied with red string and then placed in the outer jar, which was packed with cotton wadding and sealed with a layer of paper. Cotton wadding was placed on top of the paper seal and a layer of sugar added. The outer lid was then placed on top and the whole was wrapped in waxed paper, tied with red string and heat-sealed. A tag was attached to the string identifying the person whose placenta it was and the time, date, month and year of birth. The wrapped placenta jar was then placed with a *chisŏk*, a stone plaque bearing an inscription, in a stone box for burial. A small placenta epitaph was erected to mark the burial place.

These placenta jars have a wide shoulder and four lugs to secure the lid to the base. These jars are made from high-quality clay and covered with a blue-white glaze. The inscription on the stone plaque for these jars reads: (front) 'Buried at the time of the rabbit (5–7 am) on 13 March 1670'; (back) 'The placenta of a baby Princess [Myŏngan] who was born at the time of the dragon (7–9 am) on 18 May 1665.'

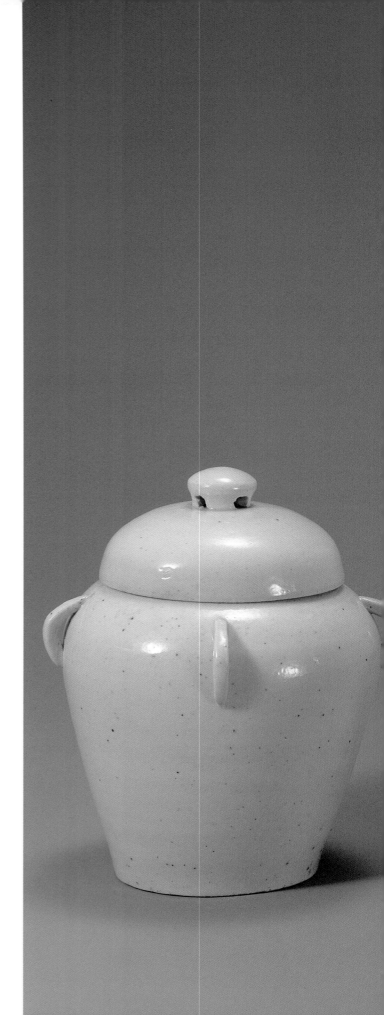

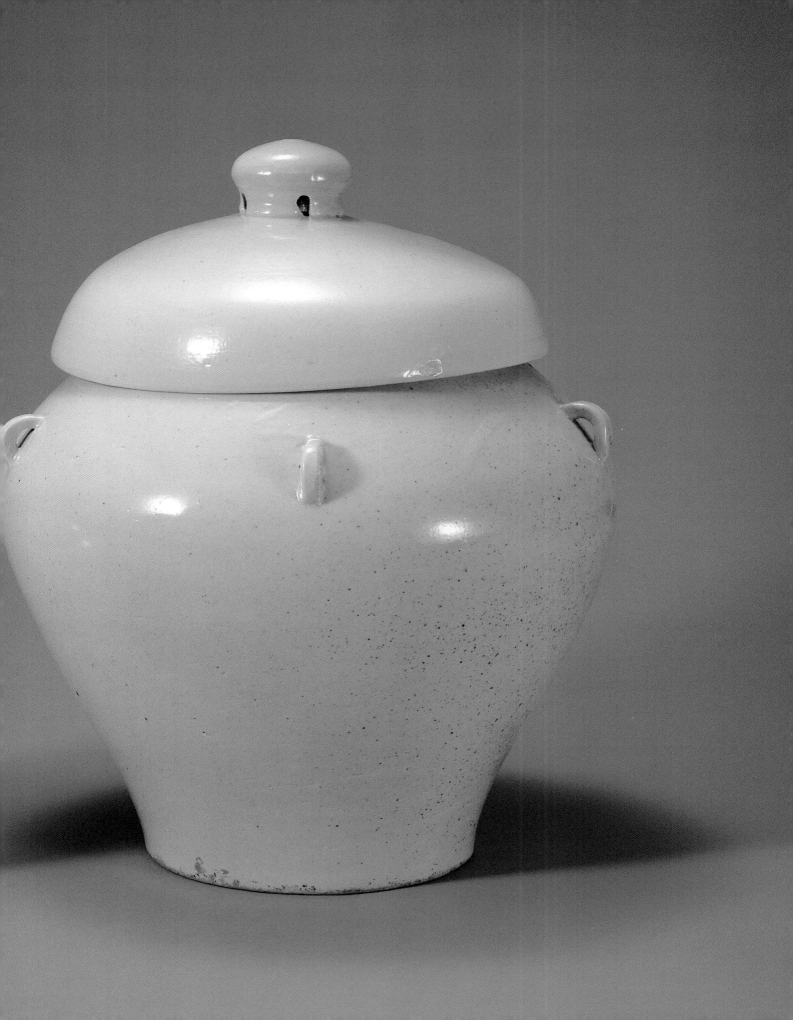

Plaque for placenta jars

Cat no. 31

1665-1670

Slate

34.9 (h) x 34.9 (w) x 5.2 (d) cm

National Museum of Korea, Seoul

Front of plaque *(above)*

Back of plaque *(right)*

乙巳年五月十八日辰時

誕生新生公主阿只氏胎

Ritual dish

Cat no. 32

Late 18th – 19th century

White porcelain with underglaze cobalt-blue *che*
(offering) inscription

6.3 (h) cm

National Museum of Korea, Seoul

This ritual dish is called *sijŏp* in Korean and was used during ancestor worship ceremonies. Upon addressing the ancestors, the celebrant would strike the centre of the bowl three times with a silver spoon and a pair of chopsticks, which were then laid to rest in the bowl. This ritual was carried out at the beginning of an ancestor worship ceremony, before making the first bow, to summon the spirit and begin the service.

After being formed on the wheel, this dish was trimmed to form a decagon. Such trimming is characteristic of the middle and late Chosŏn periods, from the mid 1600s to the early 1900s, and is especially common in ritual utensils. The walls are thin near the rim. Evidence of cutting is visible in the interior where the walls join the base. The interior of the dish is inscribed with the Chinese character *che* (or offering), which is contained within a circle. The pure-white clay is refined and the bluish cast glaze is even. The interior of the base has been deeply cut away, and the glaze was wiped from the base before the dish was fired on sand.

Chung Yang-mo

Reference: Chung Yang-mo, in Kim Hongman, ed., *Korean arts of the eighteenth century: splendour and simplicity*, Asia Society Galleries, New York, 1993, cat. no. 113, pp 189, 232.

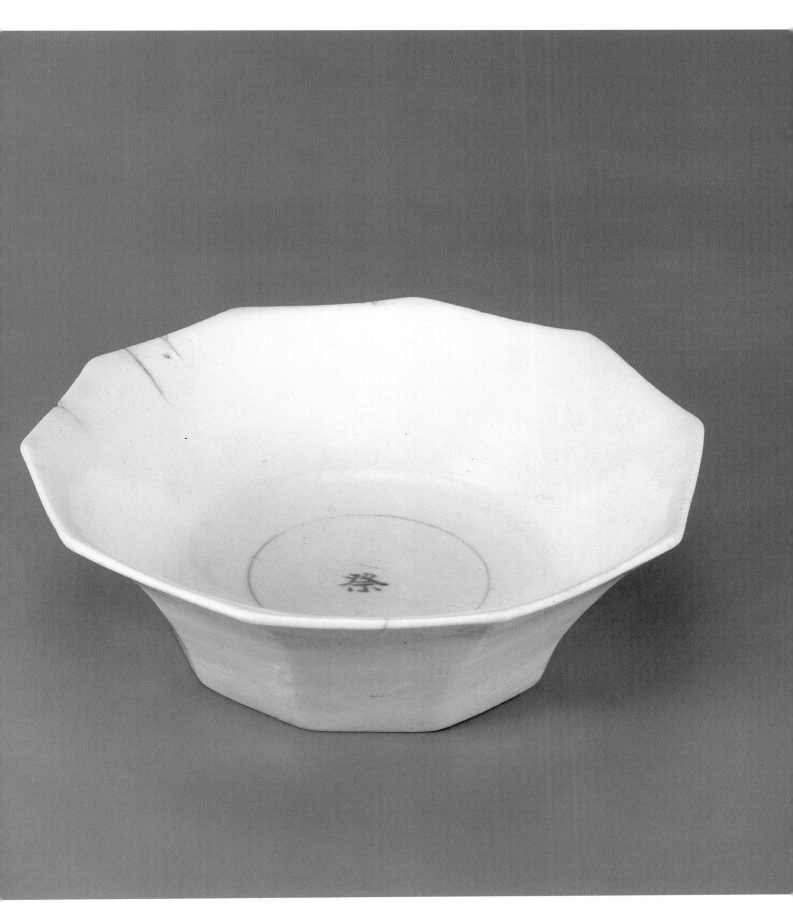

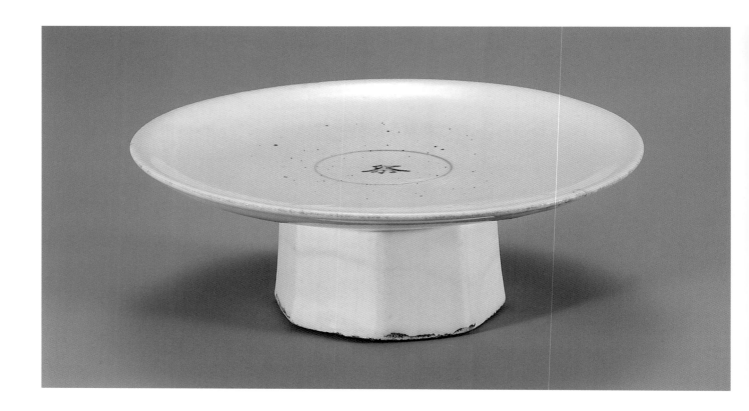

Ritual dish

Cat no. 33 *(above)*

Late 18th – 19th century

White porcelain with underglaze cobalt-blue che (offering) inscription

9.7 (h) cm

National Museum of Korea, Seoul

Ceramic ritual vessels for Confucian shrines and ancestor worship were usually simple in shape and made from pure white porcelain. This ritual dish is inscribed with the Chinese character *che* (meaning offering) within a circle. This dish is a typical shape comprising a round dish supported on a high octagonal base. The dish and base were made separately and then attached to each other. Round dishes were used for offerings of fruit and vegetables, and square dishes for food such as rice cakes, bean curd and pan-fried beef.

Brush washer

Cat no. 35 *(below right)*

18th century

White porcelain

6.6 (h) cm

Chŏng So-hyŏn collection, Seoul

This brush washer was used to wash brushes used for painting and calligraphy. The rectangular shape with a circular mouth is unusual. The simplicity of the form, including its compact size, the modesty of ornamentation and the harmony of the parts in relation to the whole, are typical elements of Korean style in the 1700s. The simplicity of the wash brusher with its softly rounded corners represents an aesthetic ideal of the Chosŏn period and highlights an appropriate relationship between form and function. The vessel is coated with a light blue cast glaze, which was wiped from the base before firing. It was made at the government kiln at Punwŏn at Kwangju in Kyŏnggi province.

Reference: Chung Yang-mo, in Kim Hongnam, ed., *Korean arts of the eighteenth century: splendour and simplicity*, Asia Society Galleries, New York, 1993, cat. no. 48, pp 141, 216.

Ritual vessel

Cat no. 34 *(left)*

Late 18th – 19th century

White porcelain

7.9 (h) cm

National Museum of Korea, Seoul

During the Chosŏn dynasty there were three forms of ancestor worship: people worshipped the ancestors of emperors, the ancestors of the current emperor and family ancestors. Many different types of ritual vessels were placed on offering tables and used in ancestor worship ceremonies

Ceramic wares began to be used in religious ceremonies during the Koryŏ period (935–1392). From the early Chosŏn period until the 1600s certain objects for ritual use, such as this vessel, were restricted to the royal family, government offices and schools. This late Chosŏn vessel used in ancestor worship ceremonies is a smaller, simpler version of a type used by the royal family. Its shape is called a *ko* and it was used for offerings of mixed rice. The clay is a delicate light tan colour, and the glaze is snow white. Glaze was wiped from the foot of the vessel before it was fired on sand at the government kiln at Kwangju in Kyŏnggi province.

Reference: Chung Yang-mo, in Kim Hongnam, ed., *Korean arts of the eighteenth century: splendour and simplicity*, Asia Society Galleries, New York, 1993, cat. no. 112, pp 188, 231–2.

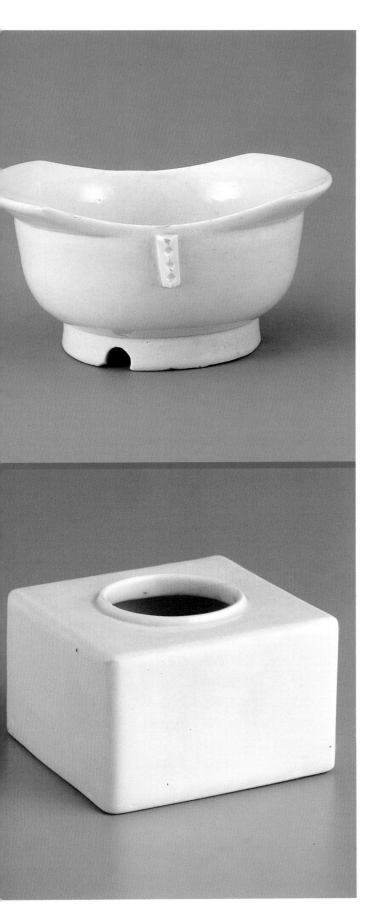

Ink container

Cat no. 36
Early 19th century
White porcelain with high-relief design of an immature dragon
4.7 (h) cm
National Museum of Korea, Seoul

The ink originally contained in this vessel was made by grinding an ink stick on an ink stone that was moistened with water applied from a water dropper. To create this vessel four curved side panels have been attached to a flat base. The rim of the container is ornamented with a hand-modelled immature dragon. Dragons were invested with powers of transformation. In spring they ascended to the sky, announcing the awakening of nature's energy and heralding spring rain. In winter they immersed themselves in water. A pale blue glaze has been thickly and evenly applied. The vessel was made at the government's Punwŏn kiln at Kwangju in Kyŏnggi province and fired on fireproof clay pellets after the glaze had been wiped from the base.

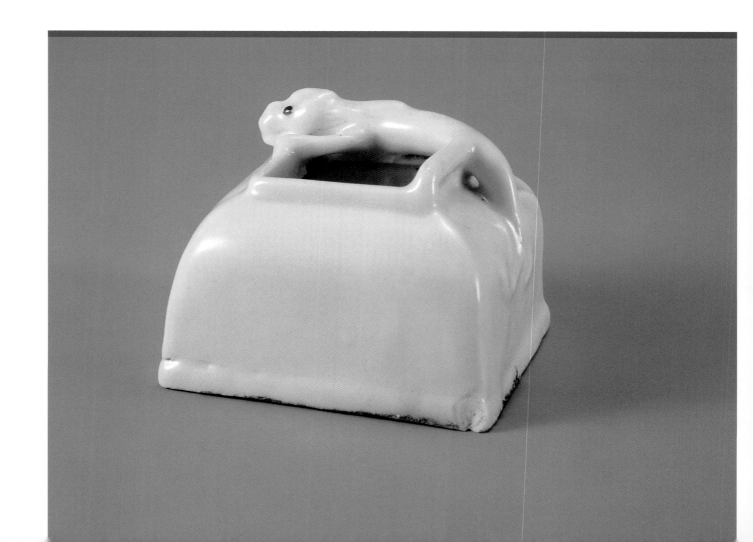

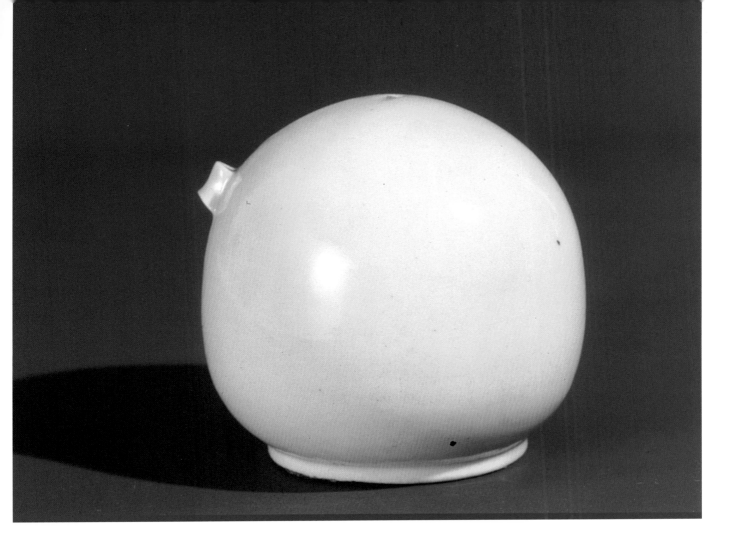

Water dropper

Cat no. 37

19th century

White porcelain

11.2 (h) cm

National Museum of Korea, Seoul

During the late Chosŏn dynasty a wide variety of vessels including water droppers, brush holders and brush rests, often in novel forms, were made by ceramicists for the use of scholars. Water droppers were used to moisten the ink stone when grinding ink for calligraphy or painting. This water dropper is described as being knee-shaped (*murŭp*) and is thought to resemble a woman's knee. The plump form, together with the white clay and snow-white glaze evoke the softness and sensuality of a female body. The vessel has a quiet presence and alludes to desirable feminine attributes such as purity, honesty and gentleness. The foot is wide and low and supports a generously proportioned body, which is necessary for storing water. The interior of the base has been deeply cut away, which indicates that the vessel was probably made at the Punwŏn kiln at Kwangju. It was fired on sand.

Reference: Chung Yang-mo, ed., *Han'guk ŭi mi 2: paekcha* [Korean beauty 2: white porcelain], Chungang Ilbo, Seoul, 1978, cat. no. 31, p 198.

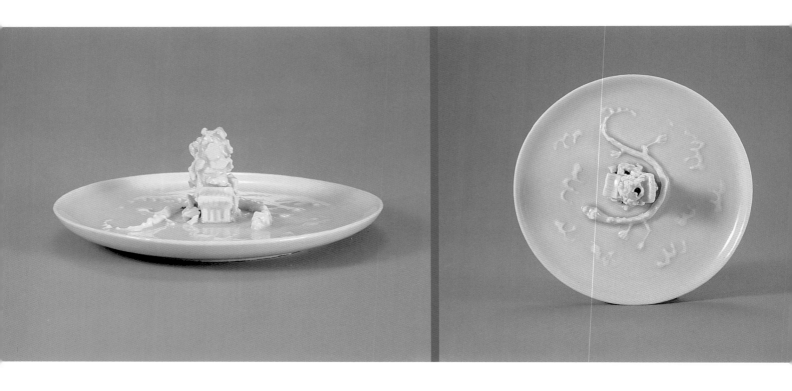

Incense holder

Cat no. 38

19th century

White porcelain with high relief and moulded decoration of a mountain, and dragon and clouds

4.1 (h) cm

National Museum of Korea, Seoul

Incense was burned for its aroma and was effective for removing bad odours. It was part of the furniture of a scholar's room. This incense burner takes the form of a mountain. Mountains cover some 70 per cent of the Korean peninsula and many of them were worshipped. Mountains were therefore a frequently used decorative motif. A house is perched near the peak of the mountain and there is another at the base. A dragon wraps itself around the mountain before ascending to heaven. In Korea the dragon was regarded as a divine animal, symbolic of the king, fertility and spring rain. The plate is ornamented with a moulded design of clouds. A pale blue glaze has been generously applied, creating an impression of the sky or heaven. A small hole was made in the top of the mountain to hold a stick of incense. The plate has a low foot. The base is unglazed and the interior has been cut away. There is evidence that fireproof clay pellets having been used in the firing.

Brush holder

Cat no. 39

19th century

White porcelain with carved low-relief design of tigers and pine tree painted in underglaze cobalt-blue

13.5 (h) cm

Kim Nak-joon collection, Seoul

This milk-white porcelain brush holder would have stored brushes used by a scholar-official for calligraphy and painting. It is coated with a bluish-white glaze and radiates grace. It is decorated with a relief design of a pine tree, clouds and a tiger with two cubs. The design was created by cutting away the negative areas. Each motif has been carefully modelled in low relief. Motifs such as the pine tree and the tigers' eyes have been painted in underglaze cobalt-blue, which brings the design to life and creates an impression of depth. In Korea tigers are regarded as sacred and are thought to repel evil and the pine tree is a symbol of longevity. This brush holder was made at the Punwŏn kiln at Kwangju.

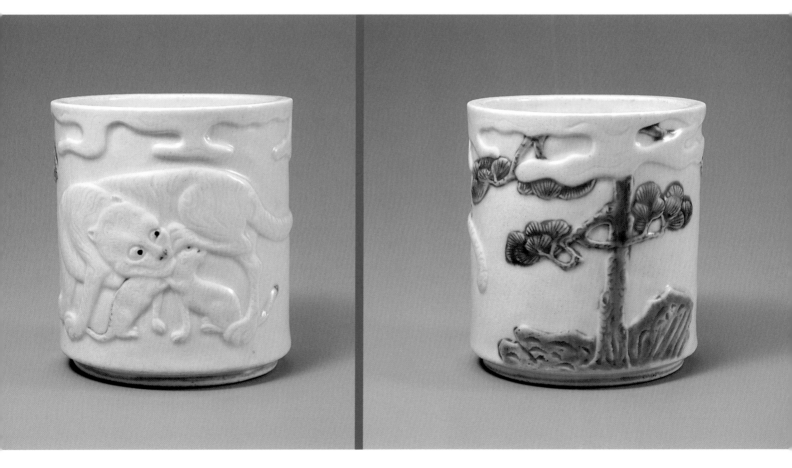

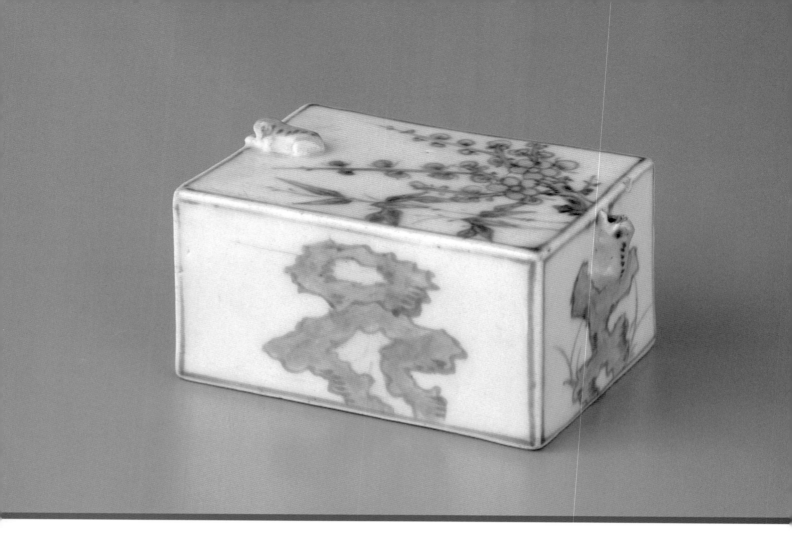

Water dropper

Cat no. 40

19th century

White porcelain with underglaze cobalt-blue design of bamboo, plum blossom and rocks

5.9 (h) cm

National Museum of Korea, Seoul

During the late Chosŏn dynasty a wide variety of vessels including water droppers, brush holders and brush rests, often in novel forms, were made by ceramicists for the use of scholars. Water droppers were used to moisten the ink stone when grinding ink for calligraphy or painting. The top of this rectangular water dropper is painted with a design of bamboo and plum blossom, and the four sides with ornamental rocks. The motifs, all symbolic of longevity and associated with the scholar, were first outlined with dark cobalt-blue and then painted with paler shades of blue to create an animated effect. A frog, also symbolic of longevity, ornaments the hole for pouring. A transparent light blue glaze has been applied to the base of the water dropper, which has been wiped away and then fired on sand. This water dropper was made at the government's Punwŏn kiln, which operated at Kwangju from 1752 to 1883.

Reference: Chung Yang-mo, ed., *Han'guk ŭi mi 2: paekcha* [Korean beauty 2: white porcelain], Chungang Ilbo, Seoul, 1978, cat. no. 109, p 207.

Octagonal water dropper

Cat no. 41

Mid 18th century

White porcelain with underglaze cobalt-blue design of bamboo and a poetic inscription

8.5 (h) cm

National Museum of Korea, Seoul

This large octagonal water dropper supported by eight feet is decorated with a poem in praise of the water dropper written in Chinese characters. 'Filling an empty water dropper/I bring it out whenever needed/Almost unnoticeable but so useful/This is the Way of the scholar.' The top of the water dropper is painted in underglaze cobalt-blue with a design of bamboo, which is symbolic of longevity and an honest and upright character. The water dropper was probably made at Kŭmsari, one of the official government kilns at Kwangju on the outskirts of Seoul. The official kiln operated there from 1726 until 1752. In 1752 the kiln moved from Kŭmsari to Punwŏn. Government kilns were generally moved every ten years to ensure a plentiful supply of wood, which was needed to fire the kiln. This water dropper was fired in a saggar at the front of the kiln, indicating that it was a work of very high quality.

Reference: Chung Yang-mo, ed., *Han'guk ŭi mi 2: paekcha* [Korean beauty 2: white porcelain], Chungang Ilbo, Seoul, 1978, cat. no. 107, p 207.

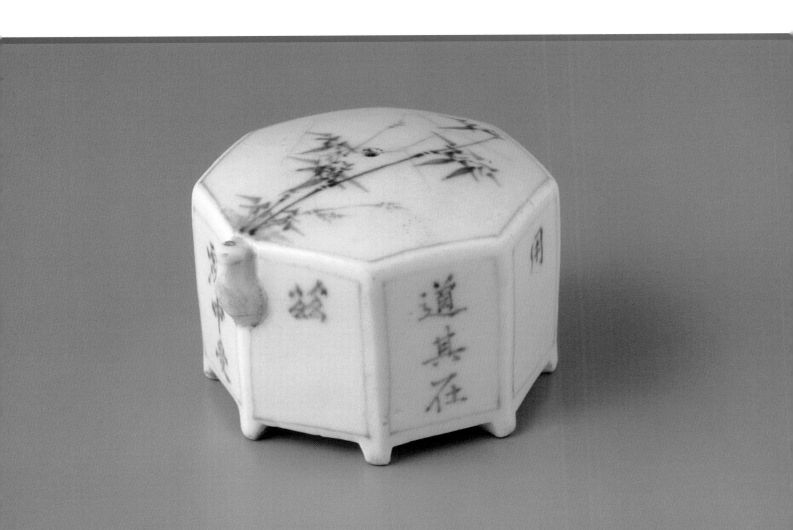

Octagonal bottle

Cat no. 42

Late 17th century

White porcelain with underglaze cobalt-blue design of
bamboo and chrysanthemum flowers

27.5 (h) cm

National Museum of Korea, Seoul

This faceted bottle is a fine example of mid Chosŏn white
porcelain with underglaze cobalt-blue decoration. It was
made at the official kiln at Kwangju in Kyŏnggi province
under the auspices of the *Saongwŏn*, the government
department that was responsible for court dining and
entertainment. It was created at a time when cobalt was in
short supply in Korea owing to difficulties of importing it from
China, which was ravaged by war. The painted design is
minimal in order to conserve the pigment and to create the
desired aesthetic effect. The bamboo and chrysanthemum
motifs, which are symbolic of an upright character and a
noble man respectively, have been carefully positioned to
create a balance between the solid colour of the pigment
and the void of the white-glazed ground. The decoration is
both restrained and elegant. The edges of the bottle have
been rounded and harmonise with the painted motifs that
derive from nature. The bottle has no foot and the rim is
everted which is characteristic of such facetted bottles. The
neck of the bottle has been repaired.

Reference: Chung Yang-mo, ed., *Han'guk ŭi mi 2: paekcha* [Korean beauty 2:
white porcelain], Chungang Ilbo, Seoul, 1978, cat. nos 63–4, p 202.

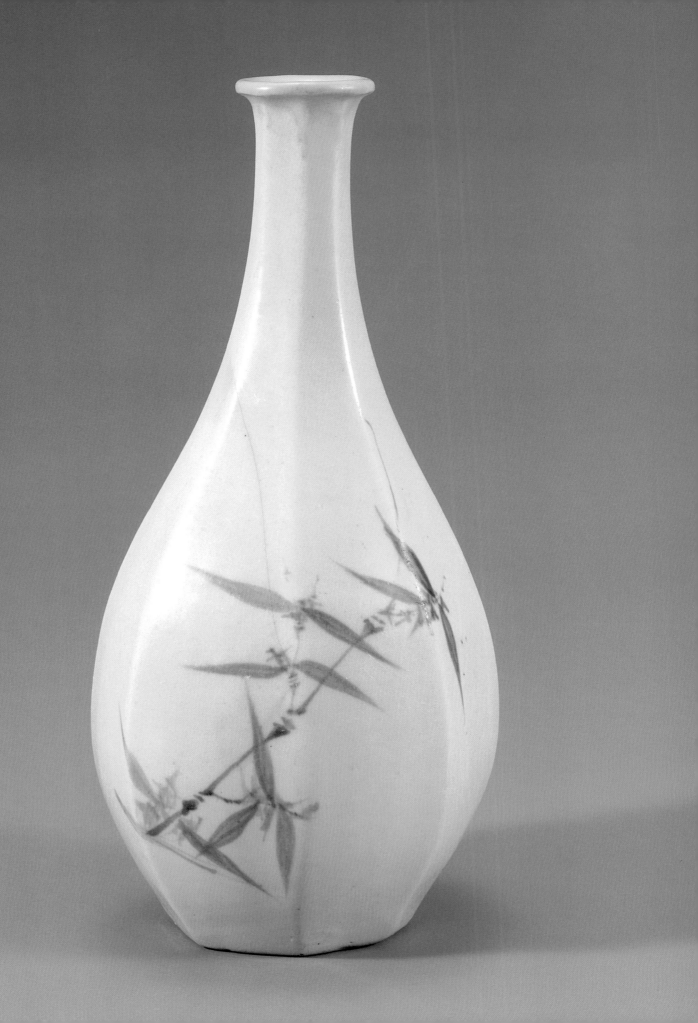

Rectangular bottle

Cat no. 43

18th century

White porcelain with underglaze cobalt-blue design of the Four noble plants

22.9 (h) cm

Ho-Am Art Museum, Yongin

The shape of this wine bottle is typical of Korean porcelain of the late 1700s. The four faces of the bottle are decorated with the Four noble plants—plum blossom, orchid, chrysanthemum and bamboo. The Four noble plants of East Asian culture symbolised human virtues and were popular decorative motifs on objects used by the upper class during the early Chosŏn dynasty. In most cases the four plants were represented individually, however, from the late Chosŏn dynasty they often appeared together on the one object, as on this bottle. A bluish-white glaze was applied to the white porcelain body. The interior of the base has been cut away and the glaze wiped away from it before the bottle was fired on sand.

Reference: Ho-Am Art Gallery [Museum], *Chosŏn hugi kukpoch'ŏn: widaehan munhwa yusanŭl ch'ajasŏ* [Treasures of the late Chosŏn dynasty 1700–1910: discovering great cultural assets], Samsung Foundation of Culture, Seoul, 1998, cat. nos 82-1, 82-2, pp 94, 217.

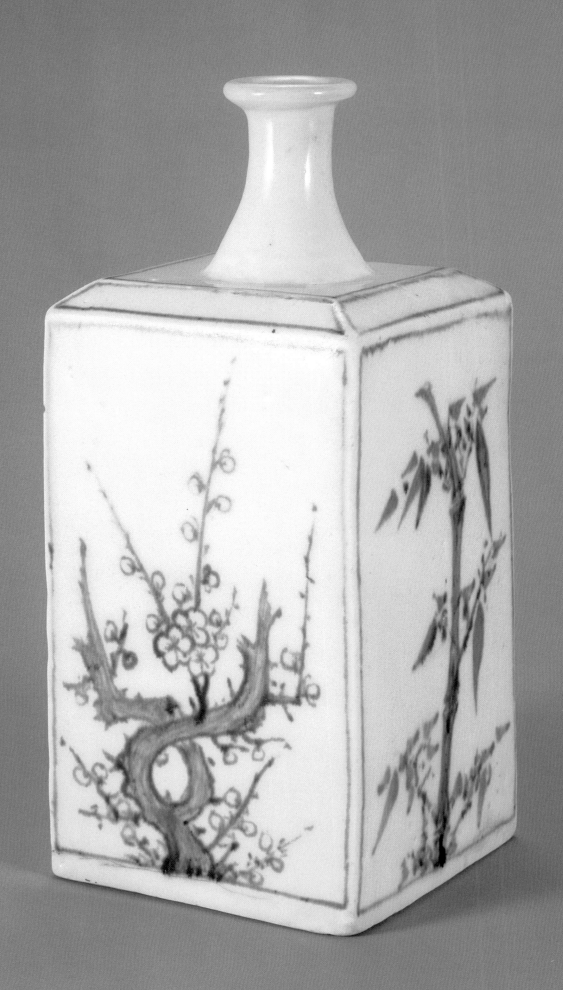

Vase

Cat no. 44

18th century

White porcelain with underglaze cobalt-blue landscape
design

32.5 (h) cm

Ho-Am Art Museum, Yongin

This object appears to have been made as a flower vase.
Only a small number of flower vases were produced during
the early Chosŏn dynasty and very few have survived. The
shape of the vase is described as *ttŏngmebyŏng*, meaning
literally a bottle that looks like a rice cake mallet. The vase
has been painted in cobalt-blue with a landscape design
from *Eight landscapes of the Xiao and Xiang rivers*. The Xiao
and Xiang rivers are tributaries of the Yangtze River in China
and were a popular subject for painting in China and Korea.
One of the scenes depicted on this vase is the autumn moon
reflected in Lake Dongting. On one side of the vase there is
a tower perched on a rocky clifftop and a flagpole, and on
the other side a punt on the river with distant mountain
peaks and a full moon hanging in the sky.

Landscape painting was popular on high-quality white
porcelain wares at the main government kilns in Kwangju in
Kyŏnggi province during the late 1700s. The high quality of
the painting and the composition indicates that the vase was
probably decorated by a prominent court artist. A pale blue
transparent glaze, which was popular in the 1700s, was
applied to the vase. The interior of the base was indented
and the vase was fired on sand. The rim has been partially
repaired.

References: Ho-Am Art Gallery [Museum], *Chosŏn hugi kukpoch'ŏn: widaehan
munhwa yusanŭl ch'ajasŏ* [Treasures of the late Chosŏn dynasty 1700–1910:
discovering great cultural assets], Samsung Foundation of Culture, Seoul, 1998,
cat. nos 84, 85, pp 96–7, 217–18

Ho-Am Art Museum, *Ho-Am misulkwan myŏngpumdorok: gomisul 1, tojagi*
[Masterpieces of the Ho-Am Art Museum: historical art 1, ceramics], Samsung
Foundation of Culture, Seoul, 1996, cat. no. 136, pp 145, 217.

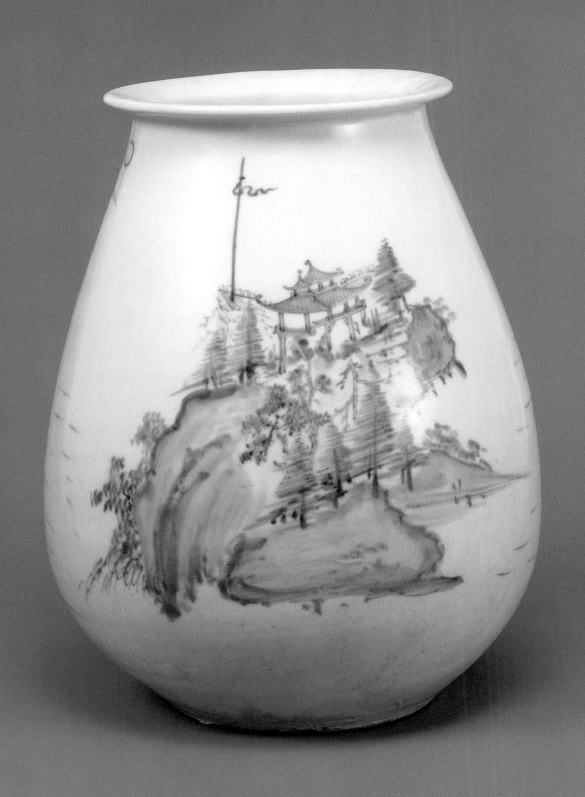

Jar

Cat no. 45

18th century

White porcelain with underglaze cobalt-blue design of
orchid, plum blossom and Chinese characters

39.8 (h) cm

National Museum of Korea, Seoul

This baluster-shaped jar has generous proportions including
an everted cylindrical neck and a full body that tapers to a
narrow base. It is given added character by the lack of
symmetry of form, firing cracks to the base and an uneven
glaze. The jar is decorated with a design of flowers and
Chinese characters. The words *su* (longevity), *pok* (happiness),
kang (peace) and *nyŏng* (health) are written in Chinese
characters in cobalt-blue and inscribed in circles. They are
interspersed with plum blossom and insect motifs. Below,
three orchid plants and a China pink emerge from a painted
base line, which may be read as the earth. The motifs are
painted in a fluent, calligraphic style in thin, dark cobalt
blue. A transparent pale blue glaze coats the jar and there is
some crazing. The interior of the foot has been cut away and
there is sand residue on the base from firing. The rim of the
vase has been repaired.

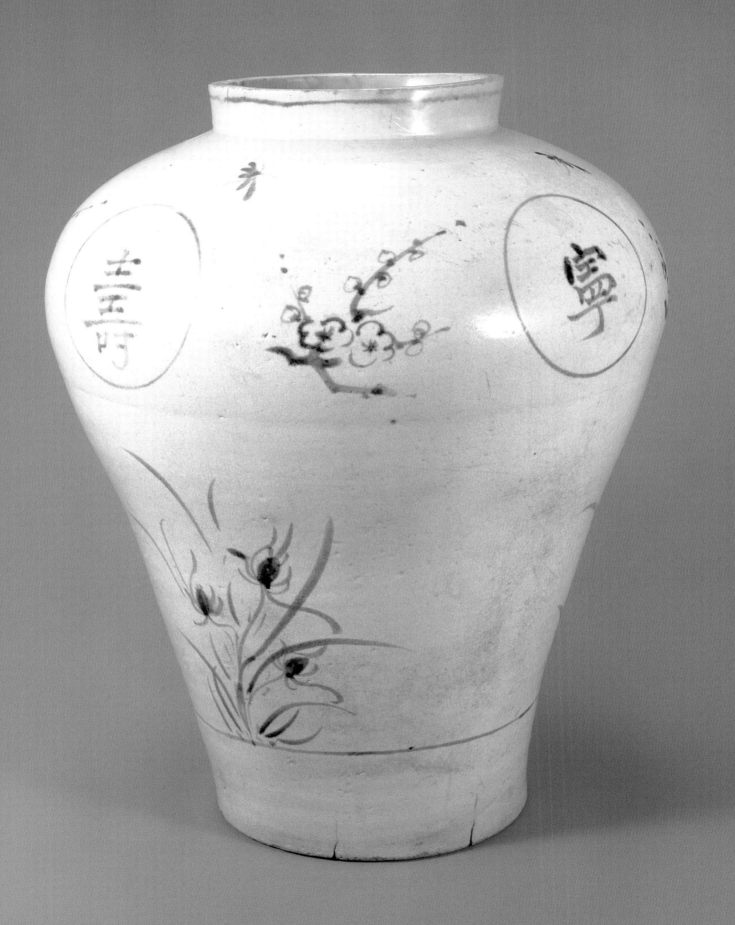

Jar

Cat no. 46

Early 19th century

White porcelain with underglaze cobalt-blue design of plum blossom and bamboo

37 (h) cm

Kim Nak-joon collection, Seoul

This jar has a high neck, full shoulder and tapers towards the base. It has been painted with a design of plum blossom and bamboo. The design has been carefully composed to follow the shape of the jar. The branches and leaves of the bamboo were executed using the *molgol* (or boneless) technique and the blossoms and buds were painted using the *kurŭk* technique in which the motif is first outlined and then filled in with colour. There is a sacred fungus border pattern at the base of the neck that serves to emphasise the painted field.

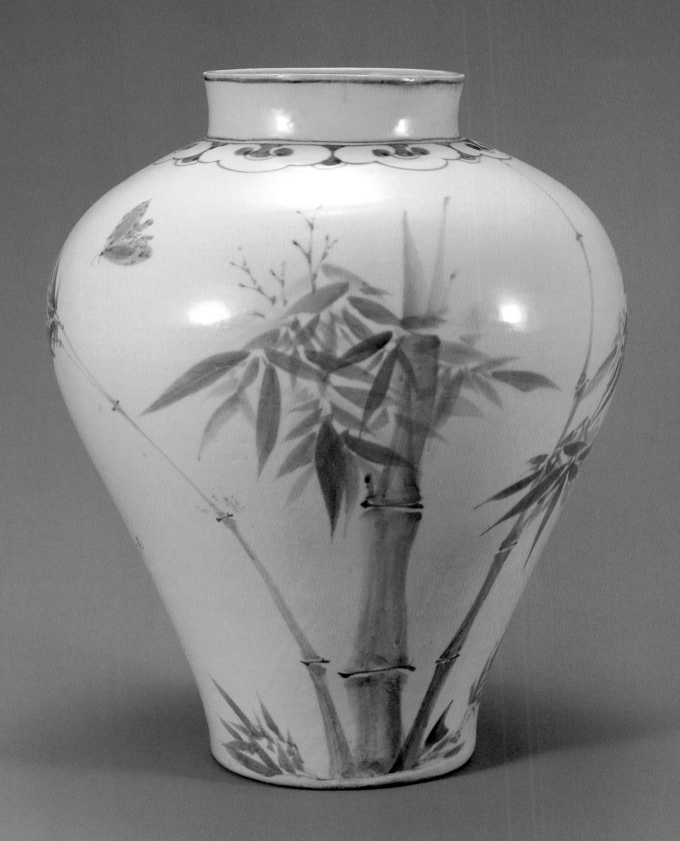

Bottle

Cat no. 47

Late 15th century

White porcelain with underglaze iron-brown rope design

31.4 (h) cm

National Museum of Korea, Seoul, Treasure no. 1060

This bottle, probably used for rice wine, has an elegant shape and is coated with a thick, even white glaze. It appears to be a high-quality porcelain from the Tomari kiln at Kwangju in Kyŏnggi province, which made high-quality ceramics for the royal family. There are two main colours of early Chosŏn white porcelain, pure white with a light blue tint and grey-white with a light blue tint. This bottle is a fine example of the latter type. The wide flaring rim, narrow neck and voluminous body are typical of bottles produced during the 1400s and 1500s.

The bottle is ornamented with a rope design, which loops around the neck and reaches down to the base in a naturalistic manner. The painted line has been executed in a series of halting brush strokes to allude to the texture and strength of the rope. The ceramic artist has created a visual pun, for the bottle would in fact have been carried with a length of rope. Another visual pun is the three-dimensional circle around the neck of the bottle, which echoes the two-dimensional circle formed by the curling end of the rope at the base of the bottle. The base has been incised with the Korean characters *ninahi*, the meaning of which is unknown.

Reference: Kim Yŏng-wŏn, *Chosŏn paekcha* [Chosŏn white porcelain], Taewŏnsa Publishing Co. Ltd, Seoul, 1991, p 77.

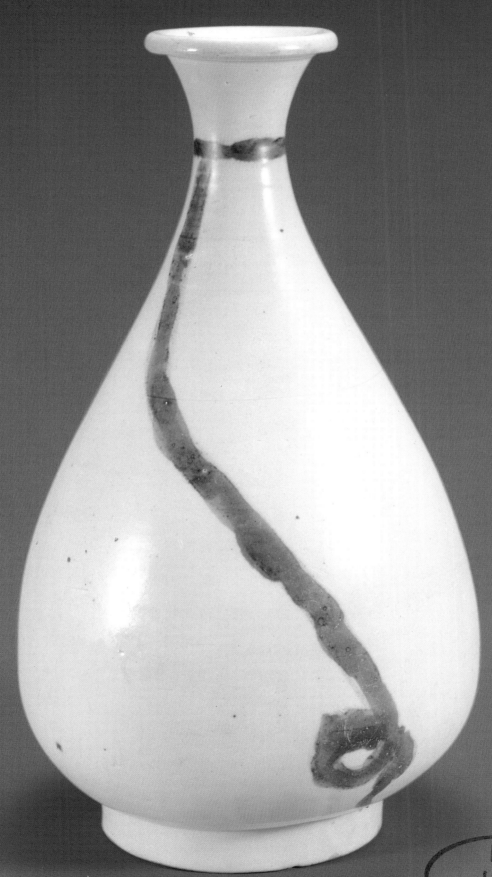

Jar

Cat no. 48

16th century

White porcelain with underglaze iron-brown design of
bamboo and plum blossom

41.3 (h) cm

National Museum of Korea, Seoul,

National Treasure no. 166

The shape of this fine jar, with its outward curving rim,
generous form and the painted decoration at the shoulder
and base, is similar to the white porcelain jars painted with
underglaze cobalt-blue produced in China during the reigns
of the Zhengde (1506–1521) and Jiajing (1522–1566)
emperors of the Ming dynasty (1368–1644). The high quality
of the painting indicates that the jar was probably painted by
an official artist from the government bureau of painting,
known as *Tohwasŏ*. Artists were invited to decorate numerous
porcelain vessels intended for court use. Ceramics used in
the court were the responsibilty of the *Saongwŏn*, a
government department that supervised their production.

Bamboo, symbolic of modesty and an upright character, and
plum blossom, symbolic of longevity, are two of the Four
noble plants of East Asian culture and were favourite
subjects for Korean scholar-artists during the Chosŏn
dynasty. They are also symbolic of husband (bamboo) and
wife (plum blossom). The artist has painted the bamboo
design with bold, sure strokes. Areas of thickly applied iron-
brown pigment have burned through the clear glaze and
have turned russet, which gives the painting a sense of life
and three-dimensionality. The bamboo has been painted in
the 'boneless' style (*molgol*) and the plum blossom in the
'outline' (*kurŭk*) method. The jar has a fine, unblemished
surface. It was made from grey-white clay and was fired with
a thin jade-green glaze. The kiln where this jar was made is
not recorded but the high quality of the potted form, the
painting and the glaze suggest that it was made at the
central government kiln at Kwangju in Kyŏnggi province,
near Seoul. The rim of the jar has been repaired.

Reference: Chung Yang-mo, ed., *Han'guk ŭi mi 2: paekcha* [Korean beauty 2:
white porcelain], Chungang Ilbo, Seoul, 1978, cat. no. 121, p 209.

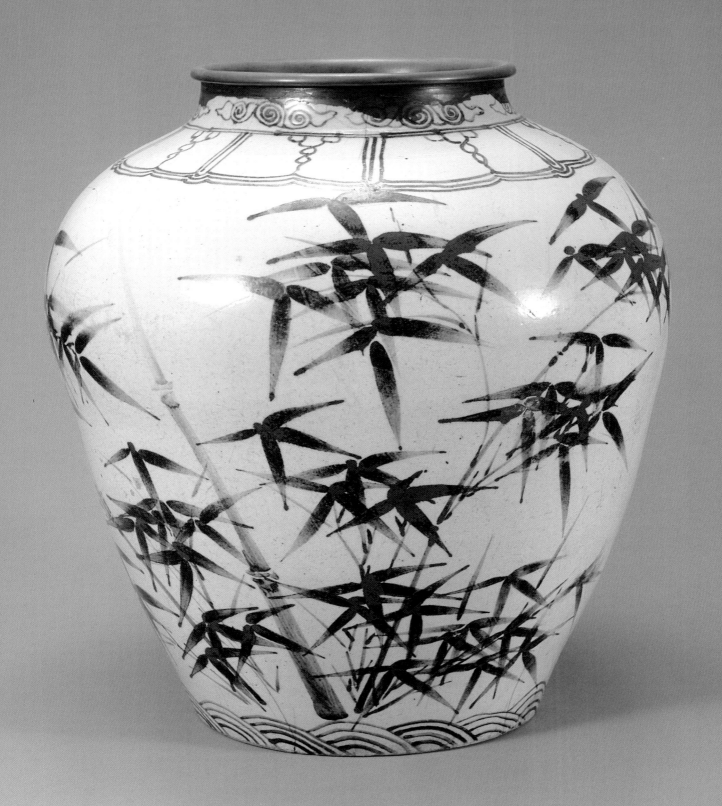

Jar

Cat no. 49

17th century

White porcelain with underglaze iron-brown design of
dragon and clouds

34.8 (h) cm

National Museum of Korea, Seoul

This jar is a typical 1600s shape with its everted rim, full,
rounded body and foot that shows no trace of sand from
firing. Korean jars painted with iron-brown dragon designs
may be traced back to the 1400s. The depiction of the
dragon displaying horns and whiskers on this jar is
characteristic of representations from the 1400s. In Korea
the dragon was a divine animal and an auspicious motif. The
dragon was regarded as symbolic of the king, fertility and the
spring rain. The strong, almost wild, dragon wraps around
the jar and is depicted with calligraphic brush strokes. There
is a chaotic overlaying of dragon and cloud motifs. The
dragon's head and the tail are clearly articulated against the
white-glazed porcelain body and meet on one face of the jar.
On the opposite face the body is densely painted and
appears tangled in its own contortions as it cavorts in
heaven. Areas of the thickly applied pigment have burned
through the clear glaze and have turned a rust colour, which
serves to heighten the dragon's sense of life and movement.
There is a wonderful balance between solid and void, action
and inaction, dark and light played out on the surface of this
fine jar.

Reference: Chung Yang-mo, ed., *Han'guk ŭi mi 2: paekcha* [Korean beauty 2:
white porcelain], Chungang Ilbo, Seoul, 1978, cat. no. 124, p 209.

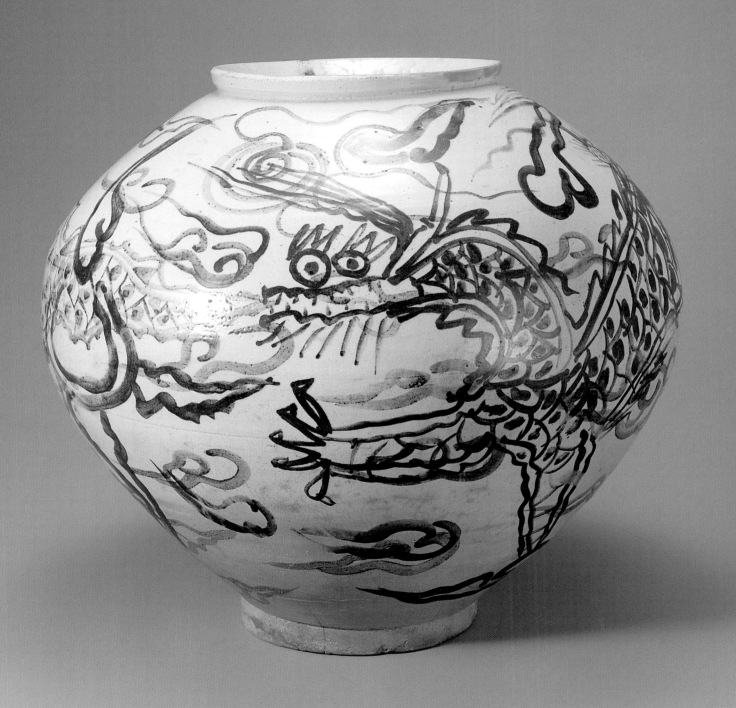

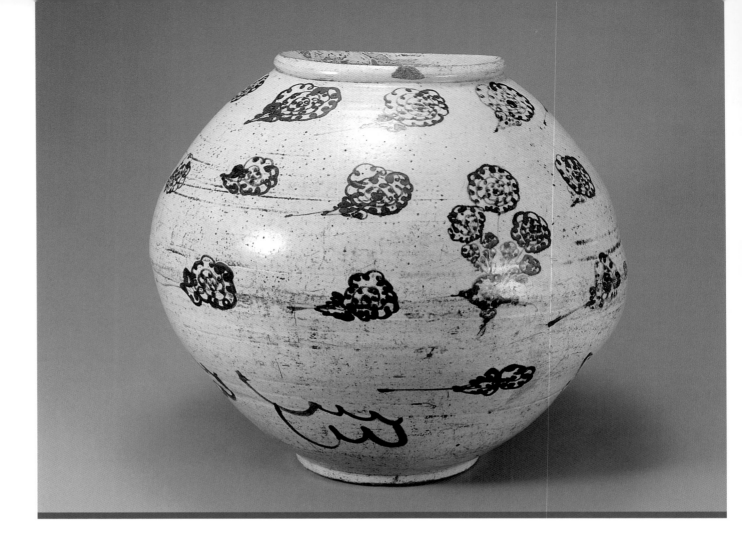

Jar

Cat no. 50

17th century

White porcelain with underglaze iron-brown design of clouds

33.5 (h) cm

National Museum of Korea, Seoul

This *talhangari* or moon-jar was made in two halves, top and bottom, which were joined together at the middle. This was because the porcelain clay used was relatively soft and did not always hold its form. Iron oxide was readily available in Korea but it was only in the 1500s that it began to be used for decorating porcelain. By the 1600s, when this jar was made, it had become a popular form of ornamentation, and the designs are generally painted in a very free manner. This moon-jar is painted with a design of clouds, which appear to be moving across the generous form of the jar, aided by a gentle breeze. The artist has expressed a natural phenomenon with simplicity and a sense of humour that is quite endearing.

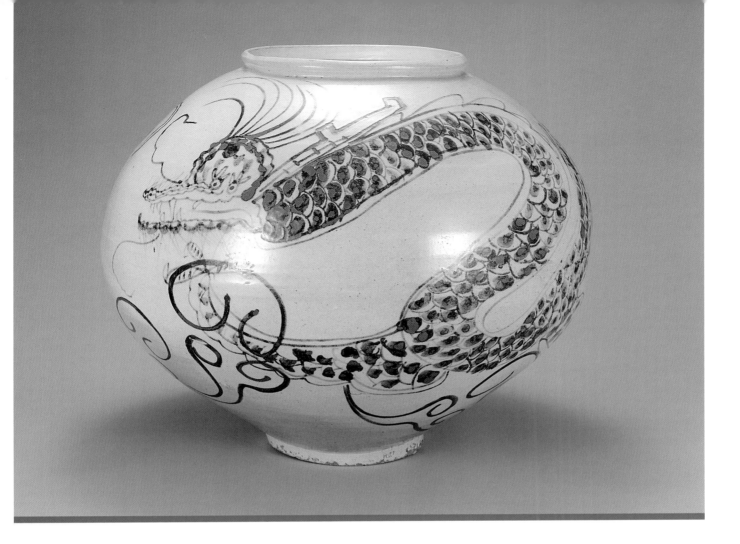

Jar

Cat no. 51

17th–18th century

White porcelain with underglaze iron-brown design of
a dragon

31.5 (h)cm

Kim Nak-joon collection, Seoul

This moon-jar (*talhangari*) is decorated with a humorous-looking dragon and abstract clouds painted with bold brushstrokes in underglaze iron-brown. The depiction of the dragon with its relaxed posture, witty abstract face, simplified scales, open mouth and protruding eyes are typical of the period. Iron oxide was readily available in Korea but it was only in the 1500s that it began to be used for decorating porcelain. By the 1600s it had become a popular form of ornamentation for white porcelain wares, and the designs are generally painted in a very free manner. The jar was made in two halves, top and bottom, which were joined together at the middle.

Jar

Cat no. 52

Early 18th century

White porcelain with underglaze iron-brown dragon and cloud design

59.4 (h) cm

National Museum of Korea, Seoul

During the Chosŏn period, porcelain jars decorated with dragons were made for the royal family. This is the largest extant iron-brown decorated dragon jar from the first half of the 1700s. This dragon jar has a very full, asymmetrical body that tapers to a narrow base. The slightly flaring neck is decorated with an elegant scroll design. The central field has been painted with a large dragon that wraps itself around the body of the jar. The dragon is a divine animal symbolic of the king, fertility and spring rain. It is often depicted, as on this jar, chasing a flaming pearl among heavenly clouds. The clouds are auspicious and have been painted in the shape of a Buddhist swastika, symbolic of the Buddha, which was a characteristic design of the early 1700s. While the painting is spirited, it is not always clearly articulated and the colour of the iron-brown is rather turgid owing to difficulties encountered during the firing process. The jar has been coated with a translucent, pure-white glaze with a tinge of yellow. There is crazing on the lower half of the body. The interior of the base has been cut away and there are traces of sand on the base. The jar was made at Kwangju in Kyŏnggi province.

Reference: Chung Yang-mo, in Kim Hongnam, ed., *Korean arts of the eighteenth century: splendour and simplicity*, Asia Society Galleries, New York, 1993, cat. no. 24, pp 126, 211.

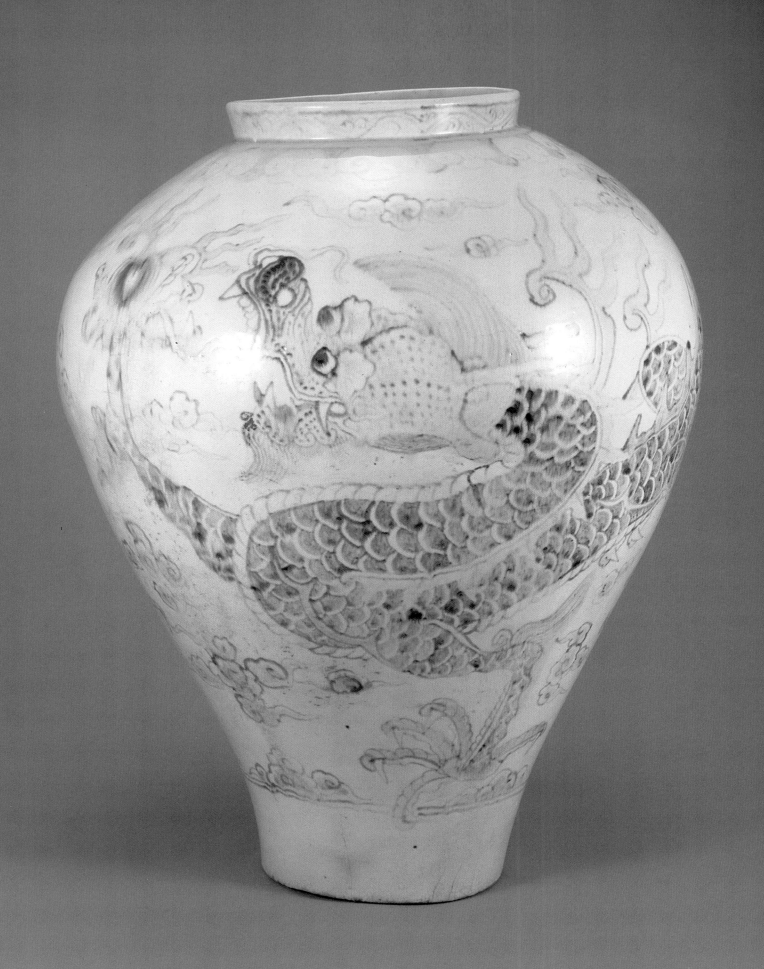

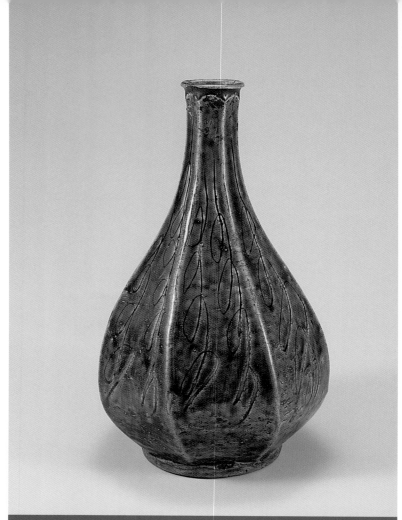

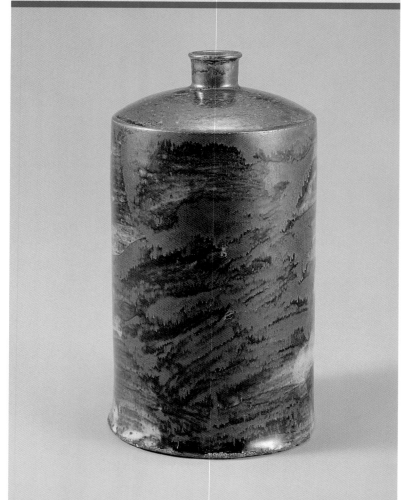

Bottle

Cat no. 53
18th–19th century
White porcelain with iron-brown (*sŏkkanju*) glaze and incised design
27.6 (h) cm
National Museum of Korea, Seoul

This seven-sided bottle was used for wine. The bottle was thrown on a wheel and was then carved to make a faceted shape. The white porcelain body has been incised with a simple spiral pattern, painted with a deep red-orange pigment (*sŏkkanju*) of iron sulfate, made from rusted and burnt iron, and then fired. Many bottles or jars decorated with this particular pigment are faceted. The coloured pigment was often used to decorate ceramics or to paint colourful designs known as *tanch'ong* underneath the eaves of traditional buildings.

Bottle

Cat no. 54
19th century
White porcelain with underglaze iron-brown design
21.6 (h) cm
Ho-Am Art Museum, Yongin

This contemporary-looking bottle was used for rice wine. The cylindrical form flares slightly at the base, which gives the bottle a feeling of solidity and stability. The white porcelain bottle has been painted with a large brush heavily laden with iron-brown pigment to create an all-over design. The colour gradation from black to brown to russet, where the iron-brown has burnt through the clear glaze, is of particular interest. The base is undecorated. A transparent glaze was applied to the vessel including the base, which was wiped off before being fired on sand.

Reference: Ho-Am Art Gallery [Museum], *Chosŏn hugi kukpoch'ŏn: widaehan munhwa yusanŭl ch'ajasŏ* [Treasures of the late Chosŏn dynasty 1700–1910: discovering great cultural assets], Samsung Foundation of Culture, Seoul, 1998, cat. no. 93, p 219.

Epitaph tablets

Cat no. 55
1578
White porcelain with underglaze iron-brown inscription
Three pieces, each approx 23.8 (h) cm
National Museum of Korea, Seoul

Epitaph tablets were buried with the deceased and recorded information about the individual including their birthday, place of origin, family members and achievements. This custom seems to have developed out of the desire to record information about the deceased for posterity. It was considered much safer to bury this information rather than have it inscribed on a tombstone above ground, which could more easily be destroyed by natural disasters such as floods or landslides.

During the Koryŏ dynasty (935–1392) epitaph tablets were made of stone. In the Chosŏn dynasty they were also made of ceramic, paper and wood. Ceramic epitaph tablets were the most popular because they were relatively easy to make from clay. The shape could be rectangular, circular or take the form of a bottle, column, bowl, dish or cylinder.

According to the inscription on this set of three tablets written in underglaze iron-brown, the deceased Chŏng Tae-nyŏn (1507–1578), was a civil official during the mid Chosŏn dynasty. His family came from Tongnae, which is close to Pusan in the south-east of Korea, and his pen-name was Sa-am. He passed the civil exam known as samasi, one of the minor state examinations that a scholar needed to pass in order to sit for the next examination, in 1531. In 1532 he won first place in the state examination known as pyŏlsi, which was a special examination held during a festival event such as the accession of a new king or crown prince or the marriage of a king. Chŏng was appointed an official of the sixth rank, known as Yebinsijubu, and provided hospitality to the royal family, ministers and foreign ambassadors. He reached the position of a third-rank official known as chikchehak responsible for advising the king on literature and the arts, and writing diplomatic communiques to foreign countries. When there was an order from the king to recommend a chief among six ministers (Yukcho) everyone recommended Chŏng Tae-nyŏn for the job because of his high level of virtue and knowledge. His achievements were praised by his colleague Kim Kwi-yŏng (1520–1593) who wrote the inscription.

有明朝鮮國榮祿大夫議政府左贊成
兼判義禁府事知經筵事五衛都摠
府都摠管鄭公墓誌銘并序
資憲大夫吏曹判書兼知
弘文館大提學藝文館大提學知
春秋館事成均館事同知春秋館事
貴榮撰
東萊鄭氏吾東巨姓在麗朝有諱穆官
至左僕射九世孫諱雖仕本朝至贊
成諡良節良節生諱善卿贈判書到
書生諱程　贈參判生諱元耘

耶翁生不喜紛華靑氈之外無一松蝦
得酒輒酗量酾釅日以自娛公驚宗
廟署令今李仁弘之女今李寧大君補之
四代孫也夫人先公逝生五男三女男
日徠復開城都事日善復日馬司馬義
盤庫奉事日仁復丙子司馬洪州縣監
日純復定山縣監復登丁卯武科
安城郡敦寧府奉事家惟新義衛梁思
行次適敦寧府奉事次適造紙
署別坐金覺侍女長一女令金堅
之妾保復駿幼聟洪問女生一男二女

不事手名　居家致孝　藍織克勤
蜚英四朝　蔚爾風雲　人武泥之
天迴申之　壽爲富公　壽近八旬
考屬登庸　寀不怨遺　在公哭慟
吾民可憶　維廣治南　瓷亭之原
鑴辭納竁　用鬖萬諼
萬曆六年十二月　日

Water dropper

Cat no. 56

16th century

White porcelain with underglaze iron-brown design of
bamboo

8 (h) cm

Kim Nak-joon collection, Seoul

Bamboo does not change colour with the seasons and
therefore it is noted for its loyalty. It is strong yet supple,
despite being hollow inside. Because of these attributes it is
symbolic of the character of a man of honour, known as
kunja. The peach is symbolic of longevity. It therefore follows
that a Chosŏn scholar who hoped to live a long time and be
a man of honour would use a water dropper made in the shape
of a peach and decorated with a bamboo design. The water
dropper has been coated with a greyish-white glaze. The
glaze harmonises with the delicate colouring of the bamboo
leaves and alludes to the refined character of the owner.

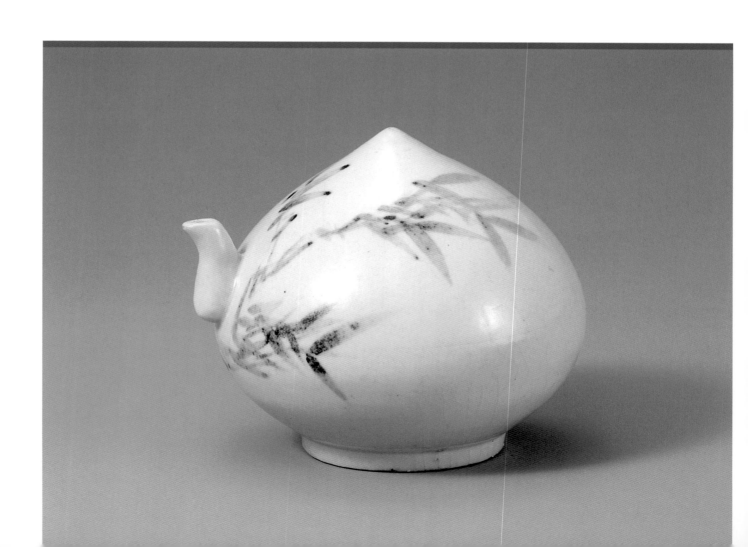

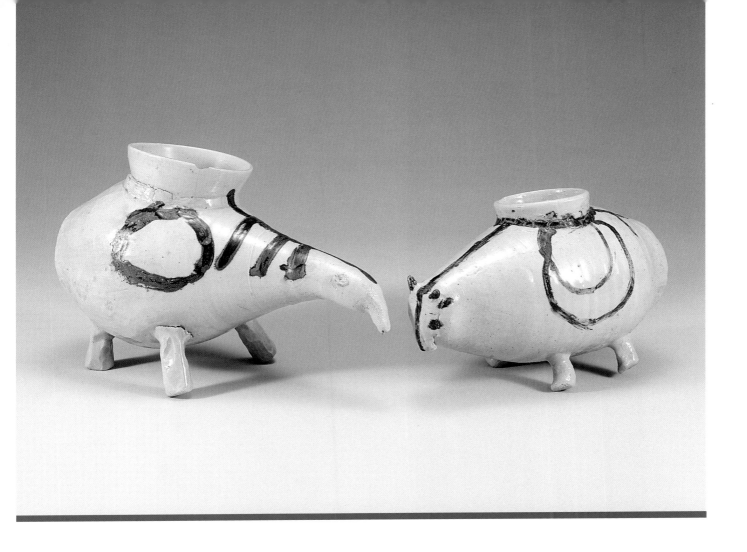

Elephant-shaped ritual vessel

Cat no. 57

17th century

White porcelain with underglaze iron-brown design

18.8 (h) cm

National Museum of Korea, Seoul

These ritual vessels have been made in the shape of an ox and an elephant. They were used during ancestor worship ceremonies, particularly in the spring and summer. The elephant-shaped vessel was used to contain unstrained rice wine or *chŏnghwasu*, which was water drawn from a well at daybreak. The ox-shaped vessel was used for clear rice wine or water drawn from a well at daybreak. Ritual vessels for this purpose were usually made of copper. Ceramic ritual vessels tend to be much simpler in form and decoration.

Ox-shaped ritual vessel

Cat no. 57

17th century

White porcelain with underglaze iron-brown design

23.6 (h) cm

National Museum of Korea, Seoul

Bottle

Cat no. 58

Late 18th – 19th century

White porcelain with underglaze copper-red duck design

27 (h) cm

Kim Nak-joon collection, Seoul

This bottle would have been used by an upper-class person for rice wine or water. It has a long neck and a full body. The sides of the neck are faceted yet the bottle retains a rounded appearance. Both sides of the bottle are painted with a copper-oxide design of lotus flowers and ducks on a pond. The copper-red colour is rich with beautiful modulation of dark and light tones. Copper-red, cobalt-blue and iron-brown were widely used on white porcelain during the late Chosŏn period. The spare design contrasts strongly with the plain white-glazed body of the bottle.

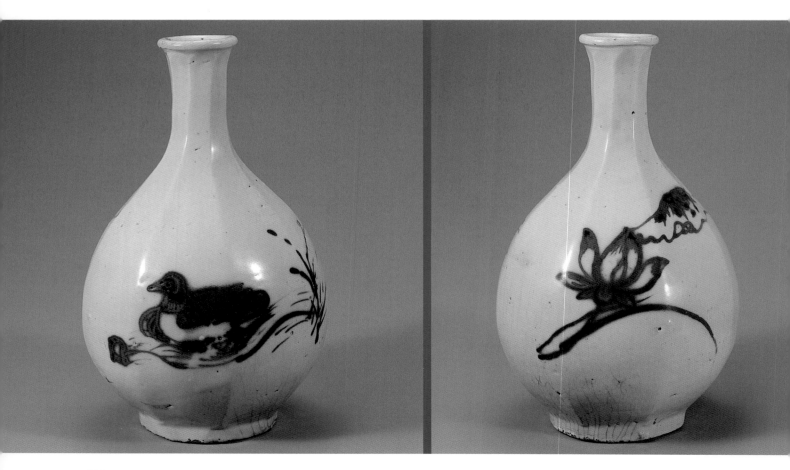

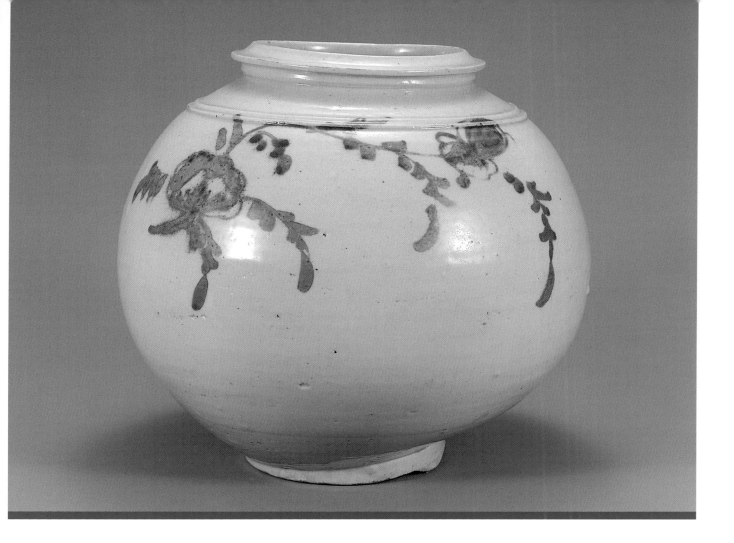

Jar

Cat no. 59

19th century

White porcelain with underglaze copper-red pomegranate design

23.6cm (h)

National Museum of Korea, Seoul

This bluish-white glazed jar has been painted with a design of pomegranates in underglaze copper-red. Pomegranates are symbolic of fertility, happiness and the desire to have many sons. During the Koryŏ dynasty (935–1392) celadon wares were painted with copper oxide, however red pigments was used sparingly. The use of copper oxide increased and became popular during the late Chosŏn dynasty, particularly in the 1700s and 1800s. This may be in part due to the influence of imported Chinese white porcelains that were decorated with a variety of colours. The copper-red decoration on this jar is uneven due to the difficulty of controlling the temperature of the kiln. The foot is broken.

Jar

Cat no. 60 *(above)*

18th century

White porcelain with underglaze iron-brown and cobalt-blue design of monkey, grapevine and characters

34.5 (h) cm

National Museum of Korea, Seoul

This snow-white porcelain jar has been painted with a grapevine design in iron-brown oxide. If you look carefully into the vine you can see a monkey holding some grapes in one hand and reaching out with the other to reach another bunch of grapes. Judging by the frown on its face it is cautious not to be caught by onlookers. The grapes and an inscription have been painted in cobalt-blue, which creates a subtle colour contrast.

According to Korean folklore monkeys are crafty animals that should be avoided, yet they are also regarded as wise. Grapes and grapevines, which often appear as decoration on Koryŏ celadons, symbolise fertility and give expression to the desire for many sons. Around the shoulder of the jar there are four characters, written in an archaic script known as seal script (*kŏ kŭm chu in*), which may be translated as 'load a cart with gold, load a boat with people'. The inscription carries a wish for affluence and success. In Korea, which was a predominantly agricultural society, labourers were regarded as a rich economic resource.

Jar

Cat no. 61 *(below)*

19th century

White porcelain with underglaze cobalt-blue and copper-red design of symbols of longevity

37.3 (h) cm

National Museum of Korea, Seoul

This jar is a fine example of white porcelain with cobalt-blue and copper-red decoration. The vibrant, clear colours indicate careful control during the firing process. A relatively large number of ceramics decorated with cobalt-blue and copper-red were produced during the 1700s and 1800s as a result of the influence of imported polychrome ceramics from China. This tall baluster-shaped jar with a high cylindrical neck and a recessed foot is typical of late Chosŏn style. It is decorated with a painted design of ten longevity motifs: crane; deer; pine tree; tortoise; *pulloch'o*, a herb thought to bring eternal youth; bamboo; rock; water; cloud; and sun. The vessel was made at the government's Punwŏn kiln at Kwangju in Kyŏnggi province. It was coated with an impure blue-white glaze and fired on sand.

Reference: Chung Yang-mo, ed., *Han'guk ŭi mi 2: paekcha* [Korean beauty 2: white porcelain], Chungang Ilbo, Seoul, 1978, cat. no. 146, p 211..

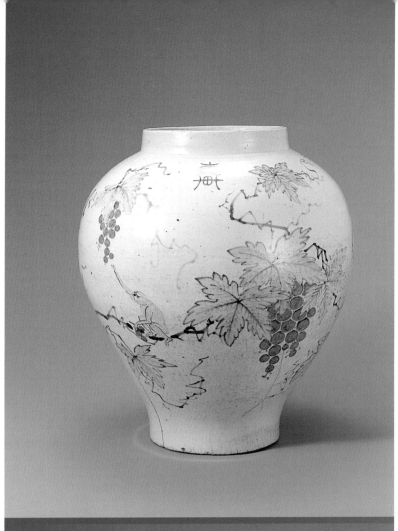

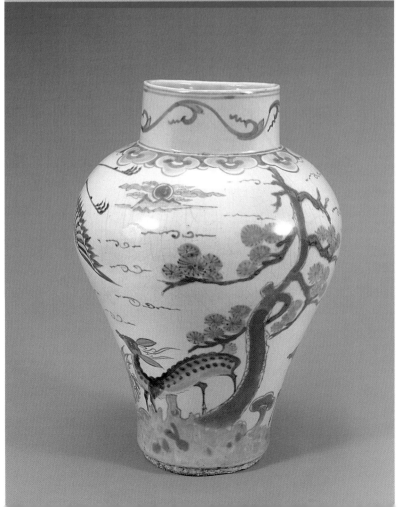

Bowl

Cat no. 62

19th century

White porcelain with underglaze copper-red and cobalt-blue decoration

7.4 (h) cm

Kim Nak-joon collection, Seoul

This vessel was probably made to hold flowers and was created in the shape of a fully opened lotus flower. The lotus petals have been incised on the interior and exterior of the vessel to give a naturalistic appearance and then painted with copper-red. The foot and the interior of the bowl have been painted with underglaze cobalt-blue. The interior has also been spattered with underglaze iron oxide. The melding of different colours gives the impression of lotus pollen and imbues the vessel with a contemporary feeling. The lotus is a symbol of purity, as the flower rises from muddied waters unsullied.

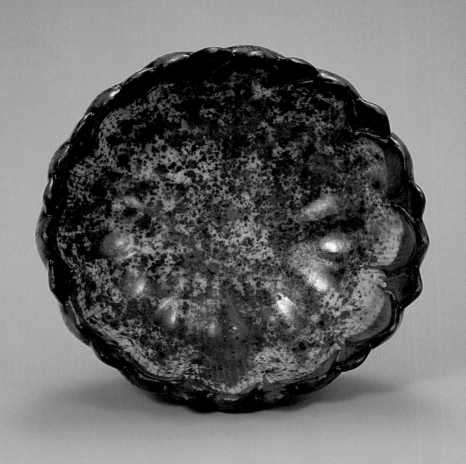

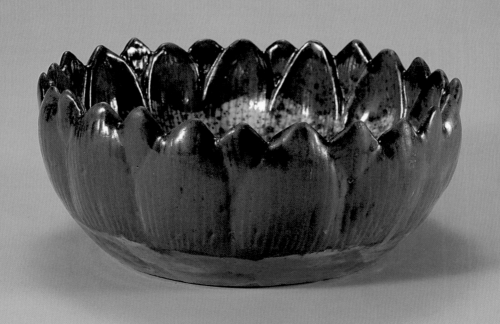

Kim Hong-do (1745–1806)

Cat no. 63
Kwan ūm and full moon
Late 18th century
Hanging scroll; ink and colour on silk
98.2 (h) x 48.5 (w) cm
National Museum of Korea, Seoul

This painting originally formed part of an eightfold screen decorated with paintings of figures derived from Chinese history. It is inscribed: 'Standing in respect before the moon. Tanwǒn.' Tanwǒn is Kim Hong-do's artist-name, meaning the garden of birch trees. Unlike the other panels of the screen, this painting depicts the Buddhist deity Kwan ūm (Guan Yin), the goddess of mercy, and a child attendant. Kwan ūm was originally the male Buddhist deity Avalokiteshvara (He who listens to prayers). Kwan ūm is worshipped by women praying for sons, wealth and protection. Buddhism was the dominant religion during the Koryǒ dynasty (935–1392) but was supplanted by Neo-Confucianism, which was the guiding ideology of the Chosǒn dynasty. Buddhism, however, continued to exert a popular influence within Korea.

Kim Hong-do was the son of a low-level military officer and is one of the best known and highly regarded artists of the Chosǒn dynasty. He was active as a court artist during the reign of King Chǒngjo (1776–1800) and is renowned for his portraits of the king and for landscape paintings executed for the court. Kim is best known as a painter of genre scenes but is also highly regarded as a painter of figures, landscape, birds and flowers. His teacher Kang Se-hwang described him as a 'new brush in the world'. Kim Hong-do was also a talented calligrapher and poet.

This painting has a traditional vertical composition. The brush strokes that articulate the figures are fine and highly animated as are those for the sea and the cliff. A subtle colour sense, achieved through the artist's mastery of the tonal variation possible with black ink, imbues the painting with an appropriately calm and serene mood.

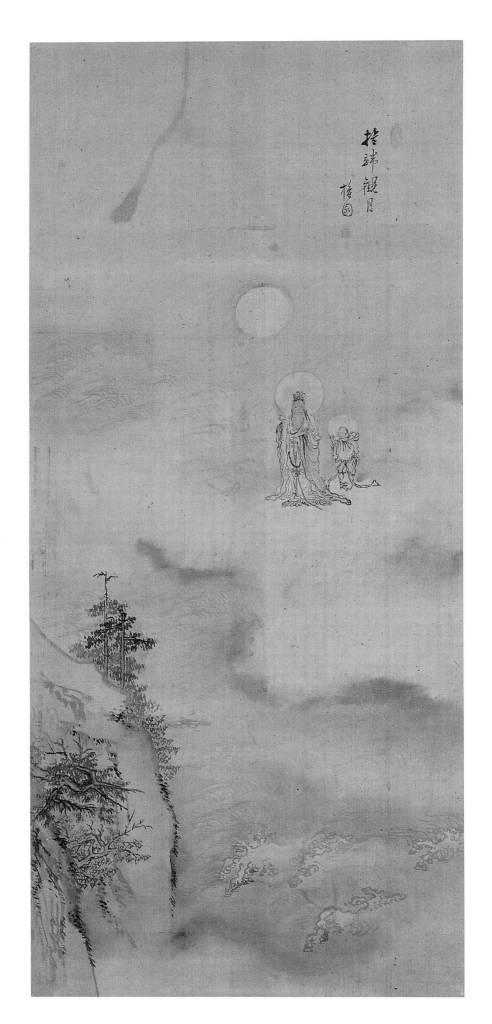

Kim Tŭk-shin (1754–1822)

Cat no. 64

Pair of genre paintings

1815

Hanging scroll; ink and light colours on silk

95.2 (h) x 35.6 (w) cm each

Ho-Am Art Museum, Yongin

Kim Duk-shin, whose artist-name was *Kŭngjae*, was an official court painter who worked at government bureau of painting, known as *Tohwasŏ*, during the late Chosŏn dynasty. He came from a family of famous artists including Kim Ûng-hwan (1742–1789), his uncle, who was senior to Kim Hong-do (1745–1806) (see cat. no. 48) and Kim Sŏk-shin (1758–?), his younger brother. Kim Tŭk-shin is well known as a genre painter.

These two panels originally formed part of an eightfold screen depicting life during the four seasons. They were painted when the artist was 61 years of age. One painting shows a scene of a bustling dock and ferry crossing, and the other a group of noblemen in a mountain valley in the spring, attended by female entertainers known as *kisaeng*. The noblemen are drinking wine, enjoying poems and listening to a man playing a Korean zither or *kŏmun'go*. Below them are two women carrying washing and a child. Stylistically Kim Tŭk-shin was influenced by Kim Hong-do, however Kim Tŭk-shin's paintings are marked by a greater attention to detail.

Reference: Ho-Am Art Museum, ed., *Masterpieces of the Ho-Am Art Museum: antique art, vol. 2, painting and calligraphy*, Samsung Foundation of Culture, Seoul, 1996, cat. no. 47, pp 67, 221.

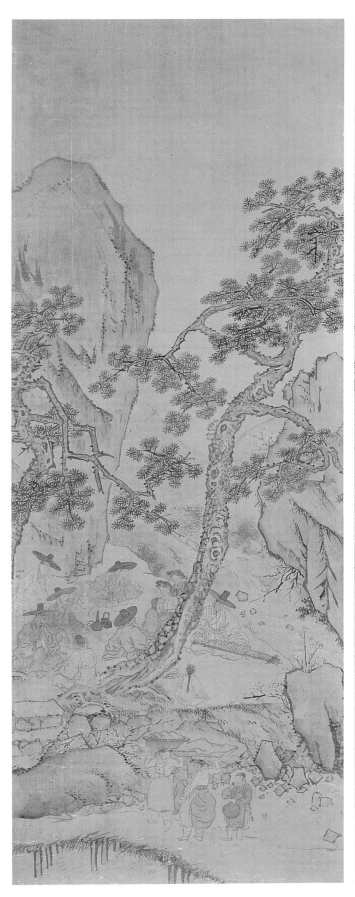
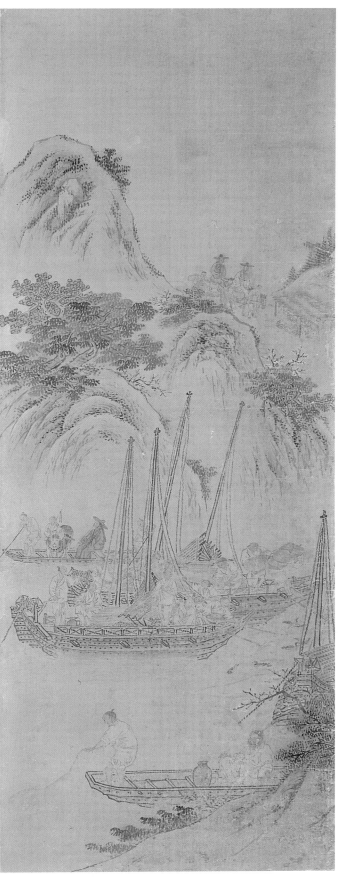

Yi In-mun (1745–1821)

Cat no. 65

Landscape

18th century

Hanging scroll; ink and colour on paper

110 (h) x 41.8 (w) cm

National Museum of Korea, Seoul

Yi In-mun was an important court artist active during the reigns of King Chŏngjo (1777–1800) and King Sunjo (1801–1834) of the Chosŏn dynasty. He was renowned for landscape painting in particular. Yi In-mun was well versed in the styles of various schools of Chinese painting and made an important contribution to the later phase of the development of *chin'gyŏng* or 'true-view' landscape painting.

This hanging scroll is one of four extant paintings by Yi In-mun of scholar-recluses who have chosen to do away with officialdom, and live in the country and enjoy nature. It is thought that they may have originally comprised part of an eight-panel screen. A companion painting bears an inscription that relates to this painting: 'Returning to my room, my wife and children have served me with barley and rice and a bracken dish which brings me great pleasure.' The scholar-recluse is seated in the male quarters of the house, known as *sarangbang*, enjoying his meal. His wife and child are in the hut beyond, which was the women's quarters, known as *anbang*. Near the gate there is an incense burner and a bottle for ritual use in ancestor worship. There is an ornamental rock in the garden, which was appreciated for its natural and rough beauty, and many large trees. The traditional vertical composition, in which motifs are placed on top of one another to indicate distance, fills the painting field. The large mountain rises majestically and imbues the painting with the power and energy of the natural world.

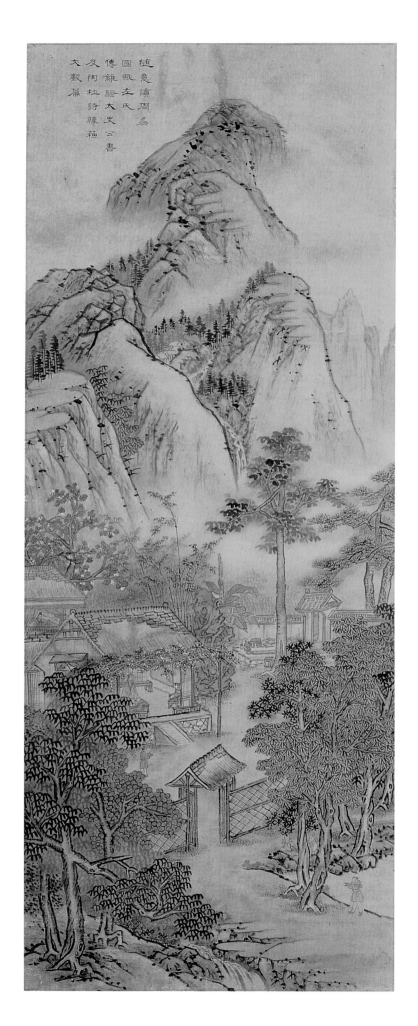

随意讀周易
國熙左氏
傳雜覽太史公書
及陶杜詩韓蘇
文數扁

Chŏng Sŏn (1676–1759)

Cat no. 66
Mount Kŭmkang
Mid 18th century
Fan leaf mounted as a hanging scroll; ink and colour
on paper
22.7 (h) x 61 (w) cm
National Museum of Korea, Seoul

The subject for this fan painting by Chŏng Sŏn is Chŏngyang temple in Mount Kŭmgang (a renowned mountain in Kangwŏn province in present-day south-eastern North Korea). It is said that King T'aejo (reigned 1392–1398), the first king of the Chosŏn dynasty, established this temple after worshipping the Tammugal Boddhisattva The inscription 'Kyŏmno' (meaning humble old man), a sobriquet used by Chŏng Sŏn, indicates that this is a work from his later years.

Chŏng Sŏn was born into an upper-class family that had fallen on hard times. For a number of generations many of the male family members had failed to achieve official rank.

Because of Chŏng Sŏn's great skill as a painter and his distinctive painting style, he achieved official rank and became a highly respected artist in the royal bureau of painting at the court in Seoul.

Chin'gyŏng or true-view landscape paintings developed during the Chosŏn dynasty. They marked a radical departure from the idealised Chinese-inspired landscape paintings of previous dynasties and highlighted the desire by Chosŏn artists to depict the world around them, including the Korean natural environment and scenes from daily life. Chŏng Sŏn is regarded as the leading exponent of this new trend in landscape painting. He first visited Mount Kŭmgang in 1711.

This painting, inscribed Chŏngyang sa (Chŏngyang temple), is signed Kyŏmno with one artist seal, Wŏnbaek, which was the name Chŏng Sŏn was given on assuming adulthood .

Reference: Yi Sŏng-mi, 'Artistic tradition and the depiction of reality: true-view landscape painting of the Chosŏn dynasty', in Chung Yang-mo et al., The Arts of Korea, coordinating ed., Judith Smith, Metropolitan Museum of Art, New York, 1998, pp 343–54.

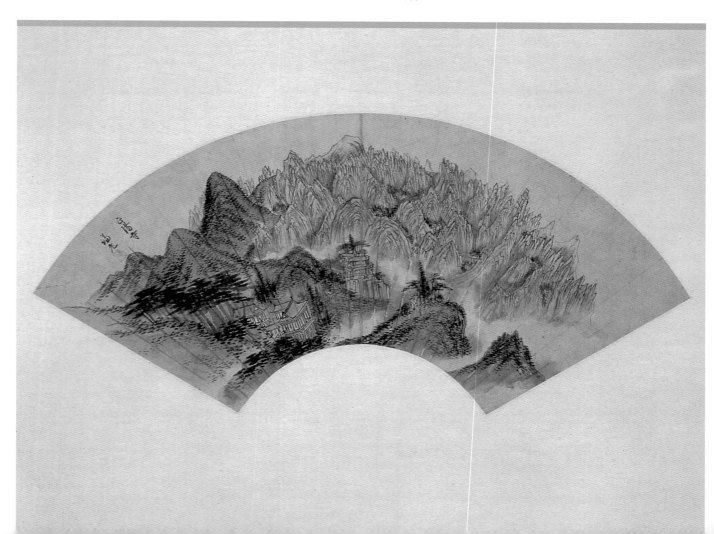

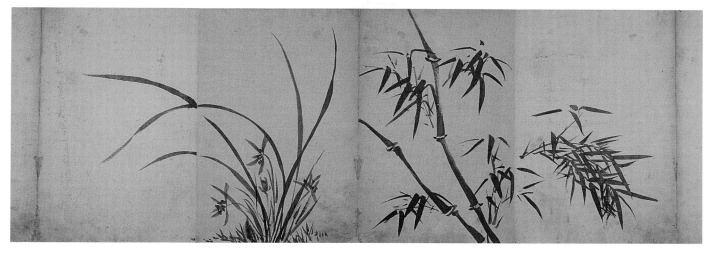

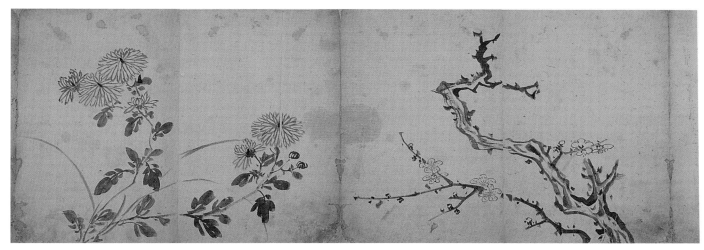

Kang Se-hwang (1713–1791)

Cat no. 67

Painting of the Four noble plants and calligraphy

18th century

Handscroll; ink on paper

37 (h) x 2848 (w) cm

National Museum of Korea, Seoul

Kang Se-hwang was a leading scholar, painter and art critic active during the 1700s. He was well known as a painter of landscapes and, during his later years, of the Four noble plants, which symbolised human virtues to which scholars aspired. This work was originally mounted as a flat painting and was later changed to a handscroll format. The handscroll, which is read from right to left, begins with a poem followed by a calligraphic inscription by Kang Se-hwang and paintings of the Four noble plants: bamboo, orchid, plum blossom and chrysanthemum.

The brush strokes are energetic and deliberate, and there is great variation in the colour of the ink and the thickness of the brush strokes, which adds to a sense of dynamism.

The inscription at the end of the handscroll reads: 'Cho Ch'anggang always wrote ch'osŏ [cursive or grass script] and painted orchids or bamboo trees at the end of the painting. People who pass these paintings around and admire them treat them as treasures, but I am afraid that my painting which is modelled on Ch'anggang's painting is not very good. [Signed] P'yoam [the artist's pen-name].' There is one seal inscribed Kwang (meaning light).

Cho Ch'anggang is the artist-name of Cho Sok (1596–1668), a painter who was active during the reign of King Injo (1621–1649). He devoted his life to learning the Confucian classics, literature, calligraphy and painting.

Reference: Yi Sŏng-mi, 'Artistic tradition and the depiction of reality: true-view landscape painting of the Chosŏn dynasty', in Chung Yang-mo et al., The arts of Korea, coordinating ed., Judith Smith, Metropolitan Museum of Art, New York, 1998, pp 354–6.

Cho Hŭi-ryong (1789–1866)

Cat no. 68

Bamboo

19th century

Hanging scroll; ink on paper

127 (h) x 44.8 (w) cm

National Museum of Korea, Seoul

This painting originally formed part of an eightfold screen, the panels of which all contain bamboo paintings. Different coloured papers such as red, yellow and blue would have been used for each panel. The bamboo has been painted with great skill, energy and a sense of naturalism, the bamboo in the foreground being painted in dark ink and that in the background in pale ink. Bamboo is one of the Four noble plants in East Asian culture and was symbolic of an honest and upright character. It was a popular subject for scholar-official artists during the Chosŏn dynasty.

Cho Hŭi-ryong was born into a middle-class family in Seoul and was active during the late Chosŏn period. He is renowned for his paintings of plum blossoms and orchids in particular. He was instructed by King Hŏnjong (1834–1849) to paint Mount Kŭmgang. In 1844 he wrote a book *Hosanwesa* (or *A history of outsiders by Hosan*), which recorded the life of middle-class people who were distinguished at painting, calligraphy, herbal medicine and fortune telling. *Hosan* was Cho Hŭi-ryong's pen-name. He was exiled in 1851 for political reasons.

The three-line inscription on this painting reads: 'I looked at paintings by Yi Sik-chae [the Chinese Yuan dynasty (1279–1368) scholar-artist Li Yan (1245–1320)] and Chin Paek-yŏ and they were wonderful. But recently Zheng Xie's [(1693–1765), Chinese Qing dynasty (1644–1911) scholar-artist noted for his bamboo painting] brush strokes have declined and are not as beautiful as they were. In making this painting I have taken a lesson from these artists, however I have not achieved high refinement as there is too much ink. Written in the eastern room of *Sojae* [the artist's house].'

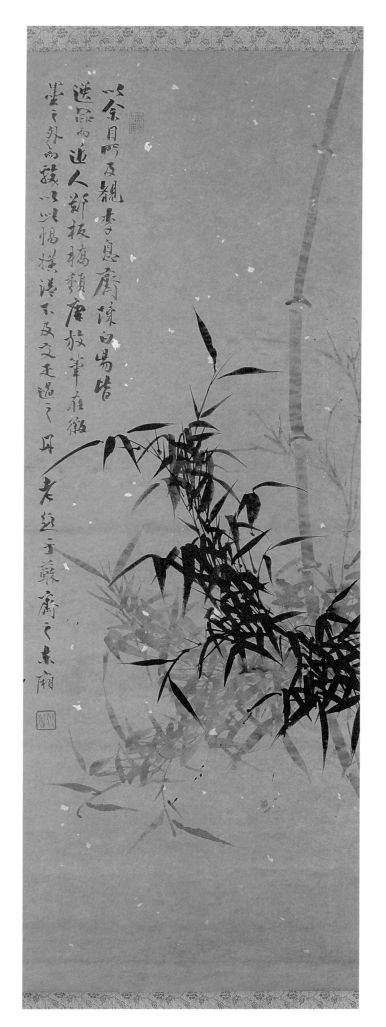

以余目所及觀李息齋陳白陽皆
逸品而道人斷板橋頗有放筆徐熙
墨之外而殺以以幅橫濤不及文正過之耳
老趣于蘇齋之東廂

131

Pyŏn Sang-byŏk (1730–?)

Cat no. 69

Cats and sparrows

18th century

Hanging scroll; ink and colour on silk

93.8 (h) x 43 (w) cm

National Museum of Korea, Seoul

Pyŏn Sang-byŏk was a member of the bureau of painting (*Tohwasŏ*) and was appointed to paint royal portraits in 1763 and 1773. As a reward for his fine portraits of the king, he was granted the position of *hyŏn'gam* or county magistrate. Aside from being a portraitist, he was particularly skilled in drawing cats and merited the nickname *Pyŏn Koyangi*, which means Pyŏn Cat. This work, which the artist signed with his sobriquet, *Hwajae*, is a prime example of the type of painting that brought him unrivalled fame.

The Korean pronounciation of the characters for cat (*myo*) and sparrow (*chak*) resemble *mo*, meaning an aged person in their 80s or 90s, and *chak*, meaning the long-lived magpie. Thus cats and sparrows represented the bliss of longevity. Such subjects not only reflected popular taste, they also signified the increasing wealth and life span of members of the non-elite classes. This painting gives life to such a subject through its simple but tension-filled composition. The aged, twisting form of the tree is painted roughly in ink. In contrast, the chirping sparrows, perched on the small branches, and the expression and movement of the two cats, exchanging looks with each other, are treated with remarkably fine, delicate brush strokes that exemplify the artist's superior skill. Sharp observation and accurate realism show the dexterity of the artists of the time. Furthermore, the newly emerging energy of the period is represented in the vivacity of the cats.

Hong Sun pyo
Professor of Art History, Ewha Women's University, Seoul

Reference: Hong Sun pyo, in Kim Hongnam, ed., *Korean arts of the eighteenth century: splendour and simplicity*, Asia Society Galleries, New York, 1993, cat. no. 85, pp 167, 225.

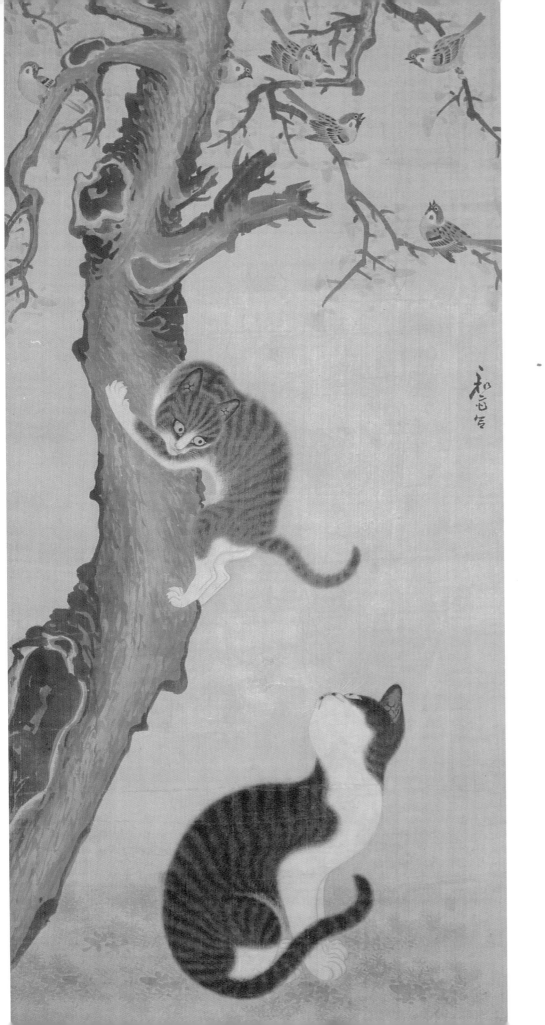

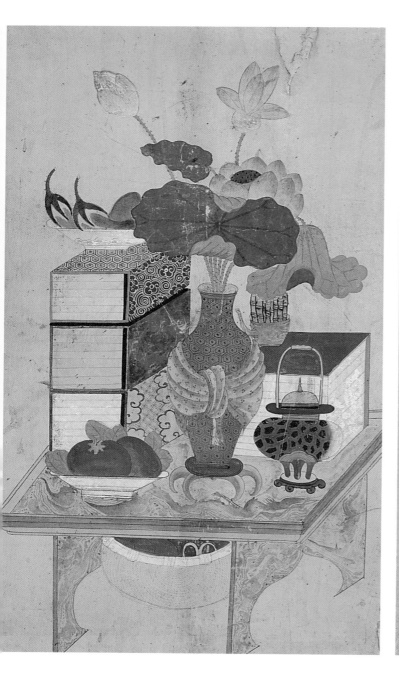
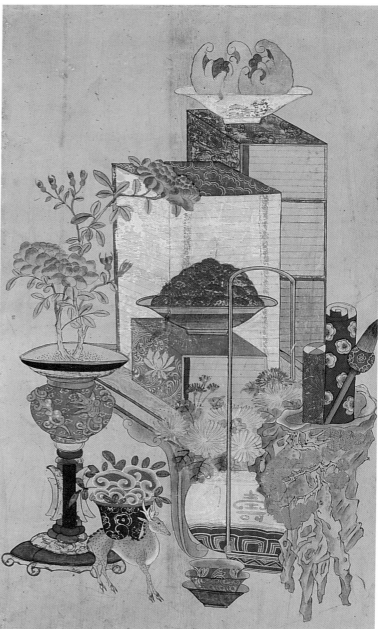

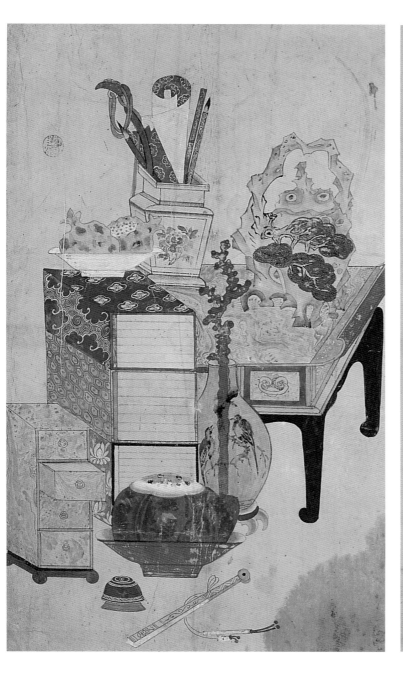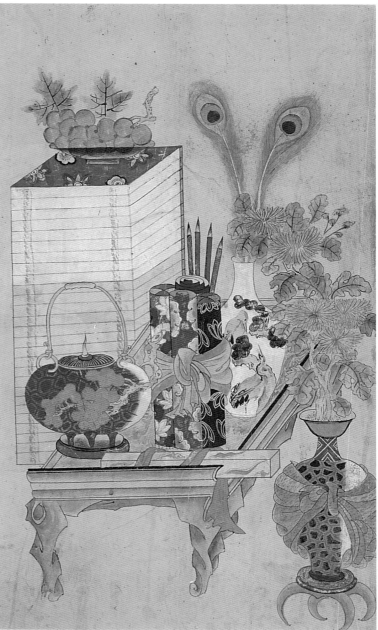

Ch'aekkŏri eightfold screen painted with design of books and scholars' utensils

Cat no. 70

19th century

Ink and colour on paper

125 (h) x 362 (w) cm

National Museum of Korea, Seoul

Pictures of books, bookshelves, stationery and indoor utensils admired by scholars are called *ch'aekkŏri* (meaning paintings of books and things). The origin of the term *ch'aekkŏri* is unknown, but these paintings are similar to *munbanggimyŏngdo* (Chinese-influenced Korean paintings of stationary and utensils) and *kyehwa* (fine-line architectural drawings). They may have some relationship to a Chinese Qing dynasty (1644–1911) style of bookshelf known in Korean as *tabogak* or the pavilion of many treasures.

Ch'aekkŏri can be divided into two groups: one painted with designs of scholars' items including books, stationery and bronze vessels that are placed inside bookshelves, which form the framework of the composition; the other painted with a design of auspicious fruit and ordinary household items against a plain background. The former has a strict composition, muted colours and depicts scholarly items such as ceramic wares, bronze wares, vases, pots, oddly shaped contemplative stones and fans. The latter category of screen employs a naive form of linear perspective. *Ch'aekkŏri* are unique to Korea and exhibit Western painting techniques, notably perspective and chiaroscuro or shading techniques.

This *ch'aekkŏri* is of the latter type and shows the Confucian respect for learning and indigenous folk or religious beliefs. The colours are bright and the drawing less sophisticated. Objects depicted include fruits that symbolise long life (peach), abundant offspring (watermelons, pomegranates, grapes, melons, eggplants), flowers or plants that symbolise prosperity (citron, peony), longevity (pine trees, *yŏngji* mushroom), a noble man (chrysanthemum) and purity (lotus). Compared with other paintings of this kind, the colours in this folding screen are rather muted, much like the *ch'aekkŏri* of the first group.

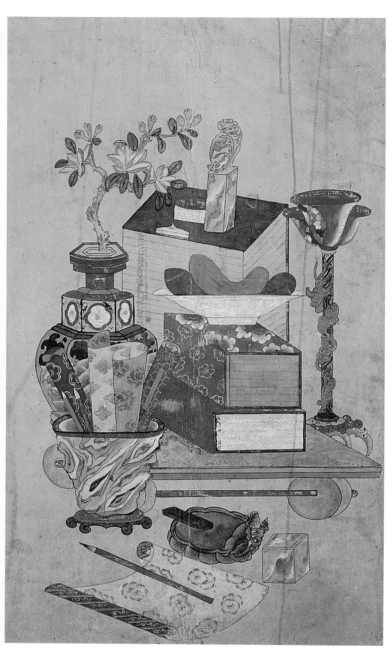

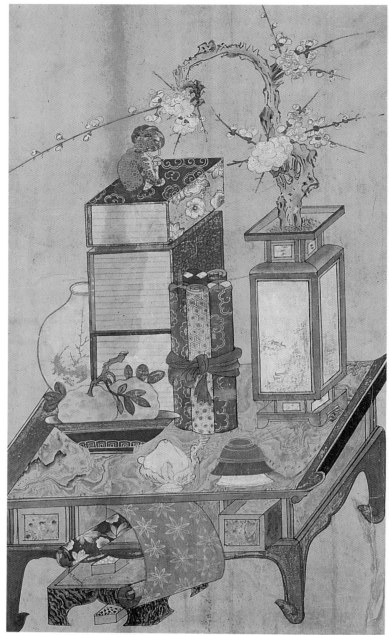

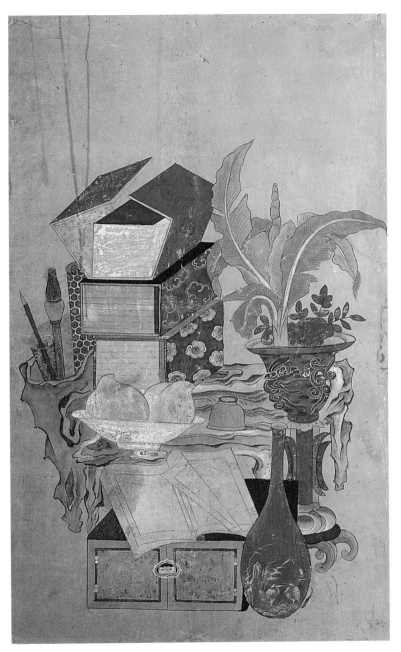
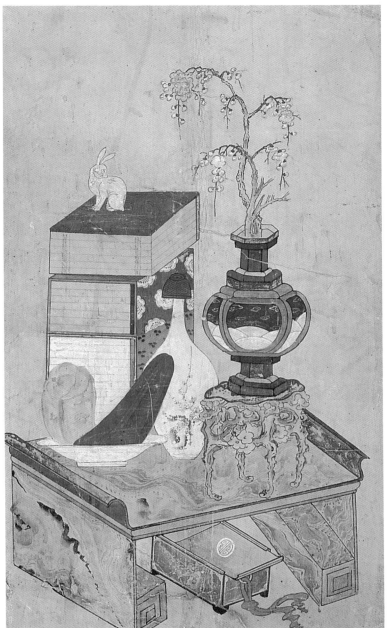

Shin Han-p'yŏng (1726–?)

Cat no. 71

Portrait of Yi Kwang-sa

1774

Hanging scroll; ink and colour on silk

67 (h) x 53.5 (w) cm

National Museum of Korea, Seoul

This is a portrait of Yi Kwang-sa (1705–1777) painted by the court artist Shin Han-p'yŏng. Yi Kwang-sa is depicted wearing a traditional-style scholar's robe known as *top'o* and a horse-hair hat known as *panggŏn*. Yi Kwang-sa studied under the scholar Yun Sun and was a highly regarded calligrapher adept at *chinsŏ* (regular script), *ch'osŏ* (grass script), *chŏnso* (seal script) and *yesŏ* (official script).

Yi Kwang-sa was exiled to the countryside in 1755 because of his involvement in the *pyŏksŏ* (Writing on the wall) case at Naju in South Chŏlla province. A poster was pasted on a wall slandering King Yŏngjo (reigned 1724–1776), saying the king's mother was originally the maid of a court lady. Even though it is alleged that Yi Kwang-sa was not involved in this incident, the poster was attributed to his political faction and because he was a member he was exiled to Puryŏng.

The painting bears the following inscription: 'This is a portrait of the esteemed Master Yi Kwang-sa, a native of Wansan, known as Tobo, the familiar name he assumed on reaching adulthood, and by his pen-name Wŏn'gyo. In 1672, during the reign of King Yŏngjo, Master Yi's place of exile moved from Puryŏng to Shinji Island [now known as Chindo]. On 26 August 1777, Master Yi passed away in his house in Kŭmsil village on Shinji Island aged 70 years'. This portrait was composed by the artist Shin Han-p'yŏng in the winter of 1774. The 28 August is Master Yi's date of birth. Master Yi was then living on the island and had adopted for himself the name "Old Man Subuk".'

Translated by Kenneth M Wells

朝鮮國完山李公諱匡師字道甫號員嶠先生遺像

我

英廟壬午 先生自富寧移謫新智島出丁酉八月二十六日卒于島之金實村寓舍壽七十三

此本卽 先生七十歲甲午冬畫師申漢枰所寫

八月二十八日卽 先生降辰 先生在島自稱壽北老人

Han Sŏk-pong (1540–1605)

Cat no. 72
Album with calligraphy including a poem by Du Fu
Late 16th century
Gold paint on indigo paper
26.2 (h) x 16.5 (w) x 2.3 (d) cm; 23 pp
National Museum of Korea, Seoul

This album contains calligraphy by Han Sŏk-pong. The leaves of the album that are pictured record part (the 11th to 22nd lines) of a poem by Chinese Tang dynasty (618–907) poet Du Fu (712–770) titled 'Looking at Zhang Xu's *ch'osŏ* [or grass script calligraphy] shown by the court official Yang'. The poem is written in grass script and the style is influenced by the Chinese calligrapher Wang Xizhi (321–379).

Han Sŏk-pong was a scholar-official responsible for writing official government documents including those sent to China during the late Ming dynasty (1368–1644). He was born into an upper-class family that fell on hard times and was raised by his mother, who earned money sewing and cooking. He was sent to boarding school for a classical education, which involved learning the Confucian classics, poetry and calligraphy.

Zhang Xu (675–750), also known as *Bogao*, was a Tang dynasty master calligrapher from Suzhou in China. He was known as 'the saint of grass script calligraphy' (*Ch'osŏng*) and as one of the eight drunken saints. The first half of Du Fu's poem praises Zhang Xu's writing and it continues with the following lines:

Above all, practising calligraphy diligently,

the water of the pond that he used to pass by became ink.

The strokes of his letters are the most brilliant,

He deems the ones he wrote in his declining years to be the best.

Since Zhang Xu and Wang Xizhi,

I don't know who shall write the model of calligraphy

for future generations.

Oh, the writing of Zhang Xu is fine,*

free, and of clear spirit.

Yang fondling the box where the calligraphy is kept,

watching the calligraphy over and over again,

forgets to eat and sleep.

Imagining how Zhang Xu might have moved his brush,

I don't think he was merely a drunkard.

Translated by Park Duk-Soo

* Literally, the poem reads 'the writing of Dongwu', but as Zhang Xu was from Dongwu province, it is interpreted as 'the writing of Zhang Xu'.

练家先出临池先妻一妻俊拔
西王王荣年里骑极来去张
王滇谁遥百代名吗峰东名
粉逸气盛清溥杨云拂篷

荀郭生点荷底急着挥
毫浑不稍观涯涘
吾杜工部作化杨殷中永张旭笔法

The Analects of Confucius

Cat no. 73

1588–1590

Copper type printed on paper

35.5 (h) x 22.6 (w) x 1.1 (d) cm

Sŏngam Archives of Classical Literature, Seoul

This traditional string-bound (sŏnjang) book is part of the Analects (Lun Yu in Chinese and Nonŏ in Korean) by Confucius and was printed in Chinese and han'gul Korean script with cast copper type. It is one of the so-called Chinese Four books (Si shu), regarded as the cornerstone of a classical education and Confucian learning. The other books, which were also printed in metal type around this time are The book of Mengzi, The great learning and The doctrine of the mean. Since the 3rd to 2nd century BCE the Chinese written language was introduced to Korea and became the language of government, official culture and the literati. It was not until 1446 that an independent Korean script known as Hunmin chŏngŭm (Correct sounds to instruct the people) was created under the instruction of King Sejong (reigned 1418–1450) of the Chosŏn dynasty. Han'gul, as the script is now known, is a unique phonetic system of writing that is much easier to learn than the complex system of Chinese characters. Its introduction during the Chosŏn dynasty highlighted Korea's growing cultural independence and promoted literacy among men and women who did not have access to classical Chinese language.

The bilingual version of the Analects, regarded as a key Confucian text, gave men not schooled in classical Chinese and women the opportunity to read this important work.

Printing with metal type ensured larger numbers of people had access to literature and learning. The calligraphy style upon which the metal type used for the Analects is based was developed in 1455 by the Korean scholar Kang Hŭi-an, who was a member of the Chiphyŏnjŏn or Hall of worthies, responsible for the development of han'gul. The metal type was cast in 1588. The size of the font is 1.4 x 1.4 cm. There are 19 characters per vertical line and there are ten lines of text per page.

冉ᅅ염子ᄌᆞㅣ朝됴로셔退퇴ᄒᆞ야놀子ᄌᆞㅣᄀᆞᆯ

ᄋᆞ샤ᄃᆡ엇디晏안ᄒᆞ뇨對ᄃᆡᄒᆞ야ᄀᆞᆯᄋᆞᄃᆡ政졍

이잇데이다子ᄌᆞㅣᄀᆞᆯᄋᆞ샤ᄃᆡ其事ᄉᆞㅣ로다

만일에政졍이이실ᄯᆞᆫ비록나를ᄡᅳ디아니

ᄒᆞ나내그與여ᄒᆞ야聞문ᄒᆞ욤이니라

○定뎡公공이問문ᄒᆞᄃᆡ一일言언而이以이興흥

邦방ᄒᆞᄂᆞ니라ᄒᆞᆫ有유諸져가잇孔공子ᄌᆞㅣ對ᄃᆡᄒᆞᄃᆡ日왈

言언不블可가以이若약是시其기幾긔也야

니와

定뎡公공이問문즈오ᄃᆡ一일言언에可가히뻐

邦방을興흥ᄒᆞ리라ᄒᆞᄂᆞ니인ᄂᆞ니잇가孔공

子ᄌᆞㅣ對ᄃᆡᄒᆞ야ᄀᆞᆯᄋᆞ샤ᄃᆡ言언을可가히뻐

이러트시그幾긔티몯ᄒᆞᆯ꺼시어니와

人신之지言언에ᄀᆞᆯᄋᆞᄃᆡ爲위君군難난ᄒᆞ며爲위臣신

不블易이어니라

人신의言언에ᄀᆞᆯᄋᆞᄃᆡ君군되옴이어려오며

臣신되옴이쉽디아니타ᄒᆞᄂᆞ니

如셕知디爲위君군之지難난이ᄋᆞᆫ댄不블幾긔

乎호一일言언而이興흥邦방乎호가잇

만일에君군되옴이어려온줄을알ᄯᆞᆫ댄一일

화 샹 거 봉 건 지 일

Handwritten book, volume 1

Cat no. 74

Hwasan kibong (Strange encounter at Mount Hwa)

18th–19th century

Ink on paper

31.6 (h) x 21.8 (w) x 0.8 (d) cm; 39 pp

Changsŏgak collection,

Academy of Korean Studies, Sŏngnam

This is the first book of the 13-volume novel titled *Strange encounter at Mount Hwa* (*Hwasan kibong*). It is handwritten in a somewhat cursive form of palace style (*kung-ch'e*) han'gŭl calligraphy. This novel is one of the many anonymous works of Korean literature written in han'gŭl rather than Chinese. Although the exact date of writing is not known, the 1700s saw the rise of this genre of Korean literature and the palace style of han'gŭl calligraphy. Vernacular literature blossomed in the late Chosŏn period, especially during the reigns of Yŏngjo and Chŏngjo. There are numerous anonymously written han'gŭl novels that have themes such as familial conflict, love, social satire and heroes of humble origin. *Strange encounter at Mount Hwa* was first published in 1917.

The palace style of calligraphy developed shortly after the invention of han'gŭl in the mid 1400s. It quickly gained acceptance because the first style of han'gŭl calligraphy, called printing style (*p'anbonch'e*), was difficult to execute as each stroke had to contain the hidden brush tip. The palace style was first used by women of the palace for letter writing and for the composition of literary works. Several famous palace women contributed greatly to the formation and development of the palace style.

This script is more cursive than the regular han'gŭl script. One can sense the movement and speed of the brush. There is also a greater variety of ink density, which can be seen especially in the finely tapered vertical strokes that tend toward the left and often form slanting strokes that blend into the next character. This produces an overall visual effect of fluency and suppleness.

The story of *Strange encounter at Mount Hwa* is set in Tang China (618–907). The hero, Yi Sŏng, is the son of Yŏngch'un but Yi Sŏng's mother's sudden death starts a chain of tragic events within the family. When Yi Sŏng's stepmother gives birth to her own son, she tries to get rid of Yi Sŏng, who somehow avoids misfortune and takes first place in the state examination. The family feud eventually becomes enmeshed with a series of palace plots involving the Tang imperial family. The hero is forced to expel his beloved wife and remarry a princess. In the end, however, he is cleared of all accusations and lives happily with his two wives.

Yi Sŏng-mi,
Professor of Art History, Academy of Korean Studies, Sŏngnam

Reference: Yi Sŏng-mi, in Kim Hongnam, ed, *Korean arts of the eighteenth century: splendour and simplicity*, Asia Society Galleries, New York, 1993, cat no. 36, p 213.

List of objects made for the wedding of a crown prince

Cat no. 75

1882

Ink on coloured paper

229.7 (h) x 25.7 (w) cm

Changsŏgak collection,

Academy of Korean Studies, Sŏngnam

This object list was made for the wedding of the crown prince who later became Emperor Sunjong (1874–1926; reigned 1907–1910), the last monarch of the Chosŏn dynasty. The date is shown on the reverse side of the scroll. The cyclical date of the wedding is indicated as *imo*, which fell in 1882, and is written on the reverse side of the scroll.

The object list includes three sets of dragon rank-badges for the crown prince as well as another set for the bride to wear on her *chŏggŭi* (a ceremonial robe embroidered with peacock patterns). Other items include pendant ornaments, called *norigae*, to be worn by the bride, embroidered screens, bedding and embroidered pillows. Most items listed come in several pairs or groups of ten to twenty, making the total number of items several hundred. This list provides testimony to the sumptuousness of royal weddings of the Chosŏn dynasty. During the reign of King Yŏngjo (1724–1776) the court ordered that spending on royal weddings be reduced and issued a book called *Kukhon chŏngrye* (Regulations on royal weddings) in which quantities to be used for each wedding were severely limited. It seems,

동궁 마마

숑이에을비 삼촌 아쳥한간

비숭 마마

젹의 홍리 일촌 아쳥한간

왼 산홍리이촌 아쳥한간

낭ㄴ의 홍비 이촌 쵸록한간

젹졔 오십 일촌 아쳥한간

진쵹 뎐 일촌 나흥한간

진쵹 낭슨 이촌 나흥한간

나흥 원앙 낭슨 일촌

쵸쳥한간 칠낭항낭이촌

쵸록한간 항갑 오쳥

나흥한간 항갑 오쳥

빅강난 자를 쪽치 십촌

however, that subsequent weddings were not orchestrated within the strict guidelines, as shown by this list.

The scroll is made up of different colours in the following order: pink, sky blue, yellow, sky blue, green, yellow and green. Pink is called azalea colour in Korea, and green is called green bean. The object list is written in semicursive palace style (*kung-ch'e*) han'gŭl calligraphy, which is easy to decipher yet exhibits beautiful fluency. The language used is somewhat different from modern Korean, especially some of the vowel sounds.

Yi Sŏng-mi, Professor of Art History, Academy of Korean Studies, Sŏngnam

Reference: Yi Sŏng-mi, in Kim Hongman, ed., *Korean arts of the eighteenth century: splendour and simplicity*, Asia Society Galleries, New York, 1993, cat. no. 33, pp 132, 212–13.

Writing table

Cat no. 76 *(above)*
Late 19th century
Pine
29 (h) x 89.3 (w) x 26.6 (d) cm
National Museum of Korea, Seoul

Whereas most pieces of traditional Korean furniture are placed against walls or in corners, this table was placed in the centre of a man's study. Tables such as this, known as *sŏan*, were used by Confucian scholars for writing and reading, and were low, narrow and easy to move. In order to work, the scholar would sit cross-legged on a cushion on the floor. In a traditional Korean house the men's quarters, known as *sarangbang*, were separated from the women's quarters, or *anbang*.

The pine wood used for this table has a distinctive grain owing to the climatic effect of four distinct seasons. Pine trees grow in Korea in great abundance, reaching maturity after a few years, and have therefore been a popular wood for household furniture. The table comprises a long, plain, wide top as a working surface, known as *ch'ŏnp'an*, and recessed legs accommodating a lower shelf or *ch'ŭngnŏl* for storing books. It was made using vertical and horizontal mortise and tenon joints. The table has been treated with a stain made from iron oxide or gardenia seeds mixed with ink or black clay before a final application of vegetable oil.

Table for ink stone

Cat no. 77 *(below)*
18th–19th century
Pine and persimmon wood
30.3 (h) x 22.1 (w) x 19 (d) cm
National Museum of Korea, Seoul

This table was used to store an ink stone and was an essential piece of furniture in a scholar's room. The table is made up of a lidded box used to store the ink stone, supported on a stand. Inside the box a water dropper, ink container and other utensils were placed. This box is made from *kam namu* (persimmon wood) which was very popular for furniture because of its dramatic wood grain, in which the dark grain is set off by a light-coloured background. There is a drawer at the base of the box for access to the ink stone. The stand is made from pine.

Reference: Park Young-Kyu, in Kim Hongnam, ed., *Korean arts of the eighteenth century: splendour and simplicity*, Asia Society Galleries, New York, 1993, cat. no. 62, pp 150, 220.

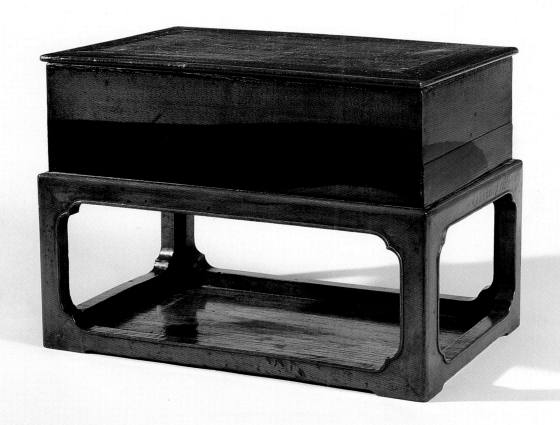

Letter rack

Cat no. 78

18th century

Bamboo

82.6 (h) x 21 (w) x 12 (d) cm

National Museum of Korea, Seoul

This letter rack or *kobi* was used to store plain and coloured papers for writing letters and poems. It was one of the few items that hung on the wall in a scholar's room in the men's quarter, or *sarangbang*. The letter rack is a light frame made from bamboo with compartments to hold rolls of paper. Different thicknesses of bamboo create visual interest and a sense of rhythm between solid and void, light and dark, thick and thin, and straight and rounded. Interesting shadows are cast by its silhouette on a white wall. This simple but refined form was designed to harmonise with the restrained aesthetic of objects in the scholar's room.

Reference: Park Young-Kyu, in Kim Hongam, ed., *Korean arts of the eighteenth century: splendour and simplicity*, Asia Society Galleries, New York, 1993, cat. no. 71, p 222.

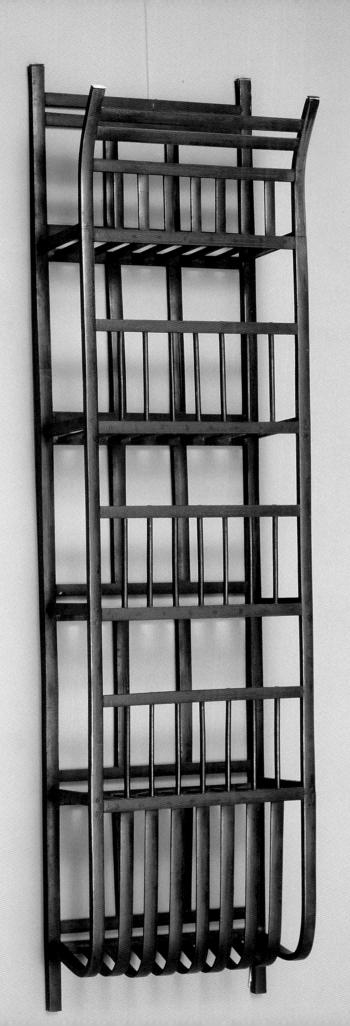

Notes on language

Korean

Except where people and institutions have established romanisations for their names and titles, the M-R (McCune-Reischauer) system of romanisation has been used in this publication. This system is now followed in the majority of works on Korea published in English.

All Korean names follow the Korean convention of family name followed by given name/s.

Chinese

The *Pinyin* system of romanisation has been used.

Bibliography

English-language publications

The arts of Korea, *6 vols, Dong Hwa Publishing Co., Seoul, 1979.*

Chung Yang-mo et al., The arts of Korea, *co-ordinating ed. Judith Smith, Metropolitan Museum of Art, New York, 1998.*

Deuchler, Martina. The Confucian transformation of Korea, *Harvard University Press, Cambridge and London, 1992.*

Eckhardt, P Andreas. A history of Korean art, *tr. J M Kindersley, E Goldston, London and Leipzig, 1929.*

5000 years of Korean art, *National Museum of Korea, Seoul, 1979.*

Griffing, Robert. The art of the Korean potter: Silla, Koryŏ, Yi, *Asia Society, New York, 1968.*

Han Woo-keun. The history of Korea, *Eul-yoo Publishing Co., Seoul, 1970.*

Ho-Am Art Museum. Masterpieces of the Ho-Am Art Museum, *Antique art, vols 1 and 2, Samsung Foundation of Culture, Seoul, 1996.*

Kim Hongnam (ed.). Korean arts of the eighteenth century: splendor and simplicity, *Asia Society Galleries, New York, 1993.*

Kim Jaihiun J. Classical Korean poetry: more than 600 verses since the twelfth century, *Asian Humanities Press, Fremont CA, 1994.*

Kim Kŭmja Paik, (ed.). Hopes and aspirations: decorative painting of Korea, *Asian Art Museum of San Francisco, San Francisco, 1998.*

Kim Wŏn-yong et al. Korean art treasures, *eds Roderick Whitfield and Youngsook Pak, Yekyong Publications Co. Ltd, Seoul, 1986.*

Kwon Young-pil (ed.). Fragrance of ink: Korean literati paintings of the Chosŏn dynasty (1392–1910) from Korea University Museum, *Korean Studies Institute, Korea University, Seoul, 1997.*

Lee Ki-baik. A new history of Korea, *tr. Edward W. Wagner with Edward Shultz, Harvard University Press, Cambridge and London, 1984.*

Lee Kyong-hee and Samsung Foundation of Culture. World heritage in Korea, *Hak Go Jae, Seoul, 1998.*

Lee, Peter H (ed.). Pine river and lone peak: an anthology of three Chosŏn dynasty poets, *tr., Peter H. Lee, University of Hawaii Press, Honolulu, 1991.*

Lee, Peter H (ed.). Sourcebook of Korean civilization: from early times to the sixteenth century, *vol. 1, Columbia University Press, New York, 1993.*

Lee, Peter H, ed. Sourcebook of Korean civilization: from the seventeenth century to the modern period, *vol. 2, Columbia University Press, New York, 1996.*

McCune, Evelyn. The arts of Korea: an illustrated history, *Tuttle, Rutland, 1962.*

McKillop, Beth. Korean art and design: the Samsung Gallery of Korean Art,

Victoria and Albert Museum, London, 1992.

National Museum of Korea. National Museum of Korea, *Tongchon Publishing Company, Seoul, 1998.*

Nelson, Sarah M. The archaeology of Korea, *Cambridge University Press, Cambridge, 1993.*

Swann, Peter. Art in China, Korea, and Japan, *3rd edn, Praeger, New York, 1965.*

Van Alphen, Jan. Korea: ceramics, *Snoeck-Ducaju & Zoon, Ghent, 1993.*

Whitfield, Roderick and Roger Goepper (eds). Treasures from Korea: art through 5000 years, *British Museum, London, 1984.*

Wright, Edward Reynolds and Man Sill Pai. Korean furniture: elegance and tradition, *Kondasha International Ltd, Tokyo, 1984.*

Yanagi Sōetsu. The unknown craftsman: a Japanese insight into beauty, *Kodansha International, Tokyo, 1989.*

Yi Sŏng-mi. 'The screen of the five peaks of the Chosŏn dynasty', *Oriental art, 42(4), 1996–1997.*

Korean-language publications

Ahn Hwi-jun. Han'guk hoehwasa *[History of Korean painting], Ilchisa, Seoul, 1980.*

Ahn Hwi-jun. Han'guk hoehwa ŭi chŏnt'ong *[Traditions of Korean painting], Munye ch'ulp'ansa, Seoul, 1988.*

Chung Yang-mo (ed.). Han'guk ŭi mi 2: paekcha *[Korean beauty 2: white porcelain], Chungang Ilbo, Seoul, 1978.*

Chung Yang-mo, Kim Wŏn-yong et al. (eds). Han'guk ŭi mi 3: punch'ŏngsagi *[Korean beauty 3: punch'ŏng ware], Jungang Ilbo, Seoul, 1981.*

Chung Yang-mo. Han'guk ŭi tojagi *[Ceramics of Korea]. Munye ch'ulp'ansa, Seoul, 1991.*

Chung, Yang-mo. Han'guk tojasa *[History of Korean ceramics], Munye ch'ulp'ansa, Seoul, 1993*

Ho-Am Art Gallery [Museum]. Ho-am misulgwan myŏngp'um torok: komisul 1, tojagi *[Masterpieces of Ho-am Art Museum: historical art 1, ceramics], Samsung Foundation of Culture, Seoul, 1996.*

Ho-Am Art Gallery [Museum]. Chosŏn hugi kukpoch'ŏn widaehan munhwa yusanŭl ch'ajaesŏ *[Treasures of the late Chosŏn dynasty 1700–1910: discovering great cultural assets], Samsung Foundation of Culture, Seoul, 1998.*

Ho-Am Art Gallery [Museum]. Punch'ŏngsagi myŏngp'umch'ŏng: Ho-am misulgwan sojang *[Masterpieces of punch'ŏng ware from the Ho-Am Art Museum: looking for the root of Korean beauty], Samsung Foundation of Culture, Seoul, 1993.*

Kang Kyŏng-suk. Han'guk tojasa *[History of Korean Ceramics], Ilchisa, Seoul, 1989.*

Kim Wŏn-yong and Ahn Hwi-jun. Sinp'an Han'guk misulsa *[Revised history of Korean art], Seoul University Press, Seoul, 1993.*

National Museum of Korea, Chosŏnjo mokkongye: Kim Chonghak hwabaek sujip *[Wood crafts of Chosŏn: Kim Chong-hak collection], National Museum of Korea, Seoul, 1989.*

Yi T'ae-ho. Chosŏn hugi hoehwa ŭi sasil chŏngsin *[Realistic spirit of Korean painting in the late Choson Period], Hakkojae, Seoul, 1996.*

Yi Tong-ju. Uri nara ŭi yekkŭrim *[Ancient painting of Korea], Hak Go Jae, Seoul, 1995.*

Yun Yong-i, Arŭmdaun uri tojagi *[Our beautiful ceramics], Hak Go Jae, Seoul, 1996.*

Yun Yong-i. Han'guk tojasa yŏn'gu *[Studies on the history of Korean ceramics], Munye ch'ulp'ansa, Seoul, 1993.*

Japanese-language publication

Chung Yang-mo (ed.). Sekai toji zenshū chōsenpen 19 *[World ceramics, Chosŏn, vol. 19], Nihon Tokyo shōgakukan, Tokyo, 1980.*

About the authors

Michael Brand

Michael Brand is Assistant Director at the Queensland Art Gallery. After receiving his PhD in art history from Harvard University in 1987, Michael Brand was Co-Director of the Smithsonian Institution's Mughal Garden Research Project in Pakistan before being appointed as the first head of the new Department of Asian Art at the National Gallery of Australia in 1988. Major exhibitions he has curated and publications he has edited or authored at the National Gallery of Australia include *The age of Angkor: treasures from the National Museum of Cambodia*, 1992, and *The vision of kings: art and experience in India*, 1995. Brand was also chair of the South Asia selection team for the Queensland Art Gallery's third *Asia-Pacific Triennial of Contemporary Art*, 1999.

Chung Yang-mo

Chung Yang-mo is a graduate of Seoul National University and an internationally renowned scholar of Korean art and culture, and of ceramics in particular. He has contributed to major international publications including: *Arts of Korea* (Metropolitan Museum of Art, New York, 1998); *Korea: Keramiek/Ceramics* (Snoeck-Ducaju & Zoon, Ghent, Belgium, for the Etnografisch Museum, Antwerp, Belgium, and the Rijksmuseum voor Volkenkunde, Leiden, the Netherlands, 1993); *Sekai toji zenshū chōsenpen* [World ceramics] (Nihon Tokyo shōgakukan, Tokyo, 1980); and *Korean arts of the eighteenth century: splendour and simplicity* (Asia Society Galleries, New York, 1993) as well as numerous important Korean-language publications. Chung Yang-mo began work at the National Museum of Korea in Seoul in 1962; he was the Director-General from 1993 until his retirement in December 1999. He is head of the Museum Department, and a member of the Connoisseur Committee, of the Cultural Properties Committee of the government of the Republic of Korea.

Kim Jae-Yeol

Kim Jae-Yeol is Deputy Director of the Ho-Am Art Museum in Yongin, where he has worked since 1982. He is a specialist in Korean ceramics, art and archaeology, and has contributed to numerous local and international publications.

In addition to his position at the Ho-Am Art Museum, Kim Jae-Yeol lectures on practice and method in art history at Seoul National University and is an expert advisor on the history of Korean ceramic art to the Art Bureau of the Ministry of Culture and Tourism in the government of the Republic of Korea.

Claire Roberts

Claire Roberts is Curator of Asian Decorative Arts and Design at the Powerhouse Museum, Sydney. She studied in Beijing from 1978 to 1981 and received a masters degree in Chinese language and art history from the University of Melbourne. Major exhibitions she has curated and publications she has edited or authored at the Powerhouse Museum include *In her view: the photographs of Hedda Morrison in China and Sarawak 1933–1967*, 1993; *Evolution & revolution: Chinese dress 1700s to now*, 1997; and *Rapt in colour: Korean textiles and costumes of the Chosŏn dynasty*, 1998. Other exhibitions include *Post Mao product: new art from China* (Art Gallery of NSW, 1992) and the China component of the *Asia-Pacific Triennial of Contemporary Art* (Queensland Art Gallery, 1996 and 1999). She is enrolled in a PhD in East Asian history at the Australian National University, Canberra.

Kenneth M Wells

Formerly Assistant and Associate Professor in the Department of East Asian Languages and Cultures at Indiana University, Bloomington, USA from 1986 to 1993, Kenneth M Wells is now a Fellow at the Research School of Pacific and Asian Studies, Senior Lecturer in the Faculty of Asian Studies, and Director of the Centre for Korean Studies at the Australian National University in Canberra. He was founder and first President of the Korean Studies Association of Australasia from 1994 to 1996. His publications include *South Korea's Minjung movement: the culture and politics of dissidence*, University of Hawaii Press, Honolulu, 1995, for which he was contributor and editor; and *New god, new nation: protestants and self-reconstruction nationalism in Korea 1896–1937*, Allen & Unwin, Sydney, and University of Hawaii Press, Honolulu, 1991.

About the museums

National Museum of Korea, Seoul

The National Museum of Korea in Seoul started as the Royal Yi Household Museum in 1908. With the establishment of the Republic of Korea it was refurbished and reorganised in 1945. The National Museum of Korea now has nine local branch museums in major historical cities such as Kyŏngju and Kwangju, and new local museums are under construction in Ch'unch'ŏn and Cheju Island. The museum houses an outstanding collection of 230 000 Korean and East and Central Asian art and archaeological objects, including a number of Korea's designated National Treasures. The museum places a major emphasis on the preservation of collections, and conserving, studying and displaying Korean art and artefacts. Committed to the dissemination of information on Korean arts and culture, the museum has coordinated a number of major exhibitions in Europe and the United States. A new national museum building, under construction in the heart of Seoul, is scheduled to open in the year 2003.

Ho-Am Art Museum, Yongin

The Ho-Am Art Museum is located just outside Seoul in Yongin, Kyŏnggi province. It is the largest private museum in Korea. Founded in 1982, the museum consists of a large main building built in the style of a traditional Korean house (han-ok), the *Heewon* traditional Korean garden, and a sculpture garden dedicated to the display of large works by the French sculptor Bourdelle. The Ho-Am Art Museum's collection is based on a group of 2000 works of art collected over four decades by the founder of the Samsung Group, the late Lee Byung-Chull (also known by his pen name 'Ho-Am'). The collection currently includes more than 15 000 works ranging from prehistoric relics to contemporary works of art, including 100 pieces designated as National Treasures or Treasures by the Korean government. The Ho-Am Art Museum has also earned an international reputation for the calibre of international art exhibitions and educational programs that it organises.

Powerhouse Museum, Sydney

The Powerhouse Museum is Australia's largest and most popular museum. Part of the Museum of Applied Arts and Sciences established in 1880, the Powerhouse Museum was purpose-built in 1988 on the site of a disused power station. Its collection spans decorative arts, design, science, technology and social history, which encompasses Australian and international, and historical and contemporary material culture. The Powerhouse Museum has a reputation for quality and excellence in collecting, preserving and presenting aspects of world cultures for present and future generations. In 1997, the museum opened its Asian Gallery with the aim of promoting a greater awareness and appreciation of Asian cultures in Australia.

Queensland Art Gallery, Brisbane

The Queensland Art Gallery is one of Australia's leading state art galleries and the major focal point for the visual arts in Queensland. Founded in 1895, the gallery moved to its award-winning new building on the banks of the Brisbane River in 1982. Its collection is devoted to both Australian and international art, with the gallery's collection of contemporary Asian art recognised internationally for its excellence. The gallery prides itself on a comprehensive and innovative exhibitions program, including collaborative projects with the Louvre in Paris, the Shanghai Museum and the National Museum of Indonesia. Since 1993 the gallery has staged the highly acclaimed *Asia-Pacific Triennial of Contemporary Art*.